ENDANGERED PLACES

ENDANGERED PLACES

FROM THE AMAZONIAN RAINFOREST
TO THE POLAR ICE CAPS

CLAUDIA MARTIN

Published by Amber Books Ltd
United House
North Road
London
N7 9DP
United Kingdom
www.amberbooks.co.uk
Instagram: amberbooksltd
Facebook: amberbooks
Twitter: @amberbooks
Pinterest: amberbooksltd

ISBN: 978-1-83886-303-6

Project Editor: Michael Spilling
Designer: Keren Harragan
Picture Research: Terry Forshaw

Printed in China

Contents

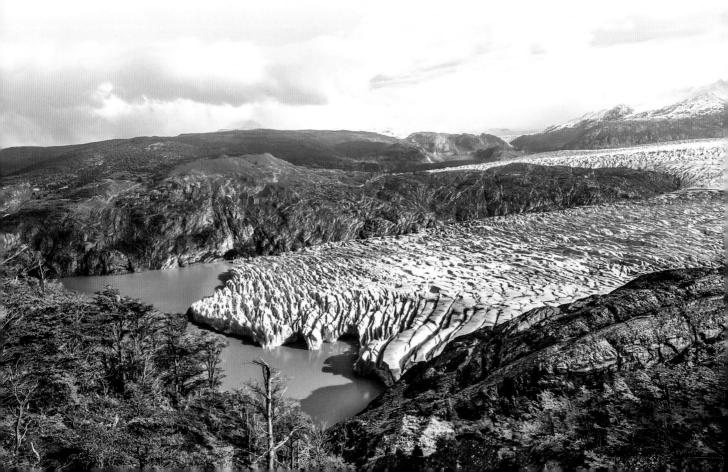

Introduction

As Earth's cleverest and most adaptable species, humankind's greatest strength – and perhaps our downfall – has always been our ambition. Our ambition has driven us to travel farther, build higher, make more, own more. Our ambition led us to sail across the ocean in rocking dugout canoes so we could be the first to reach distant islands. It led us to paint pictures on the walls of caves, to build towering pyramids and to carve cities from desert cliffs. To realize our ambitious dreams, we have also burned millennias' worth of coal, razed forests, drained marshes and changed the course of rivers.

Our ambition, combined with our devastating short-sightedness, has endangered some of Earth's most beautiful and precious places, from rainforests to reed beds, from taiga to tundra.

Yet, as Earth's cleverest and most adaptable species, we can still save these endangered places. Conservationists, restorers, rangers, biologists, farmers, legislators, activists and an army of ordinary people are at work. As with all humankind's greatest achievements, it will be hard work and collaboration that win the day. Saving our endangered places would be the greatest achievement of all.

OPPOSITE:
Tabin Wildlife Reserve, Sabah, Malaysia
This reserve was created in 1984 to protect the endangered animals of Sabah's lowland dipterocarp forest. Hidden by the trees are Sabah's largest mammals, the Borneo elephant and the banteng, a species of wild cattle.

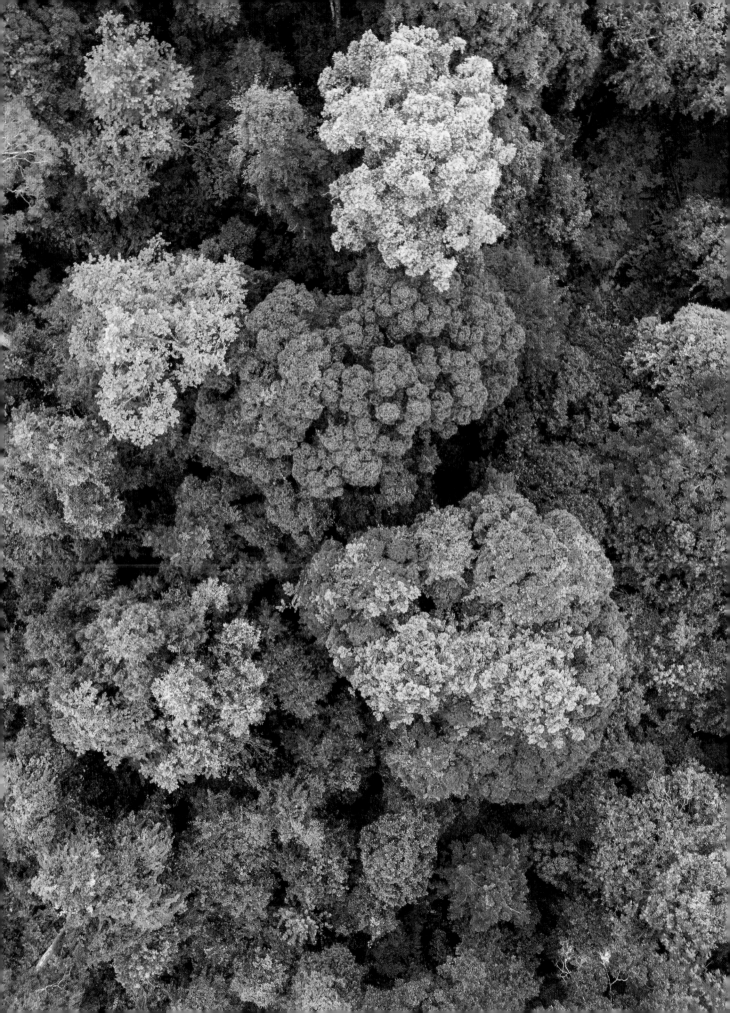

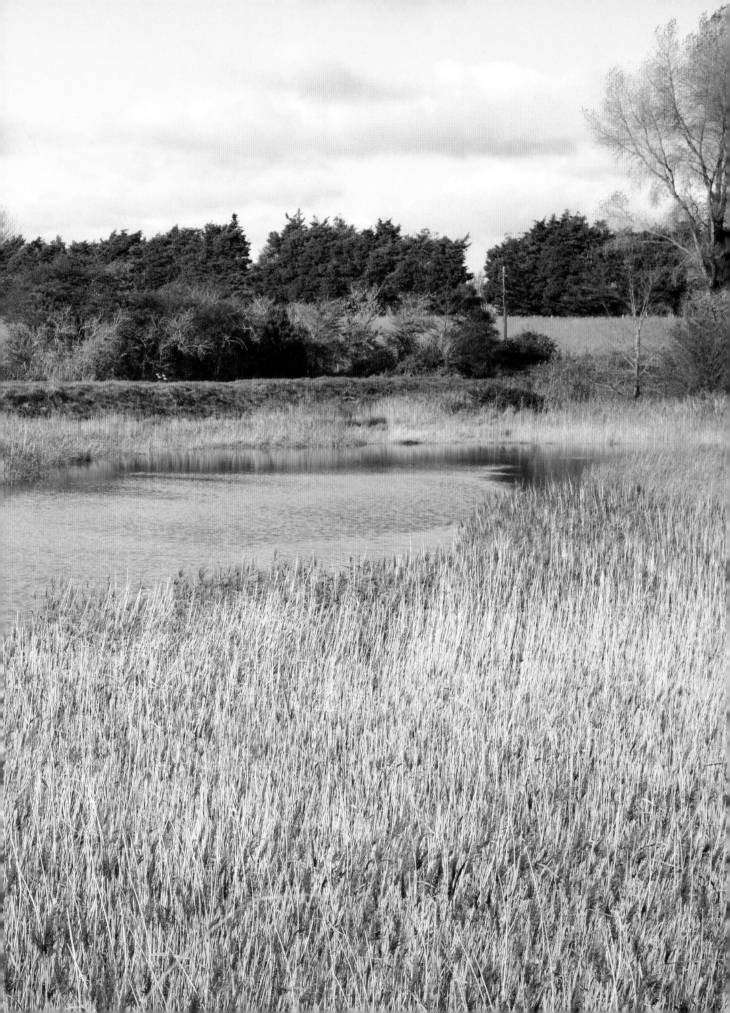

Europe

FOR CENTURIES, Europe's wetlands – its reed beds and salt marshes, its bogs and fens – were considered wastelands. Unsurprisingly, given Europe's relatively high population, small area and long, intricate coastline, Europeans undertook some of the earliest attempts at land reclamation. Efforts to drain eastern England's marshy Fenland began with the Romans. Roman refugees from 'barbarian' invasions are credited with driving the first piles into the silt of the Venetian lagoon, where the improbable city of Venice still perches precariously. One of the earliest well-documented reclamation projects was in 1612, when the 70 sq km (27 sq mile) Beemster Polder, in the Netherlands, was reclaimed from a lake using the pumping power of windmills.

It was not until the latter half of the 20th century that attitudes to these liminal habitats began to change. Europeans began to perceive the preciousness of the remaining tracts of mire and marsh, not only to biodiversity – with their otters and orchids, glasswort and grebes – but as barriers that protect us from floods, storms, wildfires and erosion. If that were not enough, every year, the world's remaining wetlands store a staggering 44.6 million metric tonnes of carbon. Across Europe, conservationists and farmers are painstakingly restoring our endangered wetlands.

OPPOSITE:

Reed bed near Shingle Street, Suffolk, England
This fen community, dominated by the *Phragmites australis* reed, is threatened by coastal erosion, leading to saltwater incursion. Yet this lingering stretch of a once-vast region of reed beds remains a stronghold of the rare but locally recovering European otter.

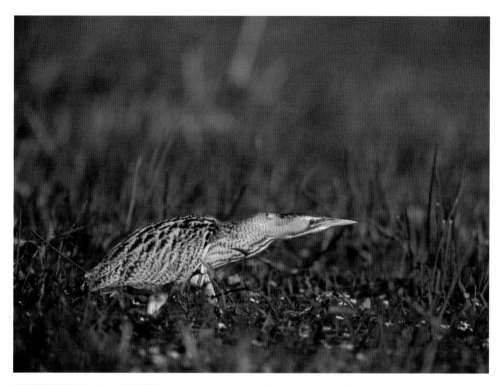

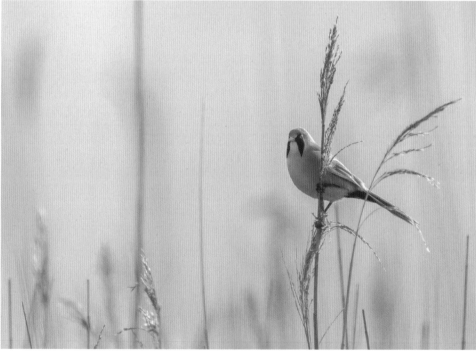

ABOVE TOP:
Bittern, reed bed, Suffolk
The Suffolk reed beds provide both a breeding and a wintering habitat for many migratory birds. Among them is the Eurasian bittern, which has a globally declining population due to the reduction in wetlands across much of its range. It typically breeds in reed beds of at least 20 hectares (50 acres), before flying southwards for winter.

ABOVE BOTTOM:
Bearded tit, reed bed, Suffolk
This passerine is named for the dark moustaches of the male (pictured). The bearded tit is a year-round resident of reed beds, feeding on reed aphids in summer and reed seeds in winter. Around 500 breeding pairs are found in England. Since they spend much of their time skulking among the reeds, their presence is only betrayed by a 'pinging' call.

RIGHT:
Starlings, reed bed, Suffolk
The common starling is in decline across western Europe due to a drop in the grassland and reed bed invertebrates that form its food. The species is known for forming huge, noisy murmurations, which – with their constantly changing shape – are a defence against birds of prey. Reed beds are particularly favoured for roosting.

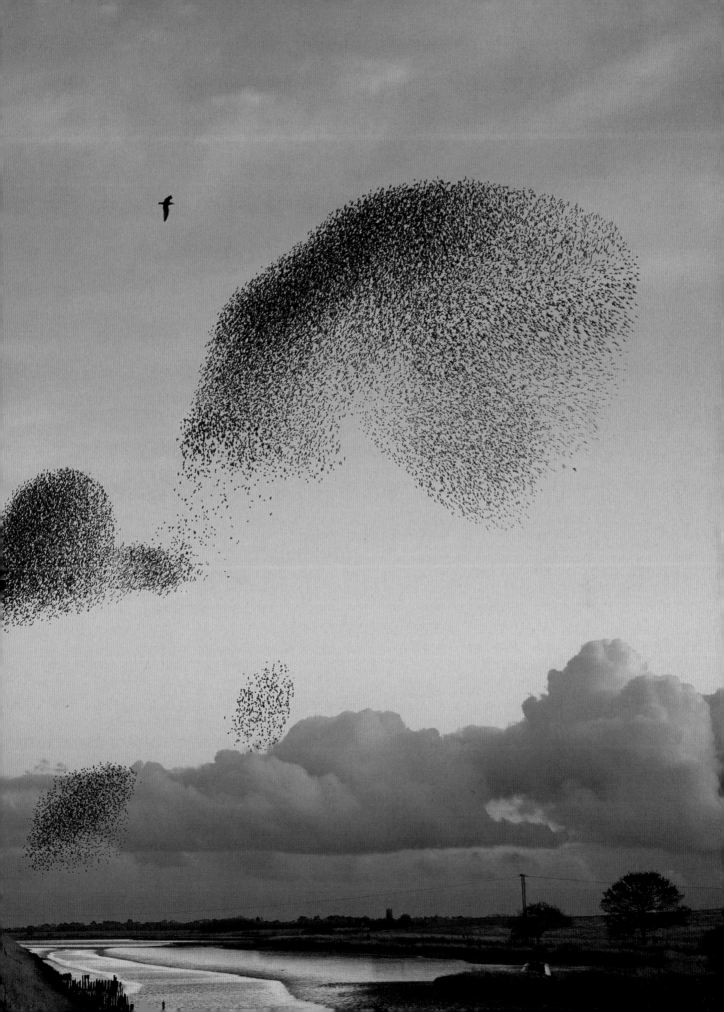

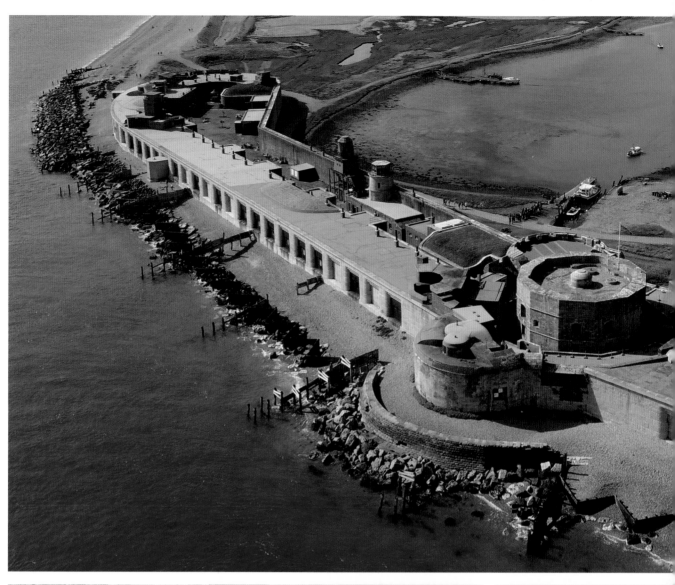

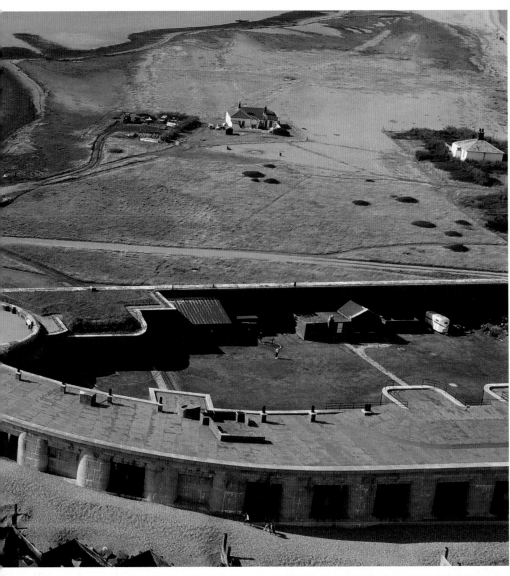

Hurst Castle, Hampshire, England
Built in 1541–44 on the orders of Henry VIII, this artillery fort lies on the Hurst Spit, a 1.6 km (1 mile)-long shingle bank at the western end of the Solent strait. The castle is increasingly endangered by coastal erosion, which led to a collapse in its eastern walls in 2021.

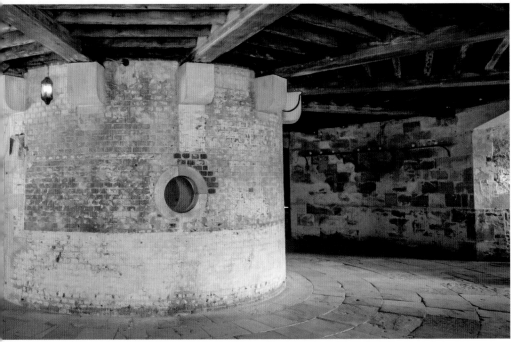

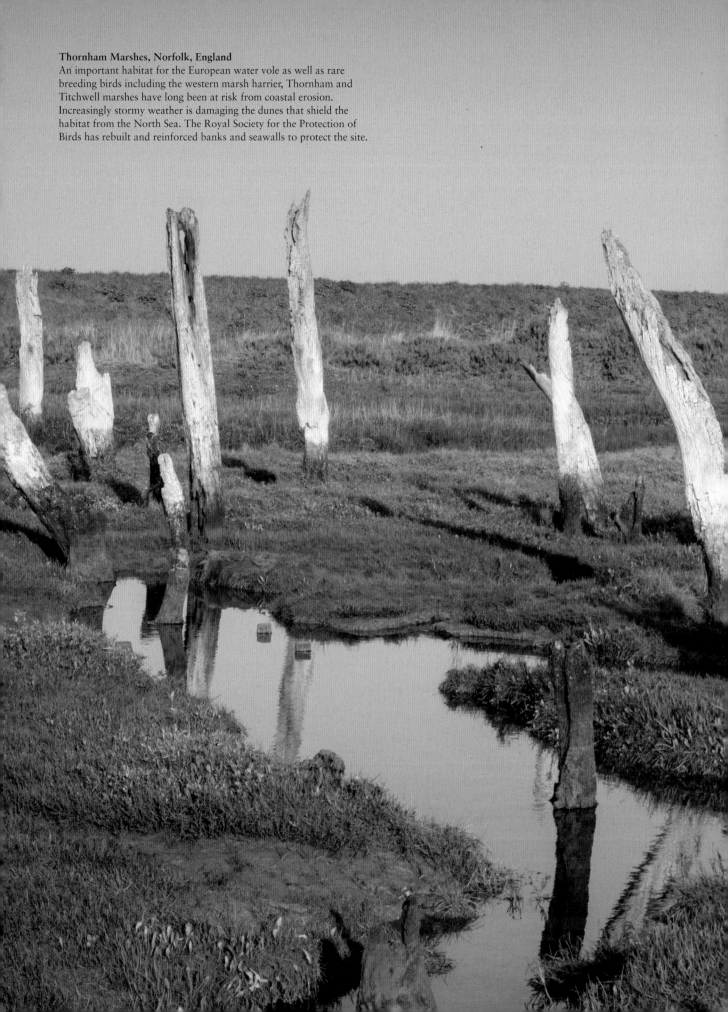

Thornham Marshes, Norfolk, England
An important habitat for the European water vole as well as rare
breeding birds including the western marsh harrier, Thornham and
Titchwell marshes have long been at risk from coastal erosion.
Increasingly stormy weather is damaging the dunes that shield the
habitat from the North Sea. The Royal Society for the Protection of
Birds has rebuilt and reinforced banks and seawalls to protect the site.

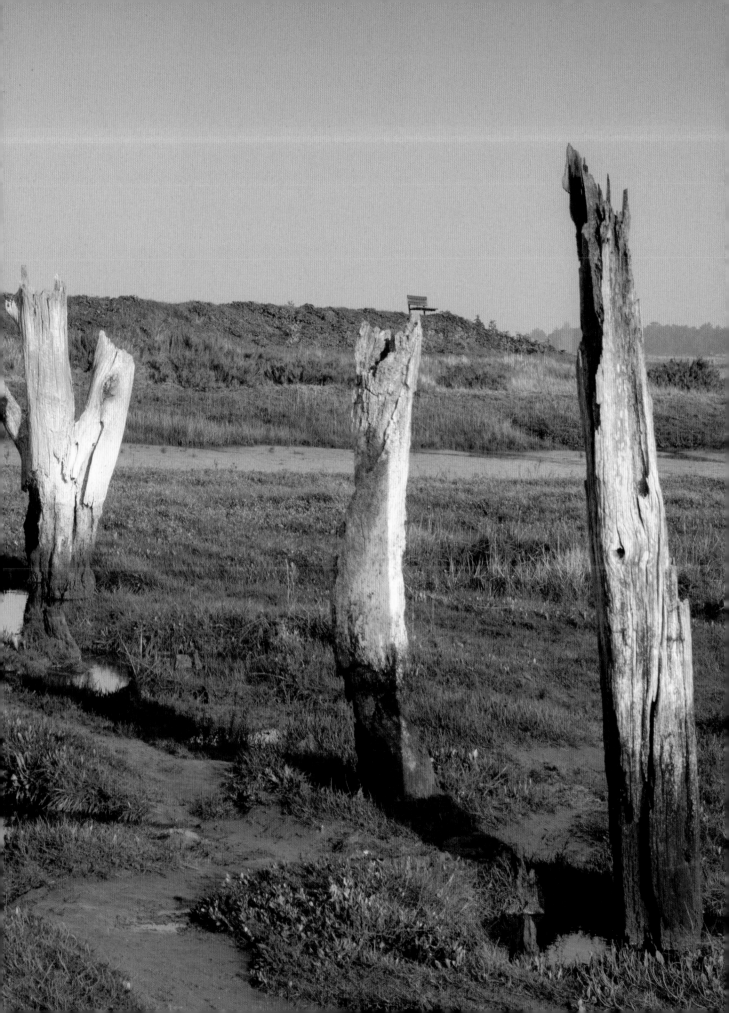

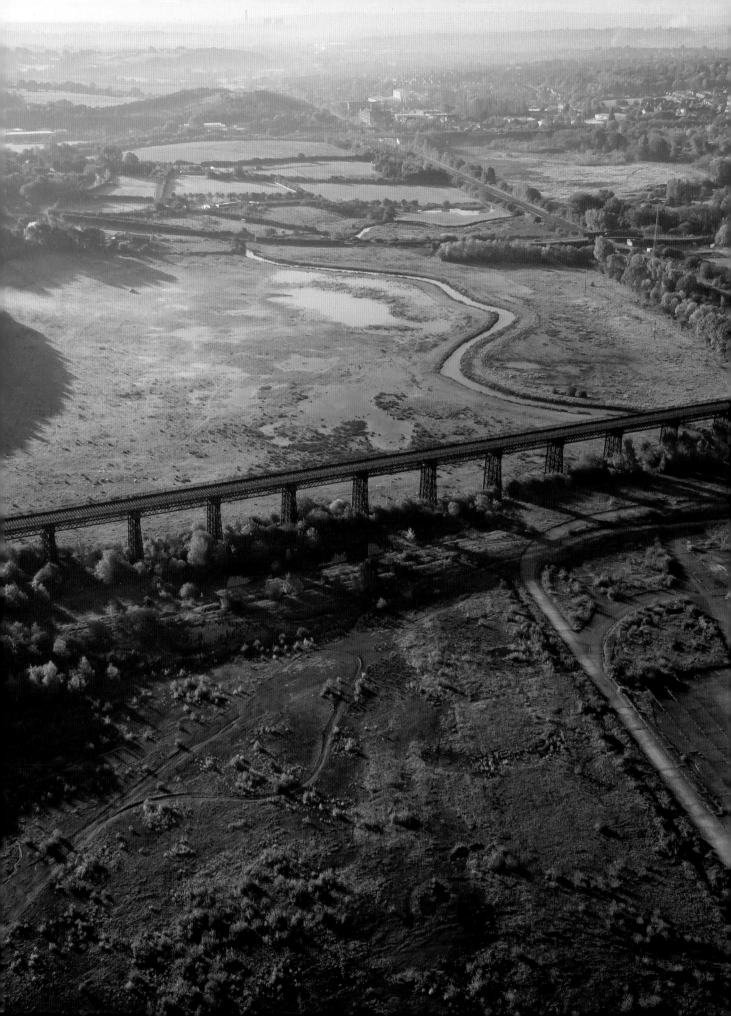

BOTH PHOTOGRAPHS:
Bennerley Viaduct, Derbyshire–Nottinghamshire, England
Completed in 1877 as part of the Great Northern Railway Derbyshire Extension, this wrought-iron viaduct was closed to rail traffic in 1968. Damage from weather, vegetation and vandalism led to the monument going on the World Monuments Watch list in 2020. Since then, restoration work has made the structure safe.

Canning and Salthouse Docks, Liverpool, England
In 2004, Liverpool's historic centre and docklands was added to the UNESCO World Heritage Site list as an example of a major trading port of the 18th and 19th centuries. The site lost its World Heritage status in 2021 due to what conservationists view as damage to the urban landscape by encroaching development, including the Everton Stadium.

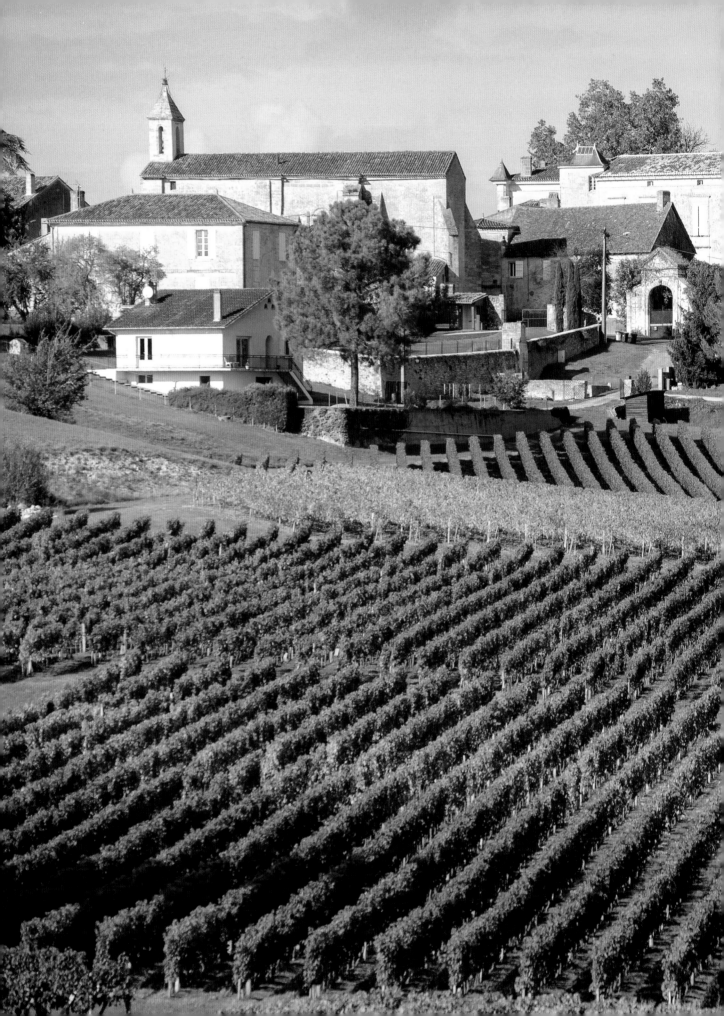

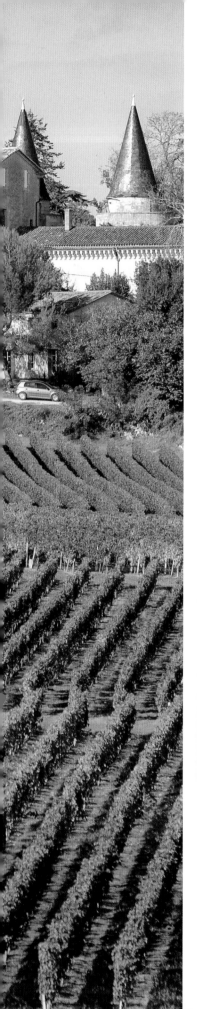

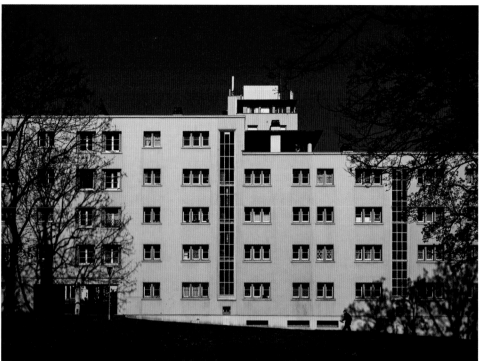

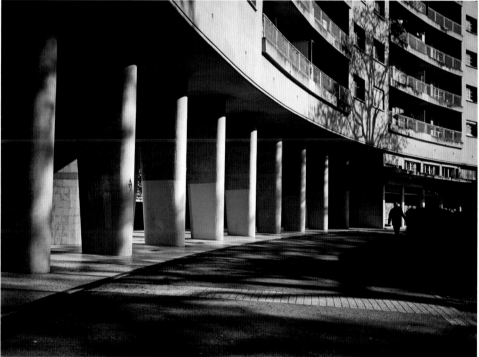

LEFT:
St-Émilion vineyards, Nouvelle-Aquitaine, France
Along with Médoc, Graves and Pomerol, St-Émilion is one of the principal Bordeaux wine regions. This cultural landscape and its wine are at risk from global warming. An increase in hot days during the flowering season is resulting in lower productivity and lower-quality grapes.

ABOVE TOP AND BOTTOM:
La Butte-Rouge, Hauts-de-Seine, France
Built between 1931 and 1965, this garden city was a landmark in social housing as well as a striking blend of bold Bauhaus and art deco design. Residents are campaigning to save their homes from demolition, despite the fact that they suffer poor soundproofing and insulation.

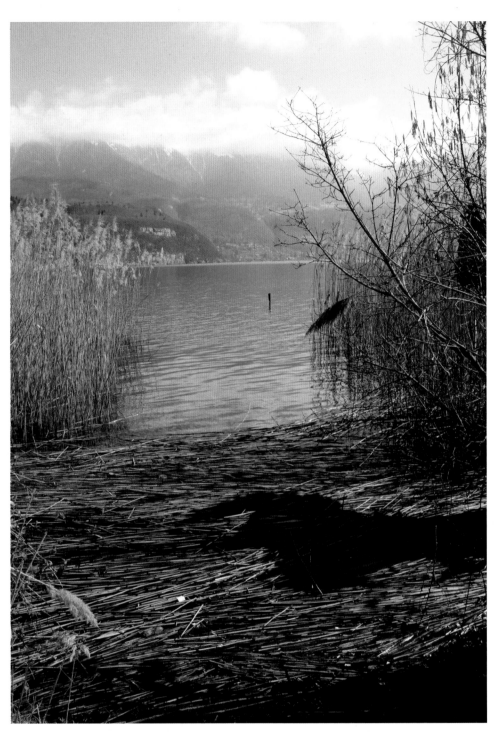

ABOVE:

St-Jorioz reed bed, Lake Annecy, Haute-Savoie, France
On the western bank of Lake Annecy, the fragile reed beds and marshes – dominated by schoenus, bulrush and purple moor-grass – are protected by the coastal protection agency. The reed beds shelter water birds including the great crested grebe, a distant relative of the flamingo known for its elaborate neck-waving mating displays.

RIGHT:

Gironde estuary, Nouvelle-Aquitaine, France
The largest estuary in western Europe experiences strong tidal currents that regularly create and destroy small islands. Along the estuary's banks are fishing huts, harbours and beach resorts. Yet both human and wild communities are threatened by rising sea levels, resulting in saltwater intrusion, as well as former upstream mining.

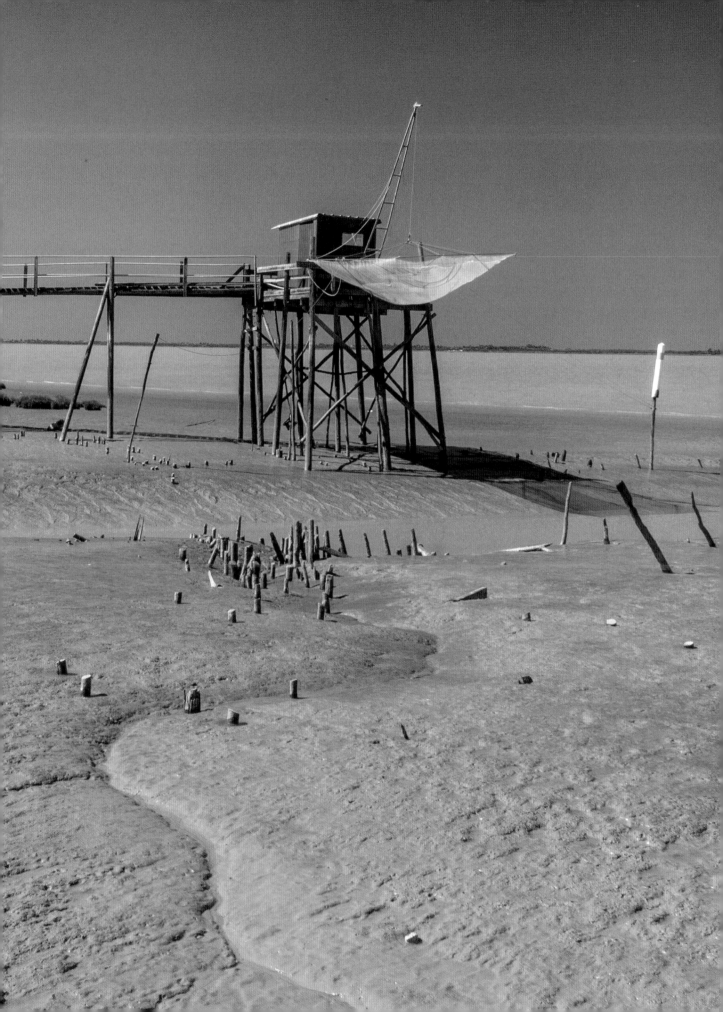

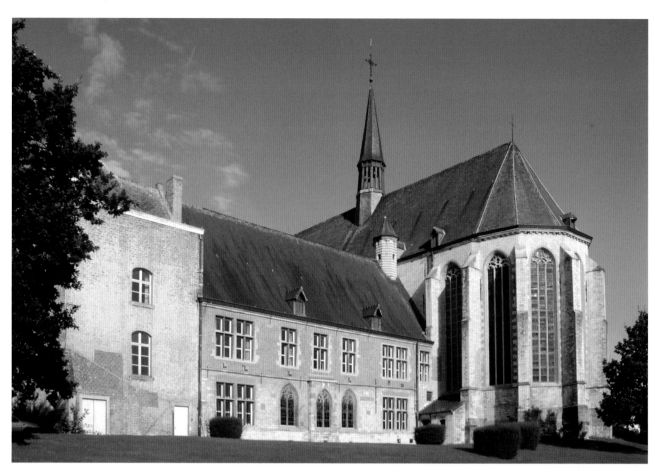

ABOVE AND RIGHT:
Couvent de Récollets, Nivelles, Wallonia, Belgium
Despite calls for its preservation, this Franciscan monastery is at risk from deterioration as well as attempts to develop the site commercially. The Gothic church, dating from the 16th century, is still used for worship.

OPPOSITE:
De Duivelskuil nature reserve, Limburg, Netherlands
This reserve features five fens, each with its own degree of acidity. Conservationists are working to protect the habitat, home to amphibians such as the natterjack toad, by encouraging grazing to prevent forest growth.

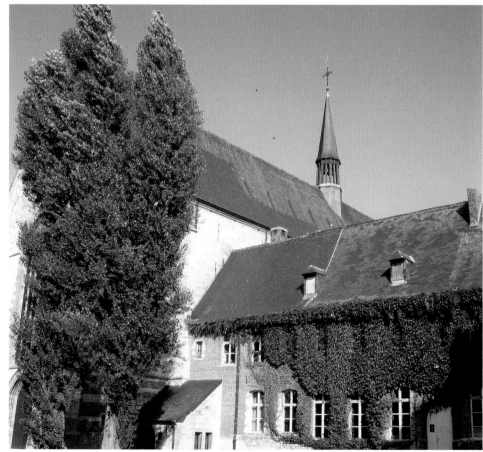

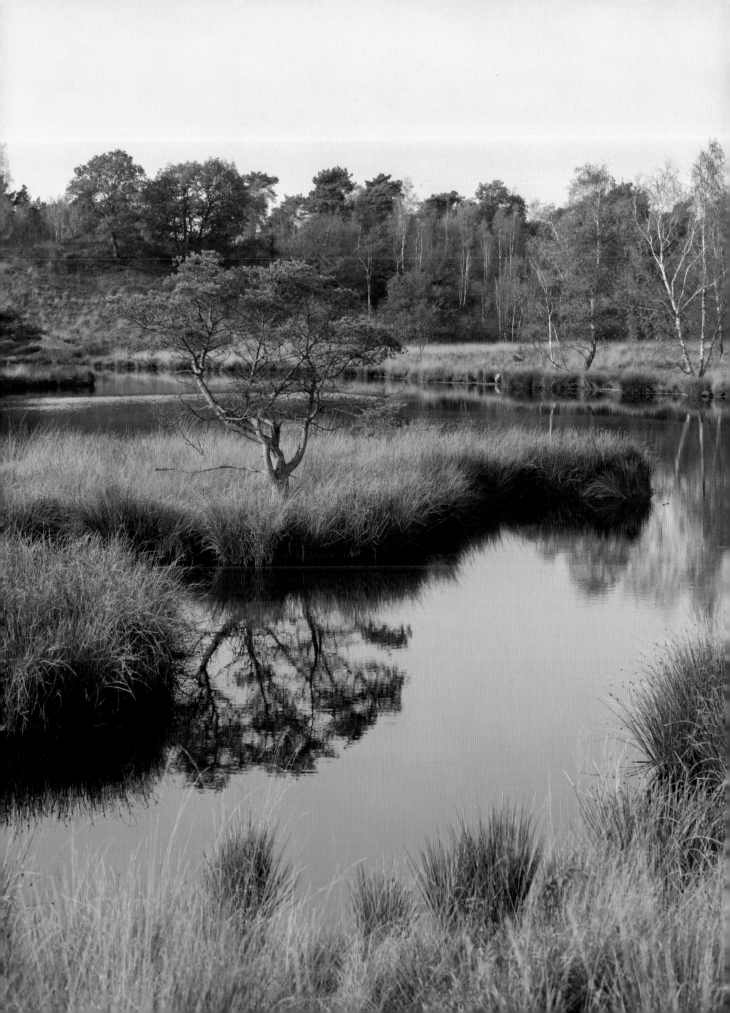

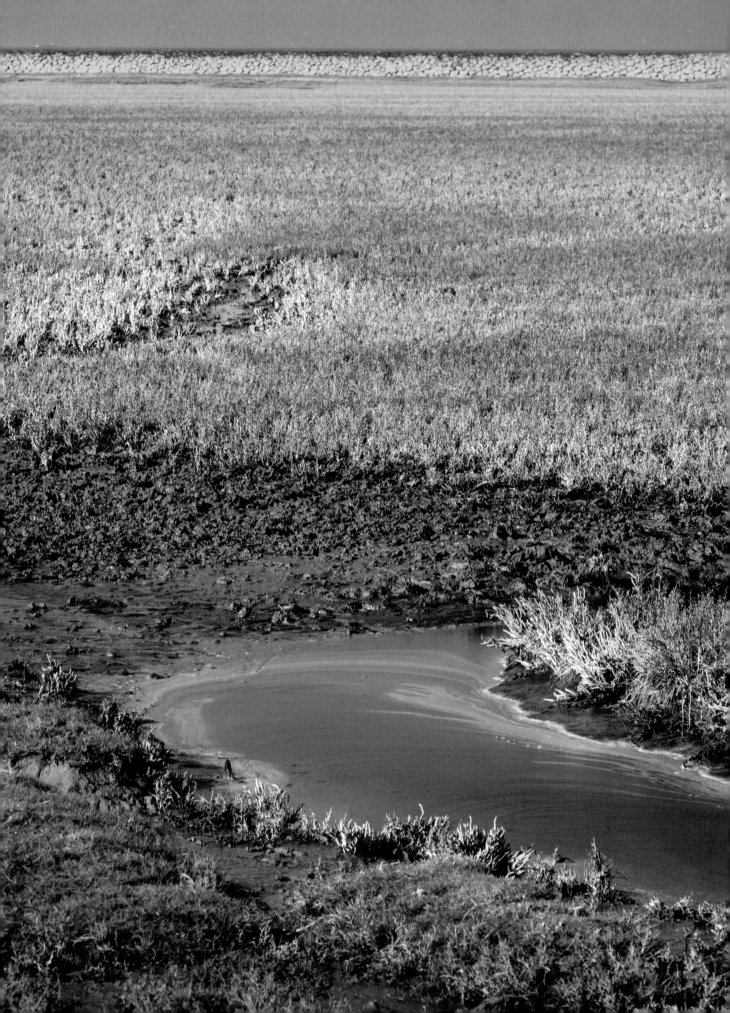

OPPOSITE AND LEFT:

Wadden Sea salt marsh, Netherlands

A key stopover or wintering site for migrating birds, this salt marsh, dominated by native glasswort (pictured), is threatened by pollution and invasive species. Once viewed as wastelands to be reclaimed, salt marshes are among the most productive habitats on Earth.

BELOW:

Simbach-am-Inn, Bavaria, Germany

Climate change is causing more frequent floods of the Inn River, a tributary of the Danube. A devastating flood in 2016 left five people in Simbach dead, as well as homes destroyed.

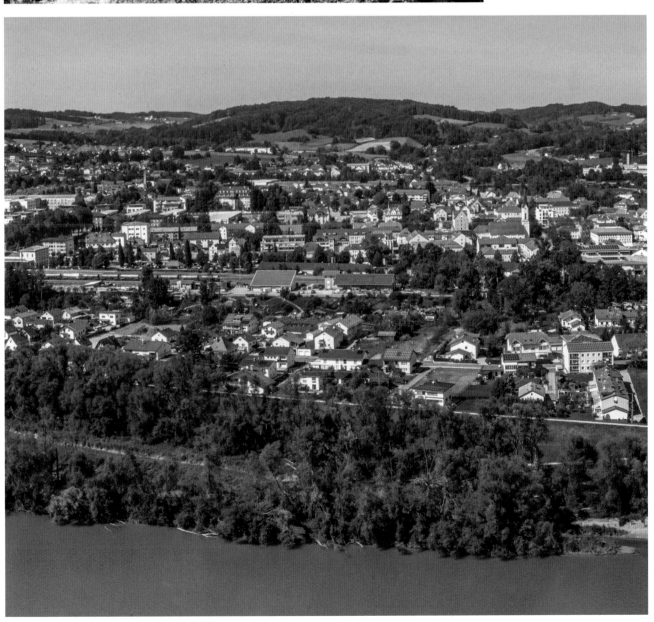

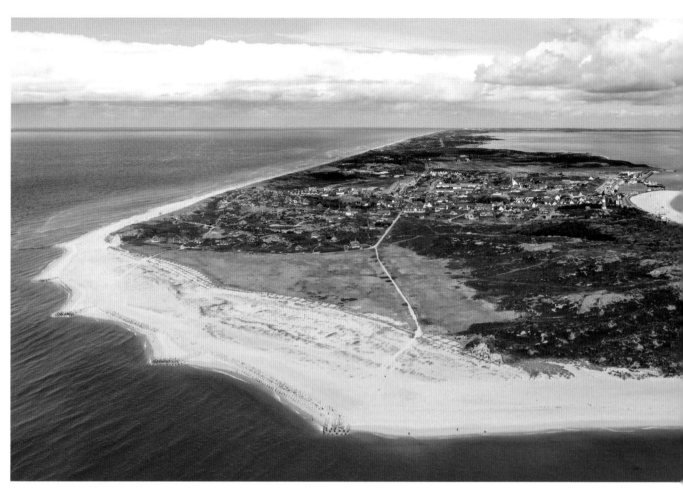

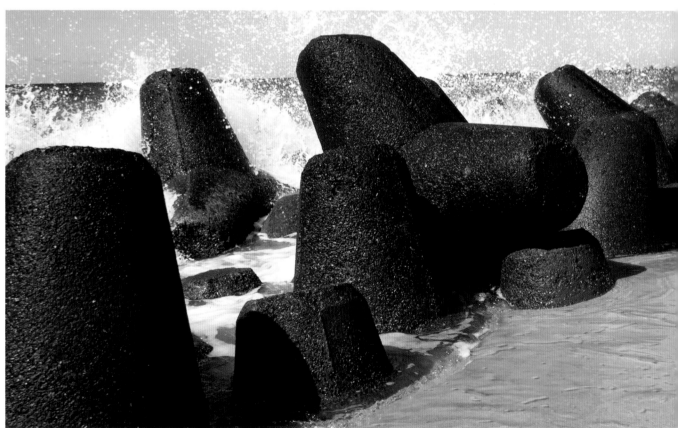

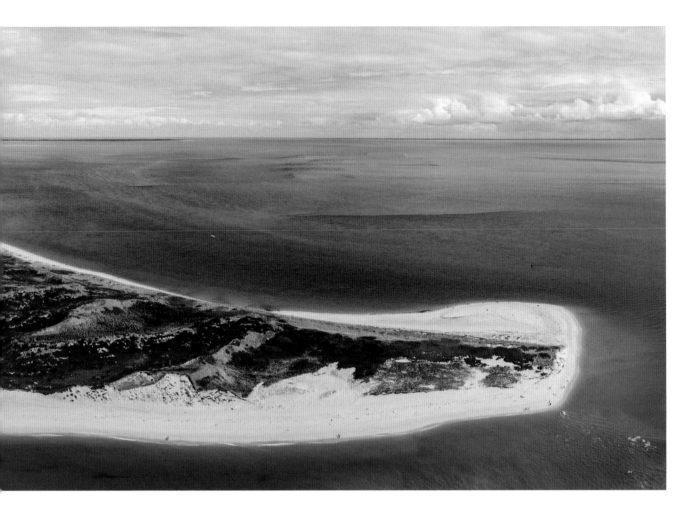

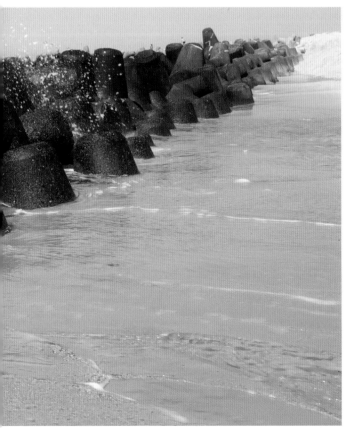

BOTH PHOTOGRAPHS:

Sylt island, Schleswig-Holstein, Germany

Germany's northernmost island is subject to constant land loss, particularly during storm tides caused by extratropical cyclones. Recent tides have put Sylt at risk of breaking in two. Since the 19th century, measures such as groynes and tetrapods (pictured) have proved ineffective. Today, dredged sand is flushed on to the shore to slow the process.

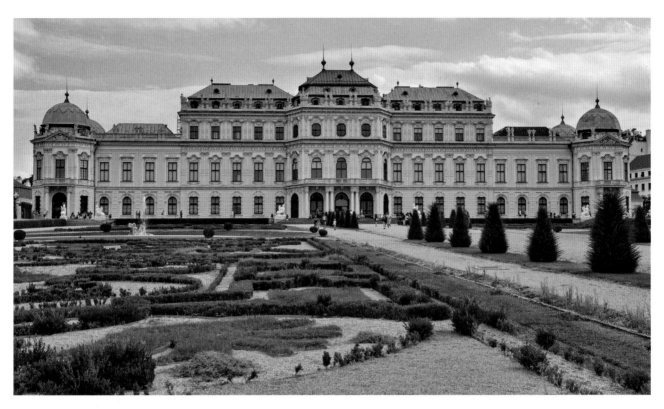

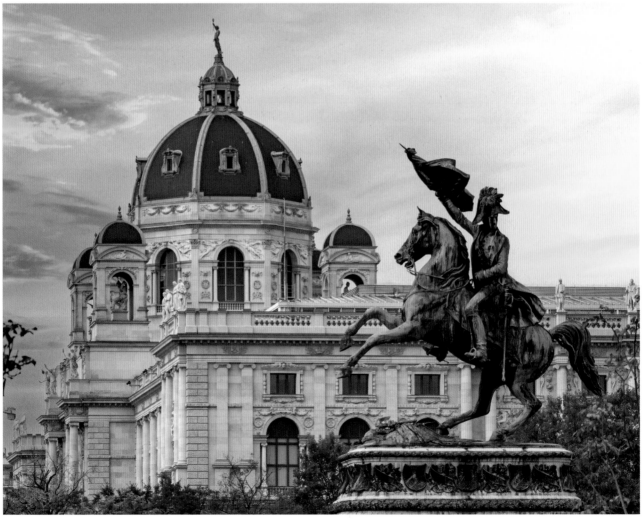

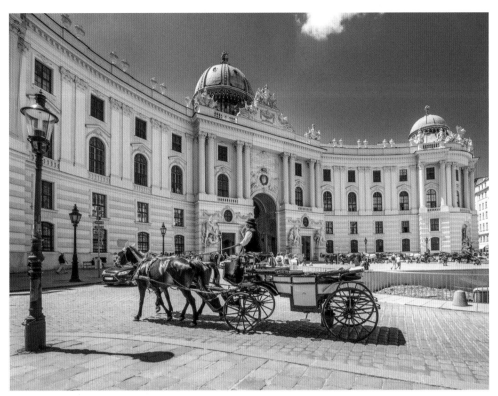

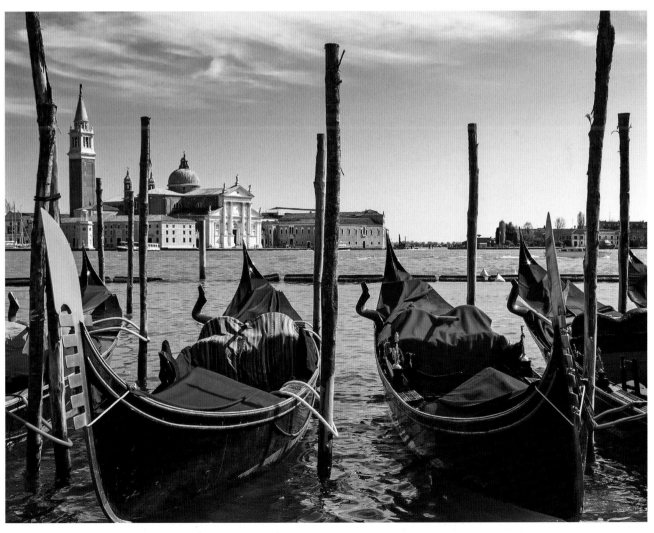

LEFT AND OPPOSITE:
Historic centre of Vienna, Austria
Vienna's historic heart, including the Belvedere Palace (opposite top), Kunsthistorisches Museum (opposite bottom) and Hofburg (left), has had UNESCO World Heritage status since 2001. Since 2017, the city has been working to remove itself from the 'in danger' list, where it was placed due to planned developments.

BELOW AND OVERLEAF:
Venice, Italy
Built on 118 islands, linked by over 400 bridges, Venice is a showcase for Venetian Gothic architecture, which was influenced by both Byzantine and Islamic styles. Home to around 258,000 people, the city is threatened by a host of urgent issues, including subsidence, flooding, excessive tourism and cruise ships that sail too close to its historic buildings.

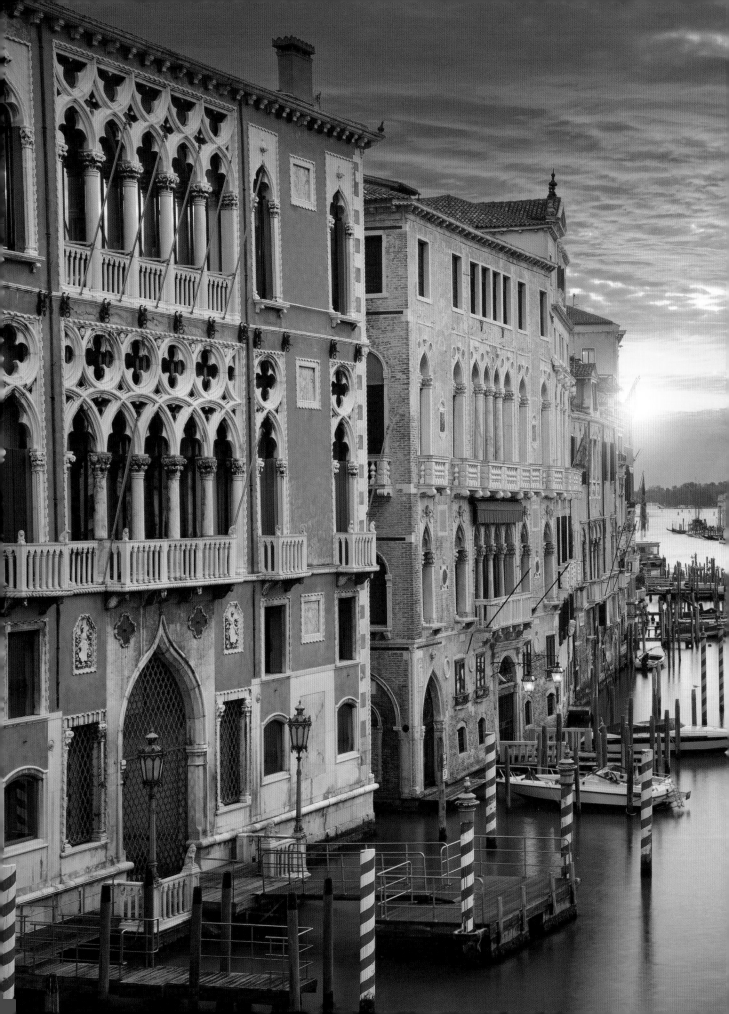

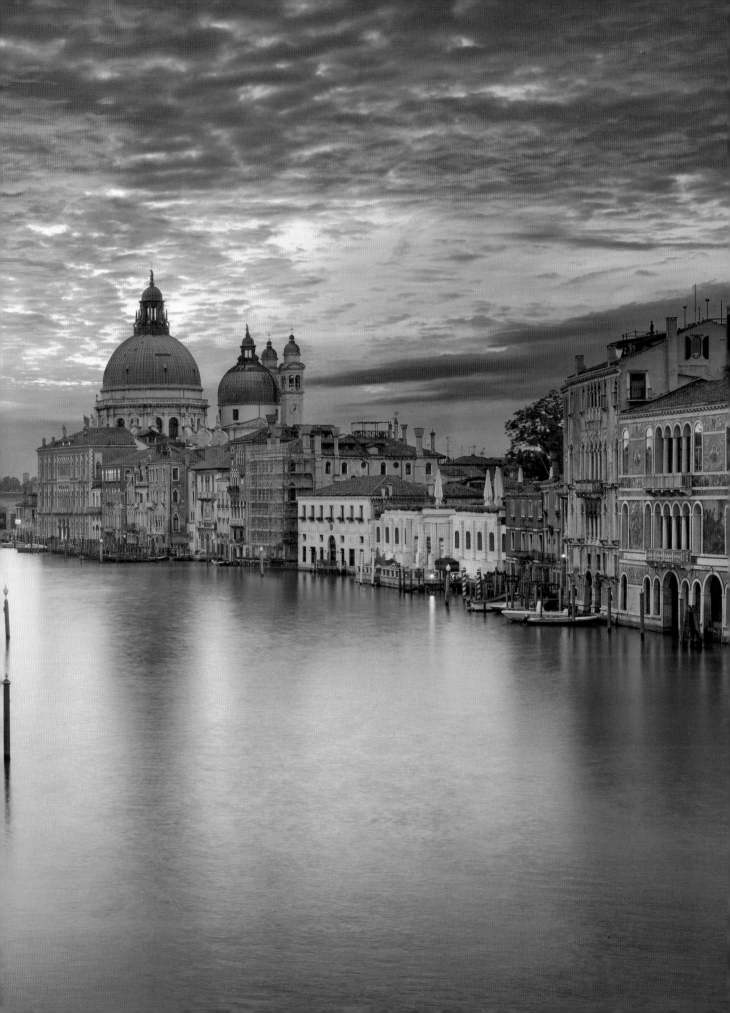

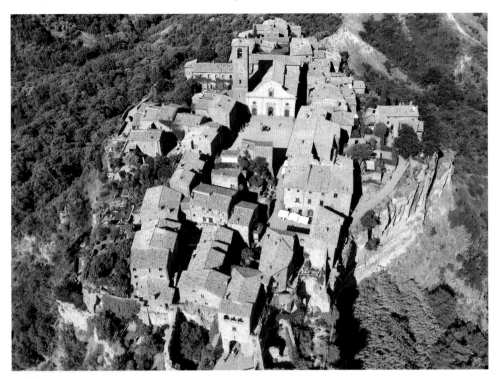

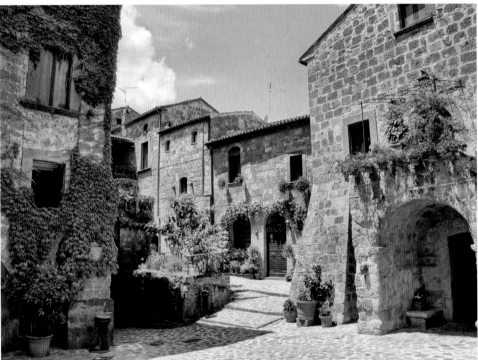

ABOVE TOP AND BOTTOM:
Civita di Bagnoregio, Lazio, Italy
Known as '*La Città che Muore*'
('The Dying Town'), this crag-
top village is reached only by
footbridge. The tuff crag is
crumbling due to its clay base,
which is subject to erosion by
streams and rainfall – worsened
by the effects of deforestation.
Despite the risks, around
20 inhabitants remain.

RIGHT:
Lake Balaton, Veszprém,
Hungary
Central Europe's largest lake,
Balaton is a destination both
for migratory birds and tourists.
Development along its shores is
damaging reed beds, which play
a vital role in filtering the water
and preventing algae overgrowth.
This is affecting the delicate
ecosystem of the shallow, silty
lake and impacting fish stocks.

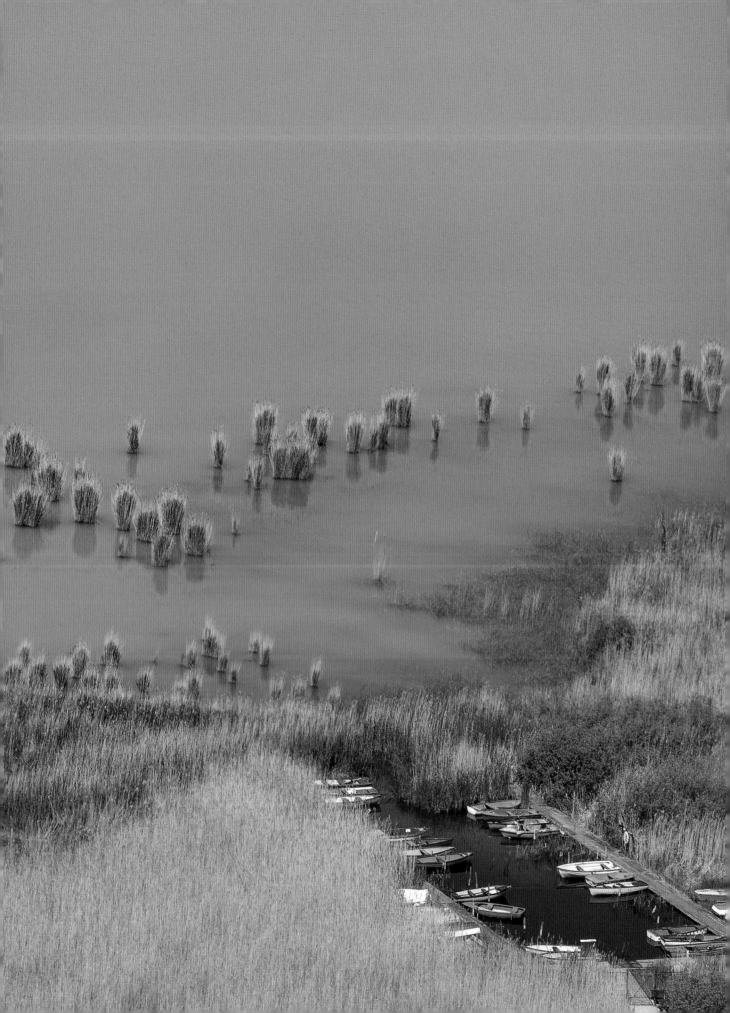

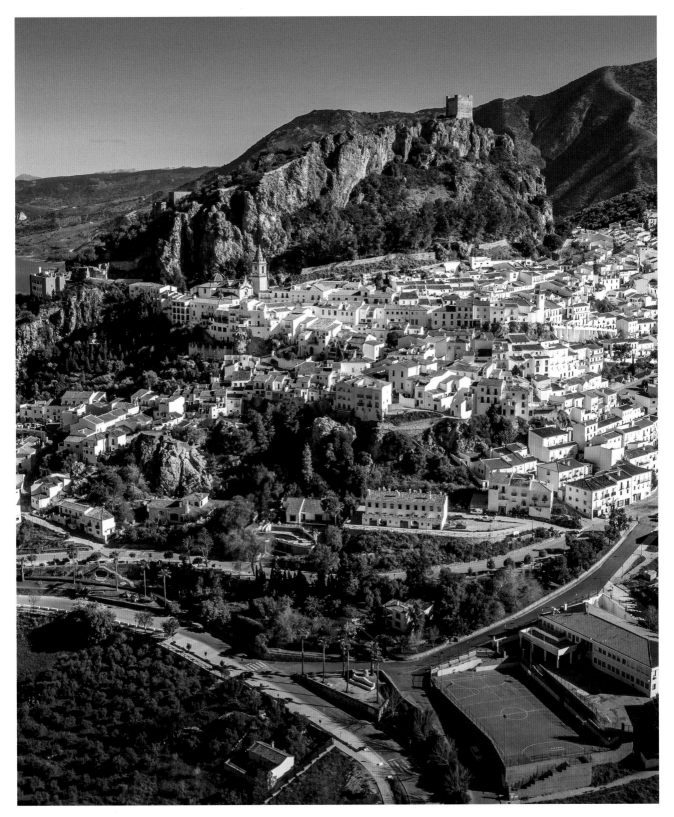

ABOVE:
Zahara de la Sierra, Cádiz, Spain
Climate change is causing longer, drier summers in southern
Spain, resulting in loss of vegetation and biodiversity. Climate
researchers from the European Centre for Research and Education in
Environmental Geosciences predict that, in the worst-case scenario,
the Mediterranean forest and scrub around this *pueblo blanco* (white
town) will have turned to desert by the end of the 21st century.

OPPOSITE TOP AND BOTTOM:
Orleans-Bourbón Palace, Sanlúcar de Barrameda, Cádiz, Spain
Built in 1853–70 by the Duke of Montpensier, this Alhambra-
influenced summer palace was abandoned by the duke's heirs in the
1950s. The building was sold to developers in the 1970s but rescued
from destruction by the city council. The cost of fully repairing the
much-decayed palace stands at several million euros, leaving this
eclectic masterpiece in need of a helping hand.

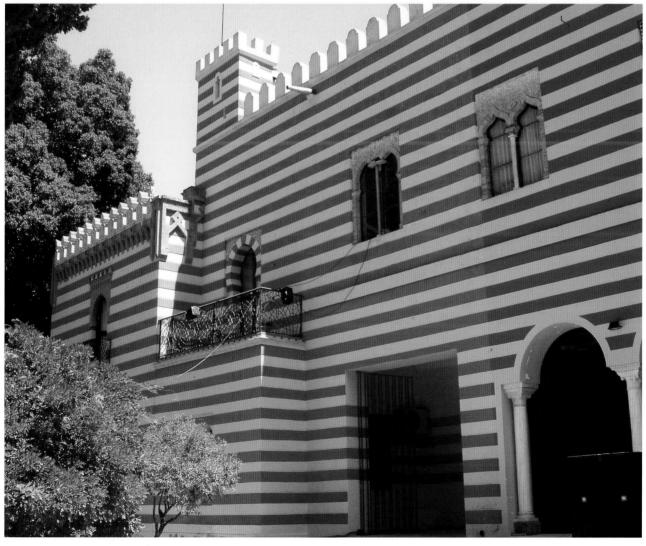

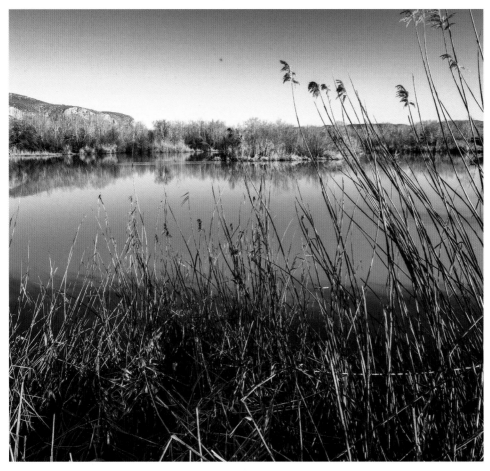

ABOVE TOP:
Sureste Regional Park, Madrid, Spain
Just a short drive from central Madrid, this fragile wildlife haven is home to wetland fauna such as the otters, common green frogs, marsh harriers and imperial herons. Water levels are dependent on the irrigation of surrounding fields. The regional government has invested time and money in habitat restoration.

ABOVE BOTTOM:
Mat Bridge, Lezhë, Albania
In 2022, Europa Nostra added this 1927 concrete-and-steel bridge to its list of heritage sites at risk of destruction. The bridge is in danger of collapse due to poor maintenance as well as the subsidence of one of its columns, caused by erosion of the riverbed as a result of gravel mining. Local people are campaigning for protection of the site.

RIGHT:
Neptune Baths, Băile Herculane, Romania
Built in 1883–86, this bath house is in the spa town of Băile Herculane, once a Roman leisure resort. Covering 4,000 sq m (43,000 sq ft), the sprawling, Austro-Hungarian baths contain four communal pools and 63 private bathing or massage rooms. The baths closed in 1989 and have since fallen into decay.

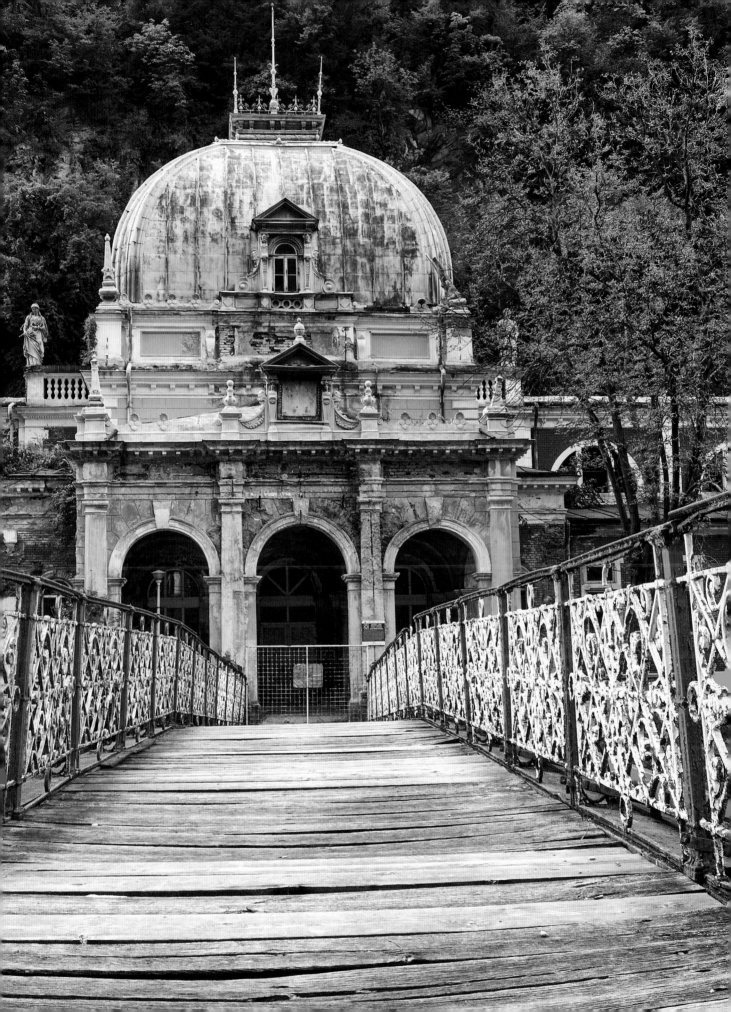

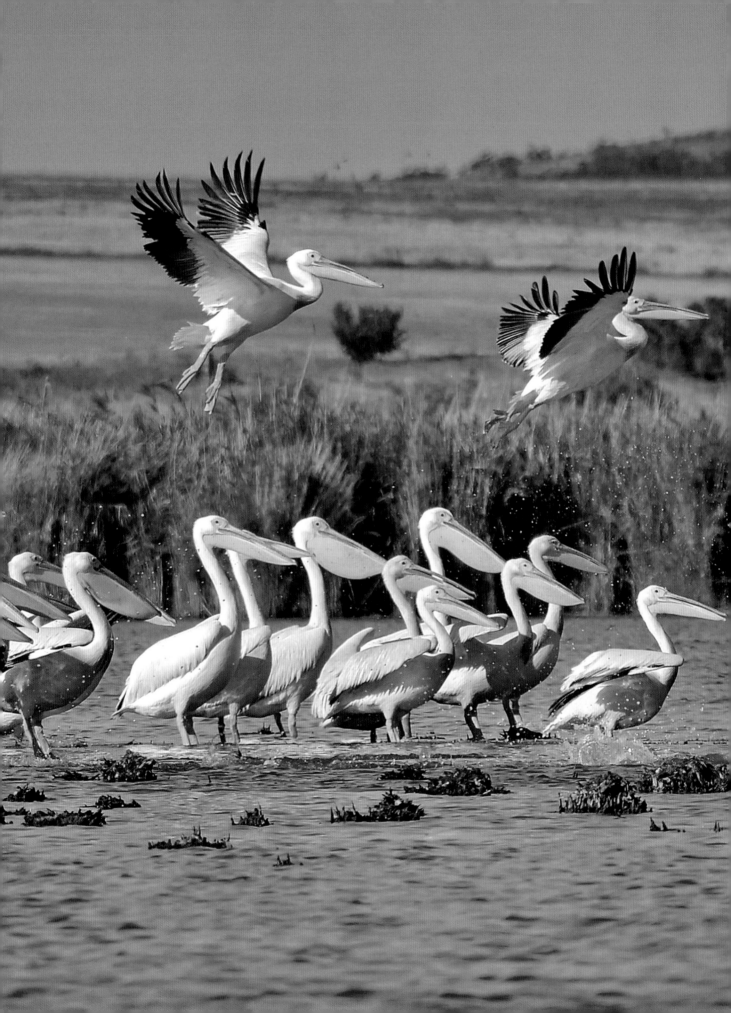

OPPOSITE:
Danube Delta, Tulcea, Romania
At 5,165 sq km (1,994 sq miles), this delta has long been affected by reed harvesting, overfishing, dam building and course correction. Even so, it remains home to species such as the largest member of the pelican family, the Dalmatian pelican.

ABOVE:
Black Sea, Ukraine–Russia
Industrial expansion and sewage pumping have altered the biological balance of this sea, causing phytoplankton blooms and mass fish deaths. The accidental introduction of the egg-eating warty comb jelly also hit fish populations. However, there has been success with pollution regulation, sewage treatment and biological control using another comb jelly.

LEFT:
St Stephen, Nessebar, Bulgaria
Originally a Thracian settlement, Nessebar was added to the World Heritage list in 1983 thanks to its Byzantine architecture. UNESCO has since declared Nessebar at risk from development, encouraging planners to find a fresh balance between history and progress.

**Patriarchate of Peć
Monastery, Peja, Kosovo**
Founded in the 13th century, this
Serbian Orthodox monastery
is a fusion of eastern Byzantine
and western Romanesque
ecclesiastical architecture. Its
wall paintings date from the 13th
to 14th centuries. The difficulties
of conservation and restoration,
combined with regional political
instability, leave the paintings at
the mercy of damp.

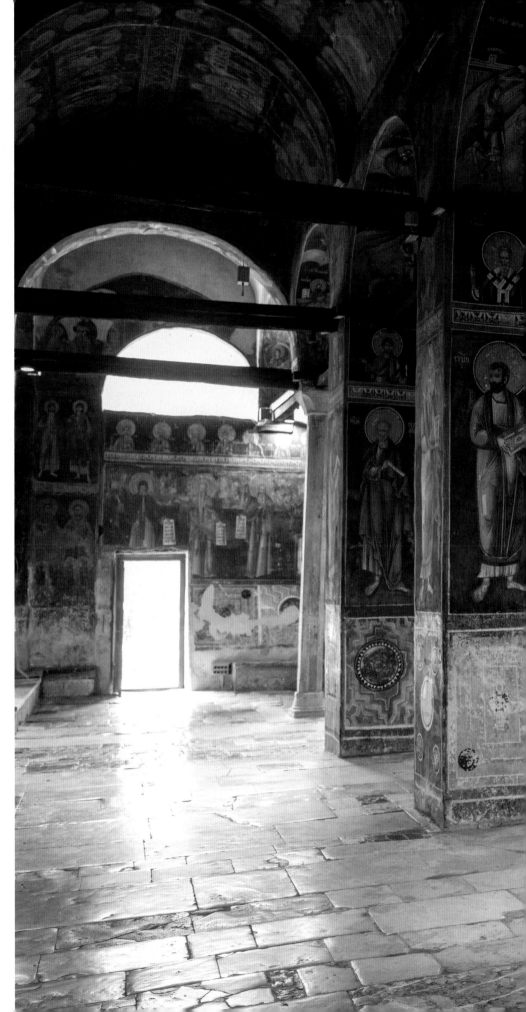

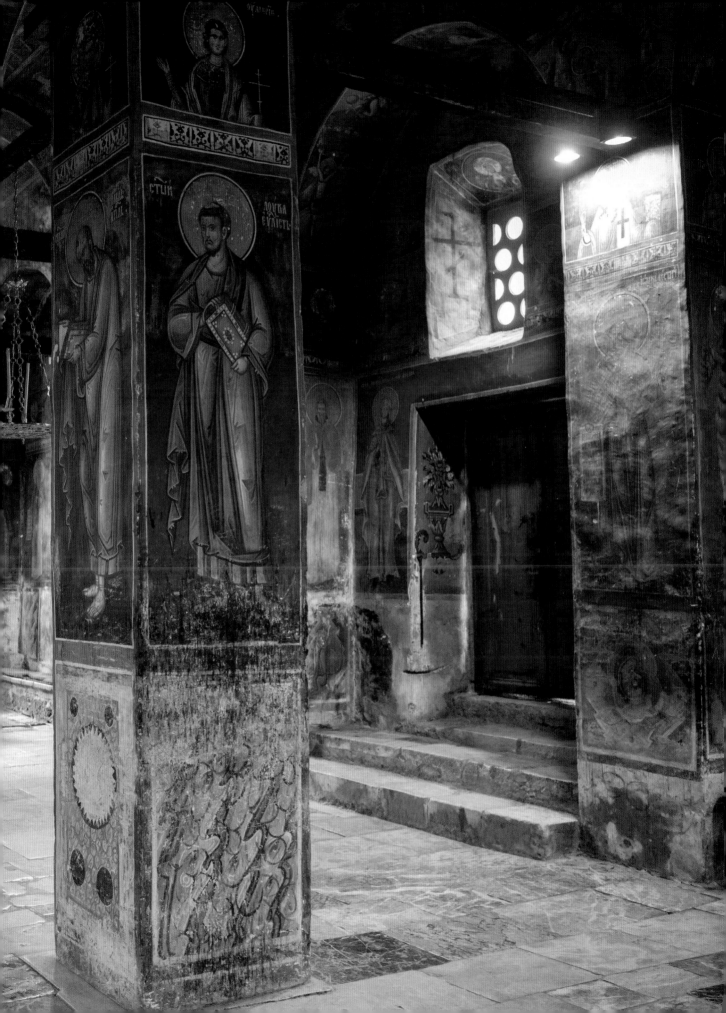

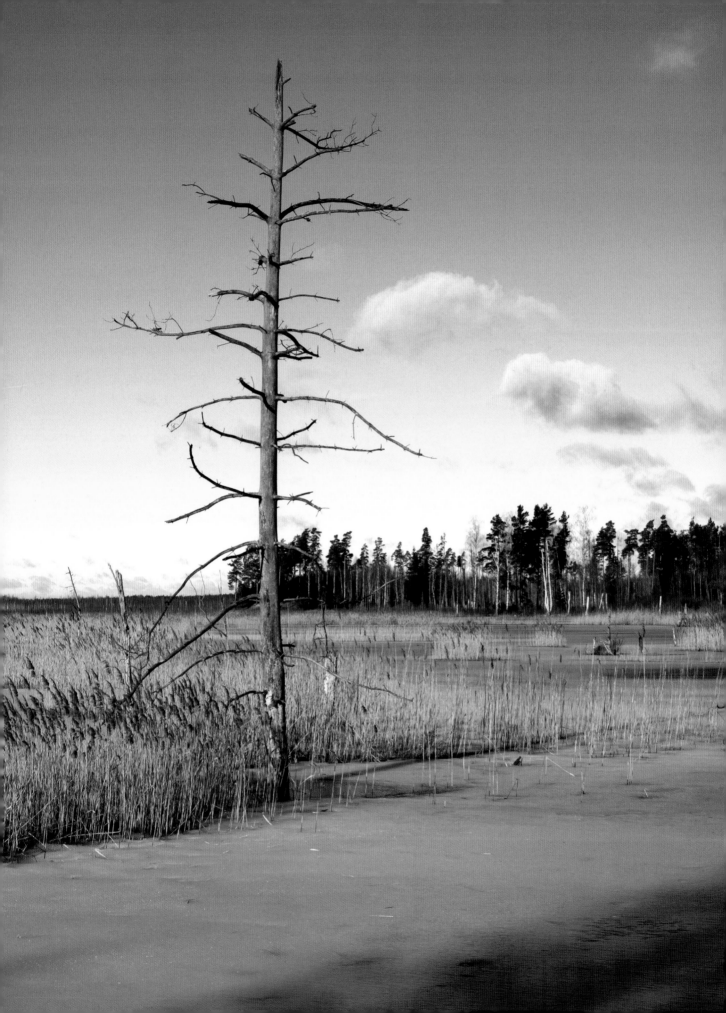

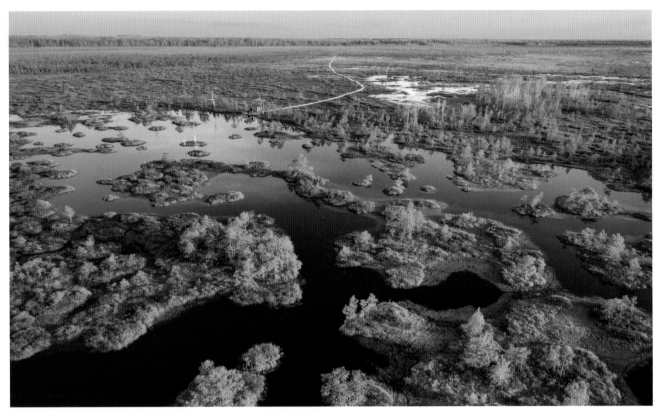

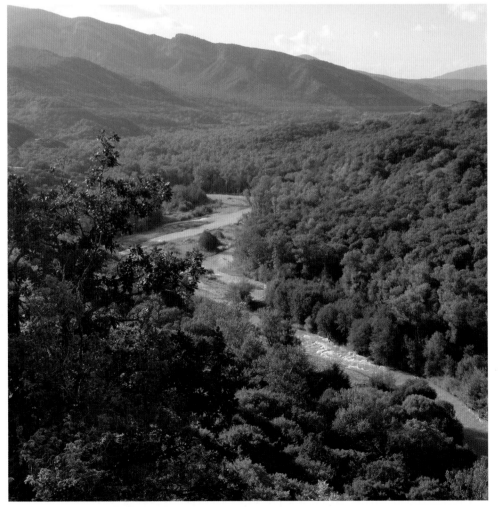

Great Kemeri Bog, Latvia
Bogs, which are wetlands
dominated by peat-forming
plants, are a globally threatened
habitat. Drainage systems built
here in the 1930s and 1970s
have reduced the water table, but
hydrology restoration measures
are beginning. Ķemeri is visited
by black storks, common cranes,
grey wolves and Eurasian lynx.

Yelnya Reserve, Belarus
Belarus's largest bog boasts 405
species of plants, many of them
– such as fen and musk orchids
– rare or endangered. Drainage
of the bog had disturbed the
hydrological balance, but
restoration work has improved
the distribution of key species of
sphagnum moss.

Iori River, Georgia
In this steppe region, the Iori
River is a key water source for
lynx, wolves, brown bears and
Persian gazelles. The surrounding
gallery forest, a vital wildlife
corridor, is threatened by logging
and unsustainable farming
practices. A conservation project
involving local stakeholders is
under way.

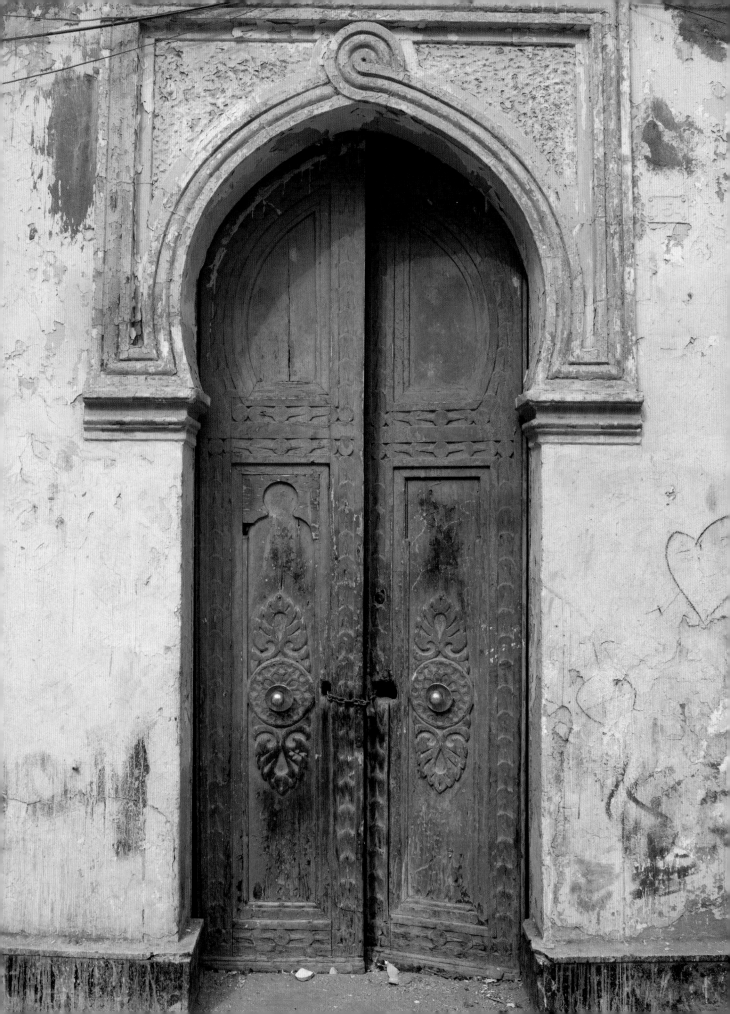

Africa and the Middle East

THE GREATEST threat to humankind's remarkable achievements – greater even than our own carelessness – has always been uncaring nature. Across Africa and the Middle East are monuments that our painstaking, inventive, visionary ancestors constructed in an attempt to stick a pin in both place and time for forever and a day. But time cannot be held back – and unopposed nature destroys these monuments diligently, year by year. The most famous of all, the Great Pyramids of Giza, are at risk from rising groundwater and the millennia of wind-blown sand that have blasted their limestone blocks. Rain, heat, cold, spreading tree roots, shuddering earthquakes and busy termites are at work on this region's monuments, from the shrines of the Ashanti to the Nabataeans' rock-cut temples.

The builders of the Great Mosque of Djenné, in Mali, knew that nature is not kind – and made a solution part of their architectural style. An in-built scaffold of rodier palm is used by the local community for annual reapplication of the mosque's plaster. This design recognizes not only the hard work that preserving our monuments requires, but also that the work must be a shared endeavour. From Mali to devastated Syria, this endeavour can only be undertaken when the local community is safe and prosperous.

OPPOSITE:
Municipal Hall, Benghazi, Cyrenaica, Libya
This disused and crumbling edifice was designed in 1924 by Italian architects Marcello Piacentini and Ivo Lebboroni in Neo-Moorish style. Its facade combines Moorish arches with Italianate motifs.

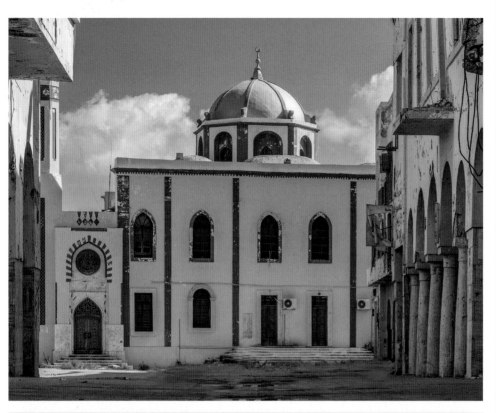

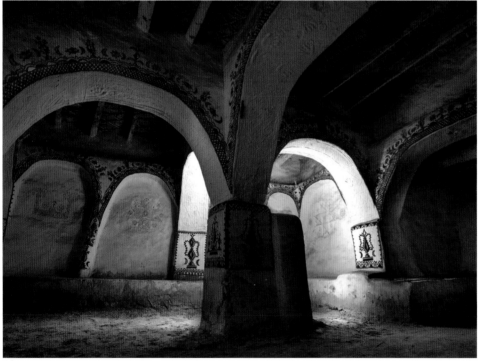

ABOVE TOP:
Atiq Mosque, Benghazi, Cyrenaica, Libya
The historic centre of Libya's second largest city has been largely derelict since 2017, when conflict resulted in the displacement of a third of residents. Additional funding is needed for large-scale rebuilding and conservation.

ABOVE BOTTOM:
Ghadamès, Tripolitania, Libya
In the Berber Old Town of Ghadamès, houses were made of mud, lime and palm trunks, with covered alleyways between for shelter from the sun. Most Old Town inhabitants left in the 1990s due to lack of infrastructure, leaving the buildings at risk of collapse.

RIGHT:
Tadrart Acacus, Ghat, Libya
The rock art at Tadrart Acacus dates from 12,000 BCE to 100 CE and features animals including giraffes, horses and cattle, as well as human hunters and dancers. The art is under threat from vandalism, theft and oil exploration, particularly the use of seismic hammers.

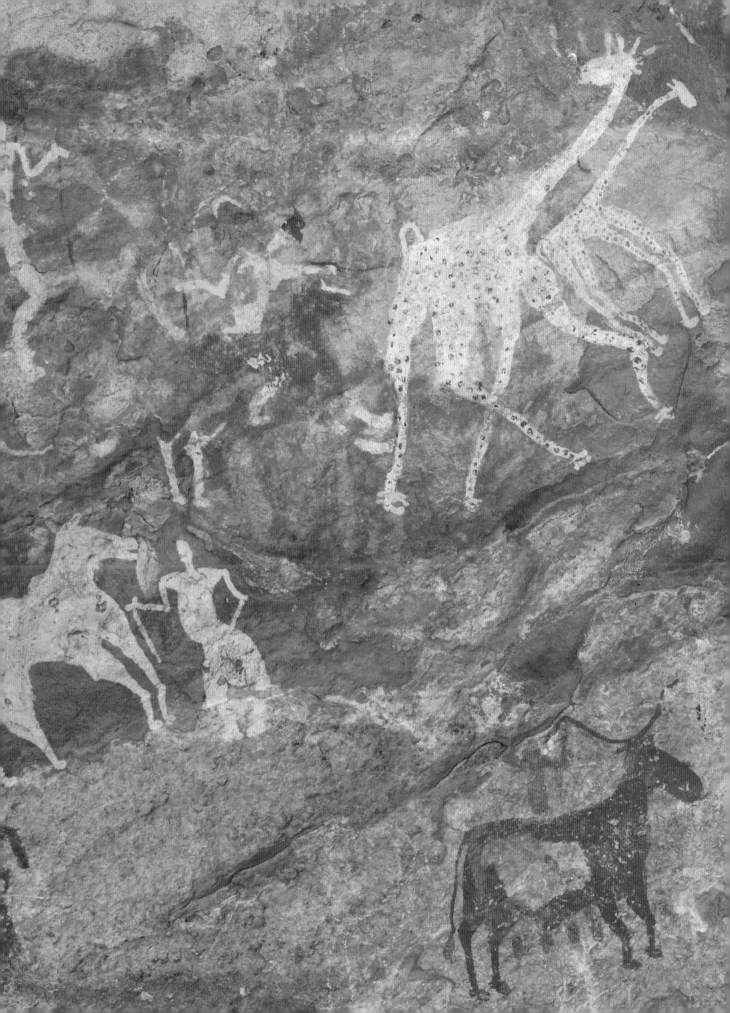

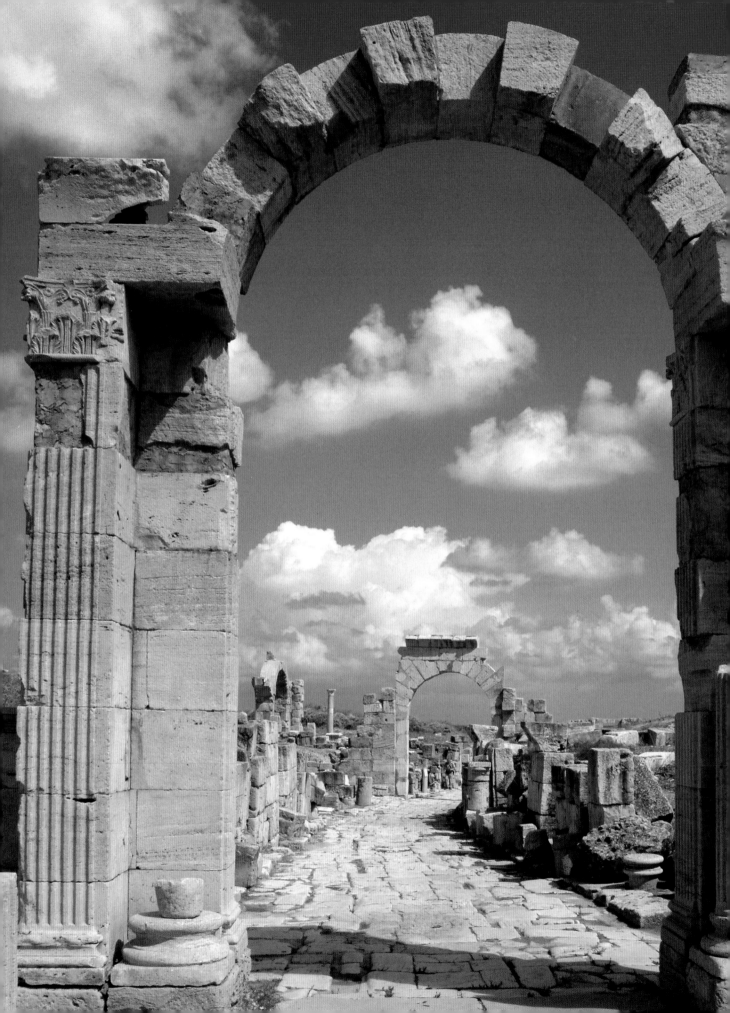

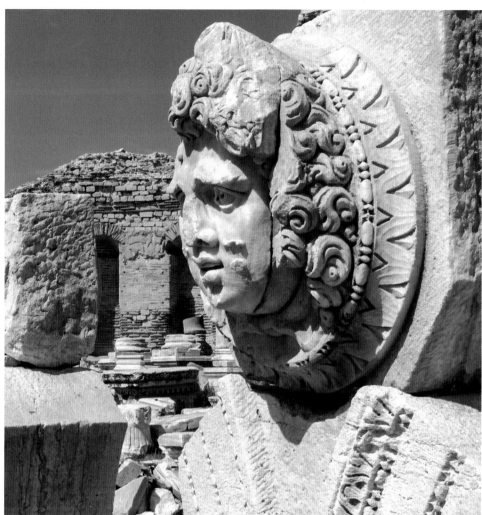

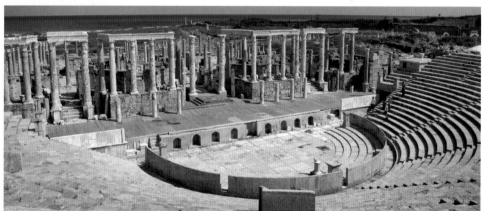

ALL PHOTOGRAPHS:

Leptis Magna, Tripolitania, Libya

Founded in the 7th century BCE, this ancient city was expanded by Roman Emperor Septimius Severus, who was born here in 145 CE. Largely abandoned in the 7th century CE, the city was excavated from the 1930s. The Libyan civil wars led to a loss of funding for conservation.

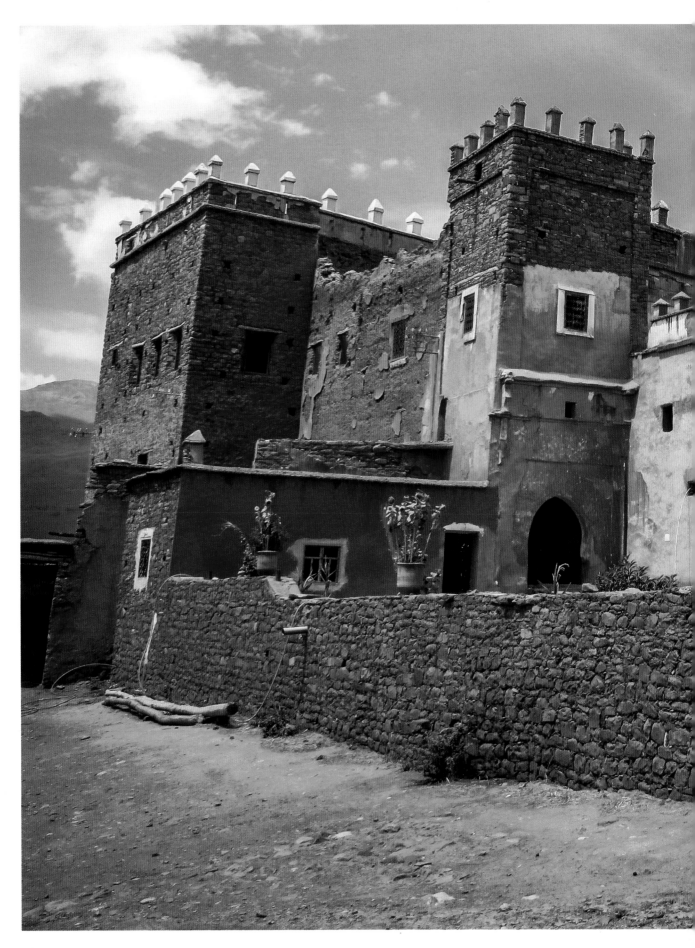

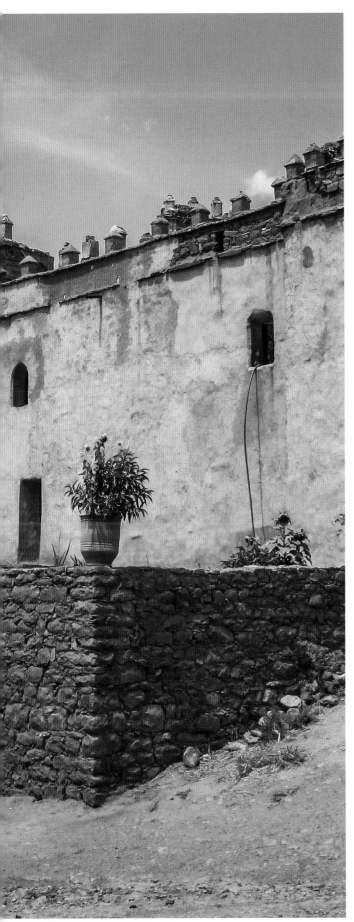

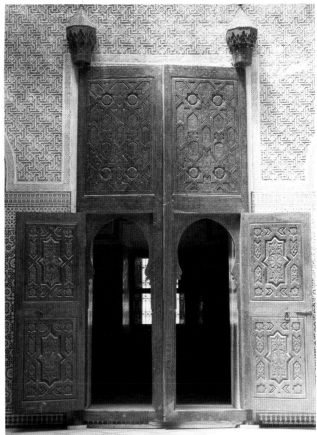

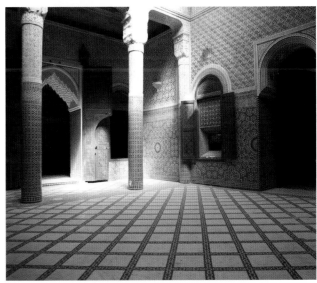

ALL PHOTOGRAPHS:
Telouet, Drâa-Tafilalet, Morocco
This kasbah, on the old caravan route from the Sahara over the Atlas Mountains to Marrakesh, was built by the El Glaoui family from 1860. The cedar-wood ceilings, carved stucco and *zellij* tiles have fallen into disrepair since the kasbah was all but abandoned in 1956, when the powerful T'hami El Glaoui fell from grace with the king.

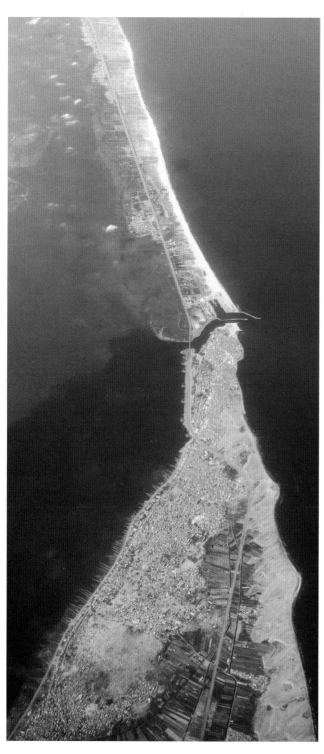

BOTH PHOTOGRAPHS:
Lake Burullus, Kafr El-Sheikh, Egypt
This brackish lake in the Nile Delta is separated from the Mediterranean Sea by a narrow strip crossed by a channel about 250 m (820 ft) wide and 5 m (16 ft) deep (pictured above). The lake is facing a steep decline in fish species due to the inflow of agricultural drainage water resulting in lower salinity.

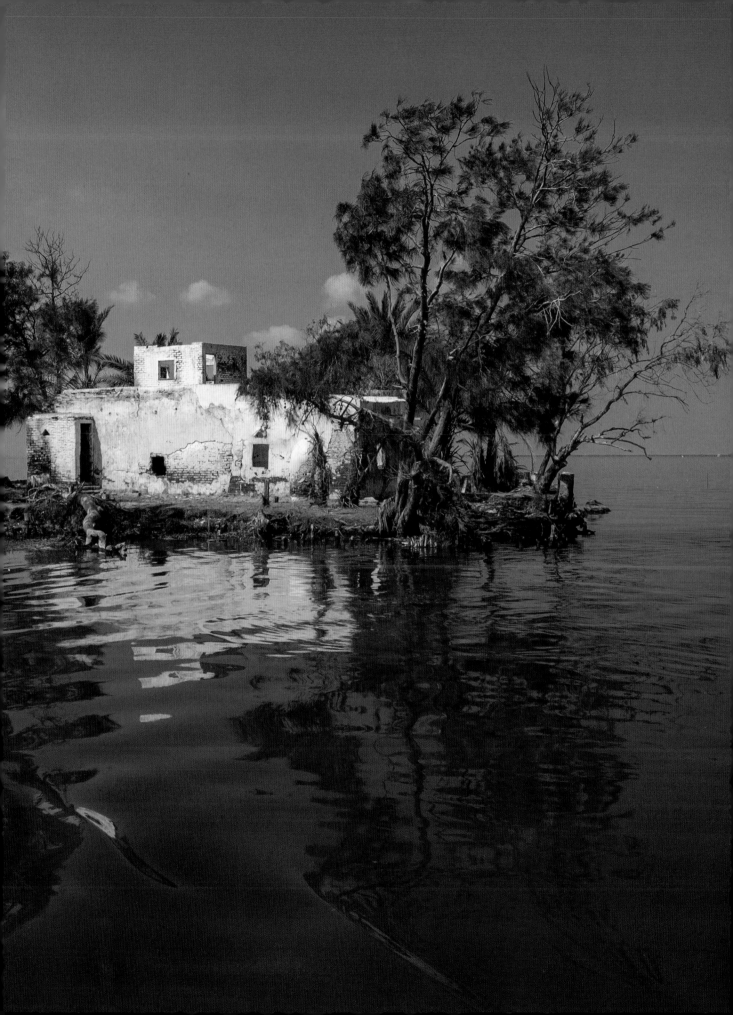

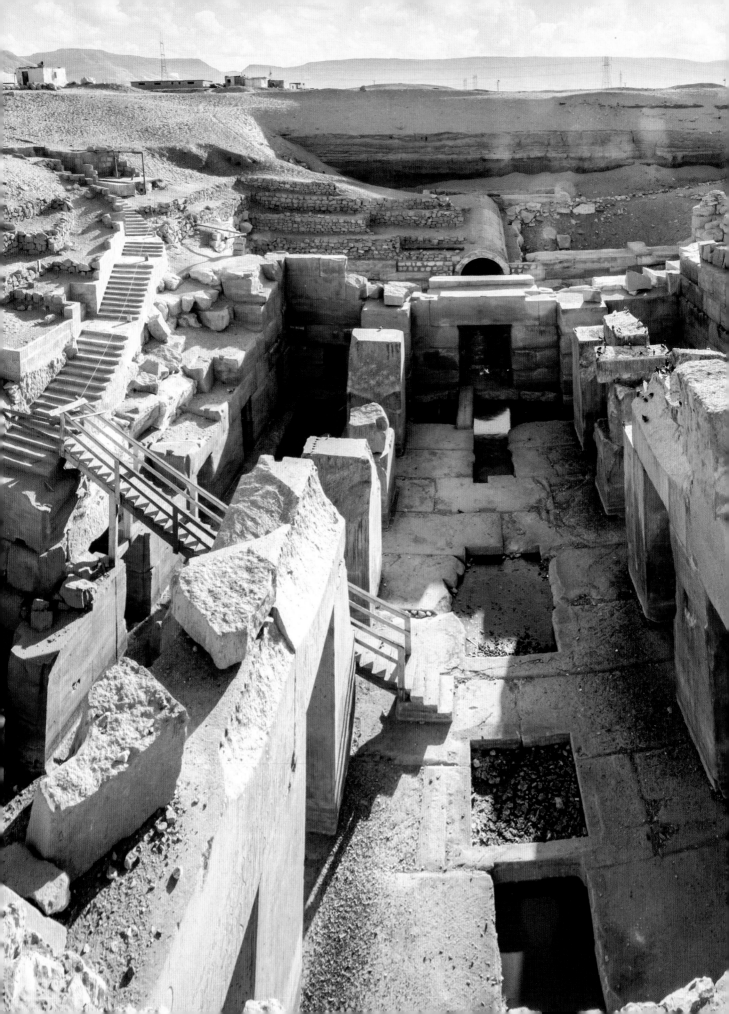

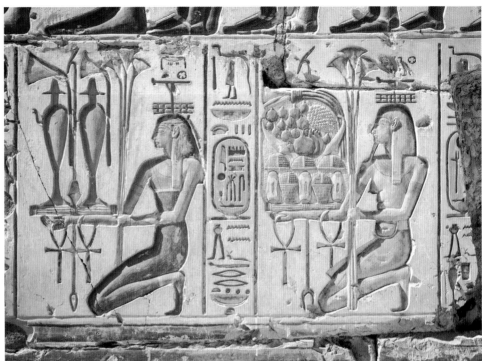

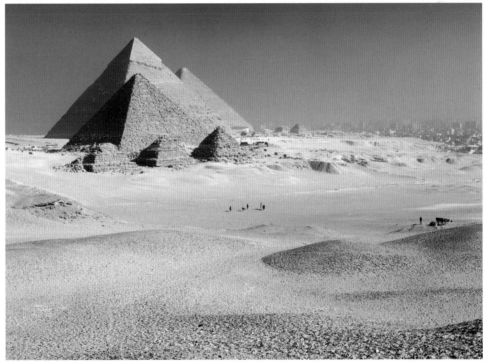

LEFT:

Osireion, Abydos, Sohag, Egypt
Part of the funeral complex of
Seti I (1294/0–1279 BCE), this
temple is centred on a deep
basin or well. The Osireion is
of unusual construction, with
massive rectangular blocks
forming numerous trilithons
(two vertical stones supporting
a lintel). The site is threatened
by the encroachment of urban
sprawl and looting.

ABOVE TOP:

**Temple of Ramesses II, Abydos,
Sohag, Egypt**
Wall paintings in the temple of
Ramesses II (1279–1213 BCE)
depict a procession of offering
bearers (pictured), the Nile gods
and Ramesses being crowned.
With the rest of the Abydos
complex, the temple is now
monitored by World Monuments
Watch, which is working with
local partners to protect the site.

ABOVE BOTTOM:

**Pyramids of Giza, Greater Cairo,
Egypt**
From front to back, the
three main pyramids at Giza
are those of the pharaohs
Menkaure (c.2532–2503 BCE),
Khafre (c.2558–2532 BCE) and
Khufu (c.2589–2566 BCE). The
complex is affected by increasing
urbanization as well as a rising
water table due to leakage from
nearby irrigation canals.

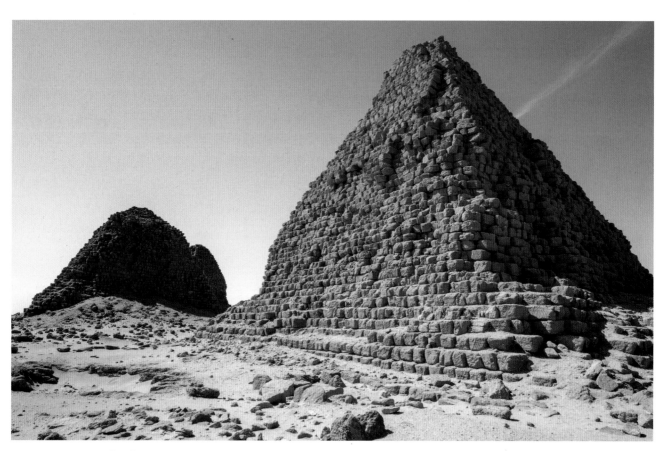

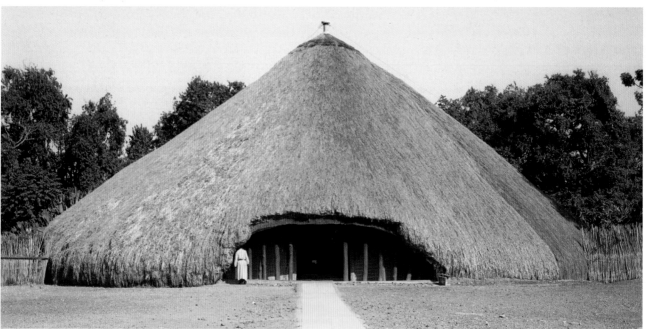

ABOVE TOP:
Nuri, Northern State, Sudan
From around 670 BCE to 310 BCE, the tombs of kings and queens of Kush were marked by pyramids, inspired by – but steeper-sided than – those of Egypt. Around 6–10 m (20–33 ft) underground, the tombs themselves are being damaged by rising groundwater.

ABOVE BOTTOM:
Kasubi Tombs, Kampala, Uganda
This burial ground for four *kabakas* (kings) of Buganda is centred on a thatched-roof palace of wattle and daub. The buildings have been reconstructed after being destroyed by fire in 2010.

RIGHT:
Timbuktu, Mali
The mosques and mausoleums of Timbuktu's Old Town are on the UNESCO list of World Heritage in Danger. Yet the whole city and, most importantly, its inhabitants are at risk from conflict, desertification and declining water supplies.

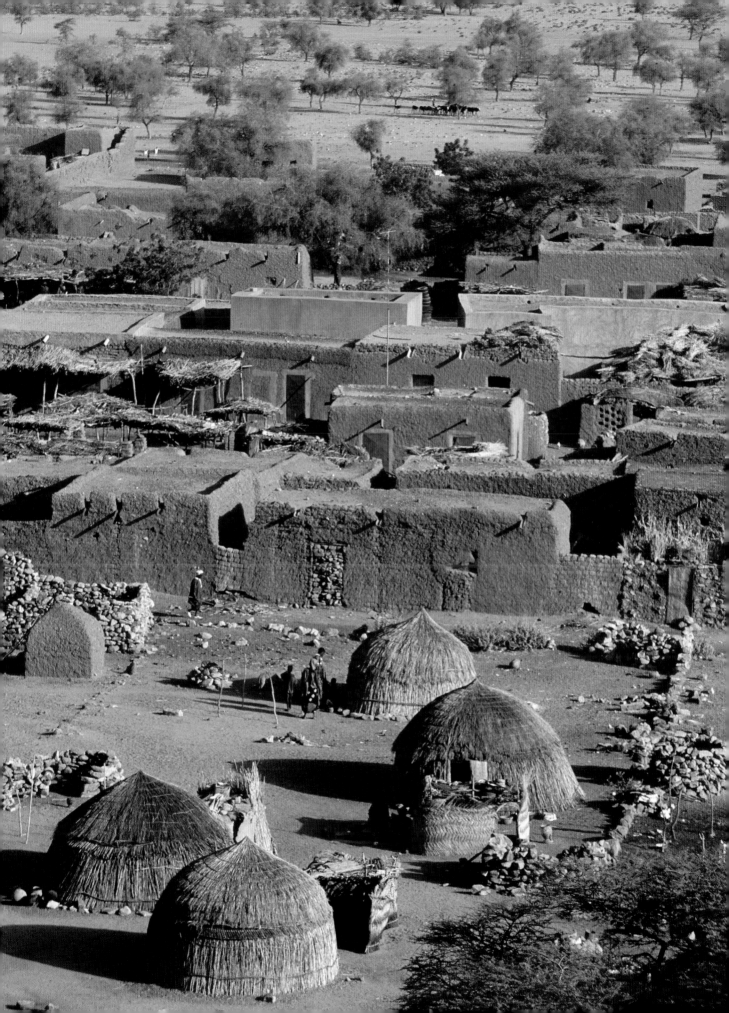

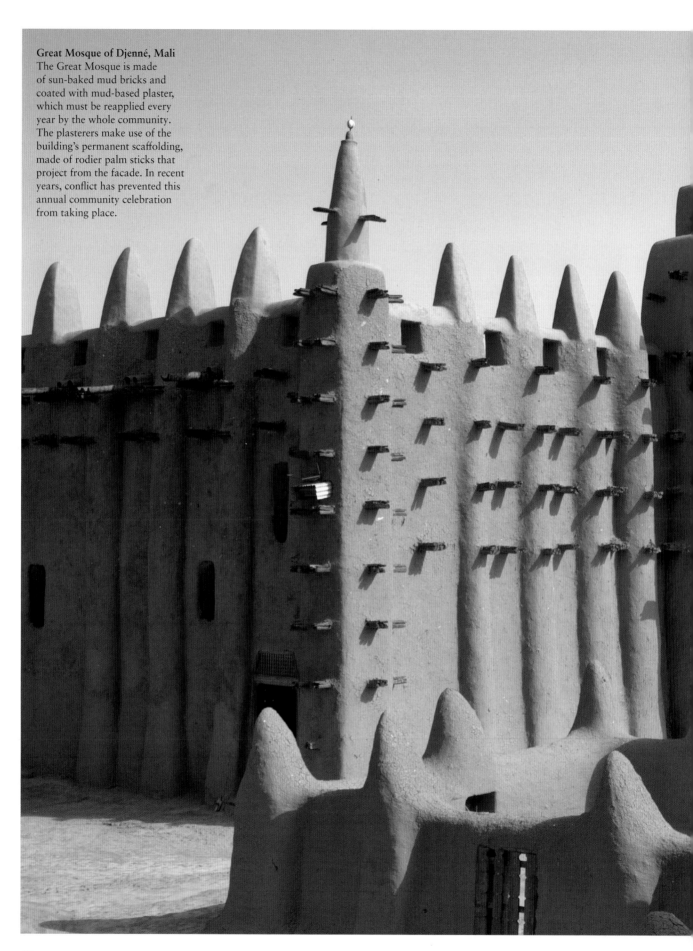

Great Mosque of Djenné, Mali
The Great Mosque is made
of sun-baked mud bricks and
coated with mud-based plaster,
which must be reapplied every
year by the whole community.
The plasterers make use of the
building's permanent scaffolding,
made of rodier palm sticks that
project from the facade. In recent
years, conflict has prevented this
annual community celebration
from taking place.

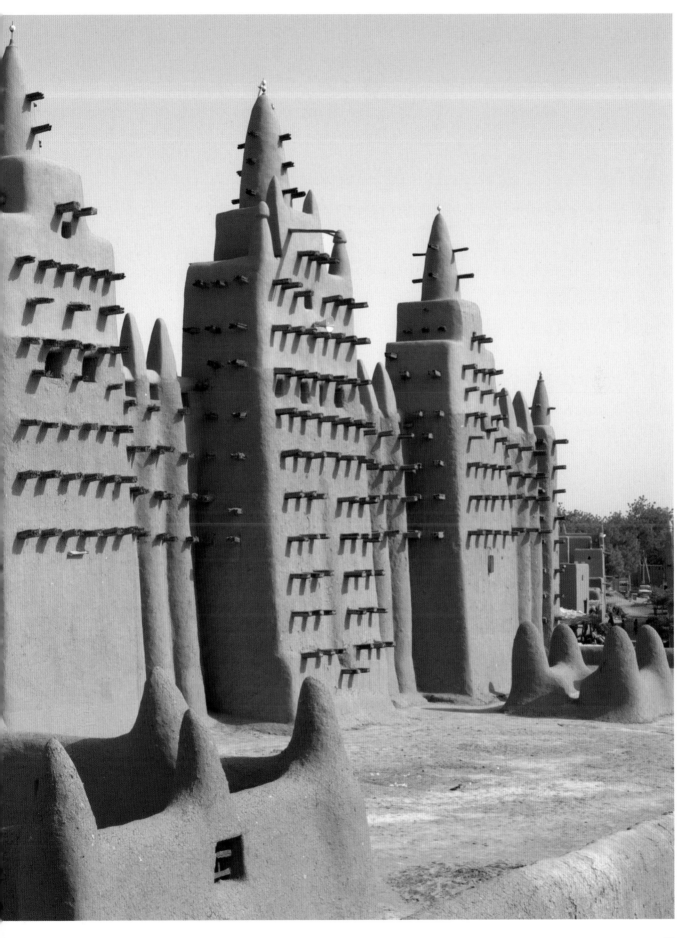

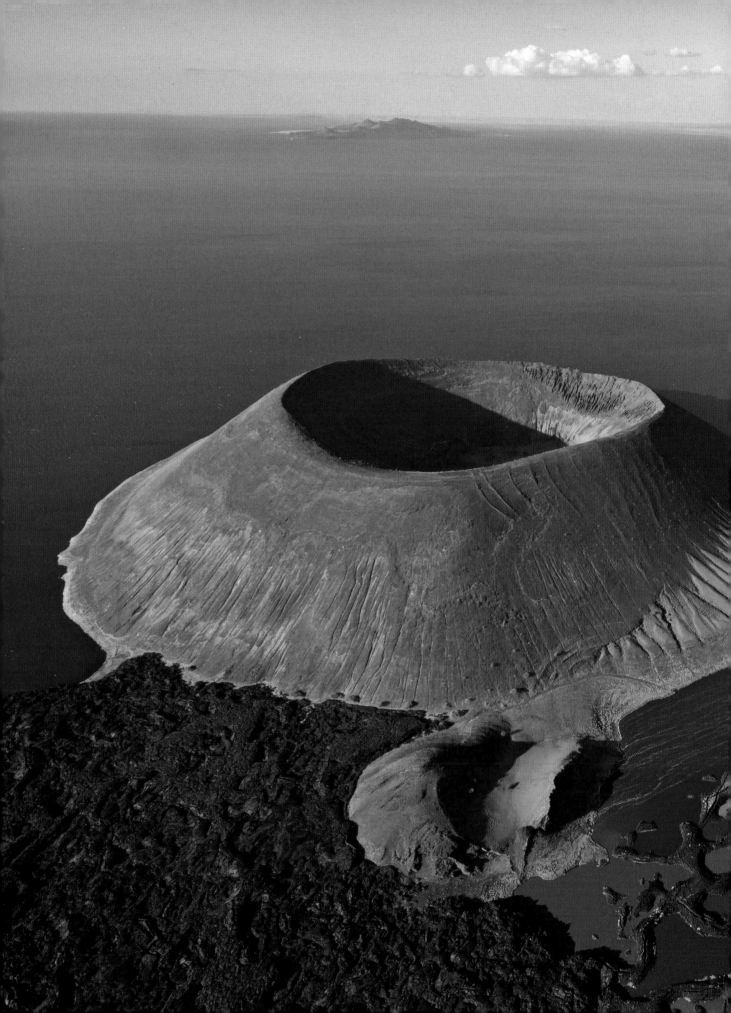

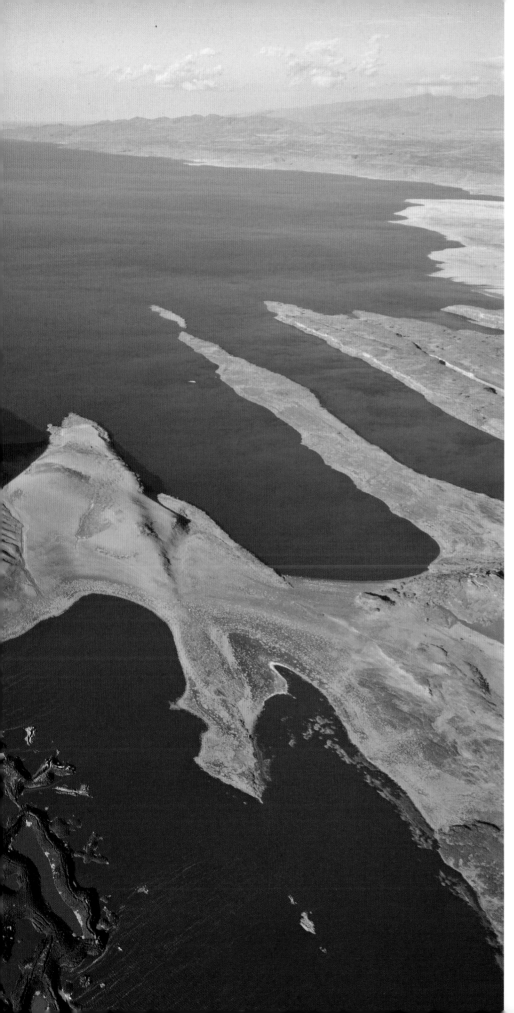

**Nabiyotum Crater,
Lake Turkana, Kenya**
The extinct Nabiyotum volcano
lies on the southern shore of
Lake Turkana, the world's largest
alkaline lake at 6,405 sq km
(2,473 sq miles). The lake gets
most of its water from the Omo
River, which is currently being
dammed by Ethiopia. Local
people fear that the dam may
impact on the livelihoods of
fishers and pastoralists around
the lake.

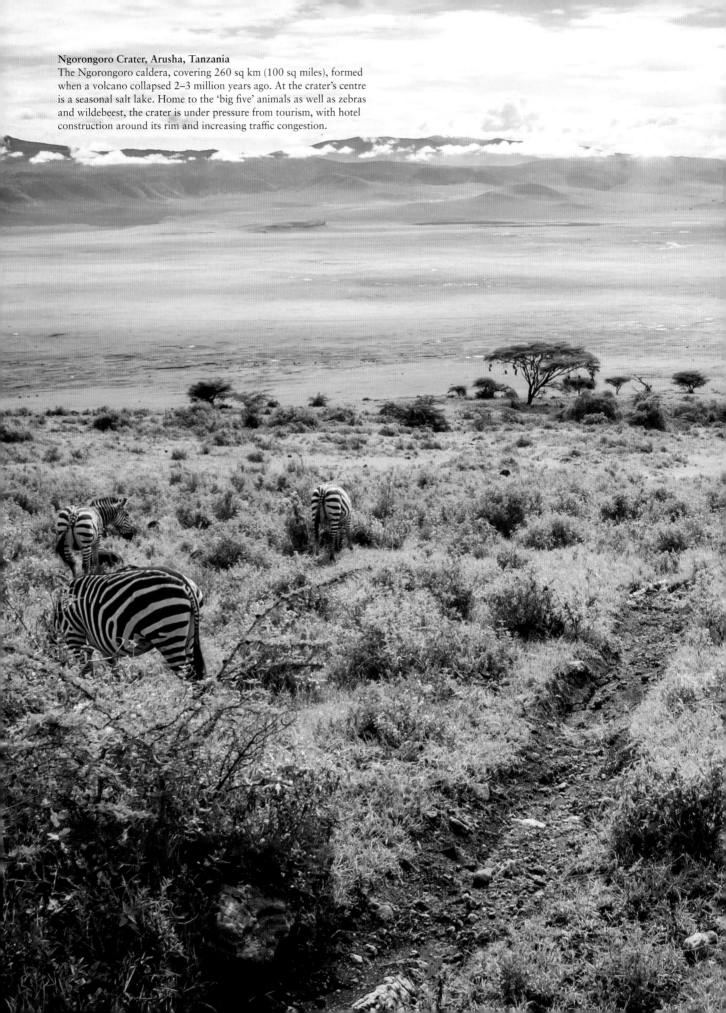

Ngorongoro Crater, Arusha, Tanzania
The Ngorongoro caldera, covering 260 sq km (100 sq miles), formed when a volcano collapsed 2–3 million years ago. At the crater's centre is a seasonal salt lake. Home to the 'big five' animals as well as zebras and wildebeest, the crater is under pressure from tourism, with hotel construction around its rim and increasing traffic congestion.

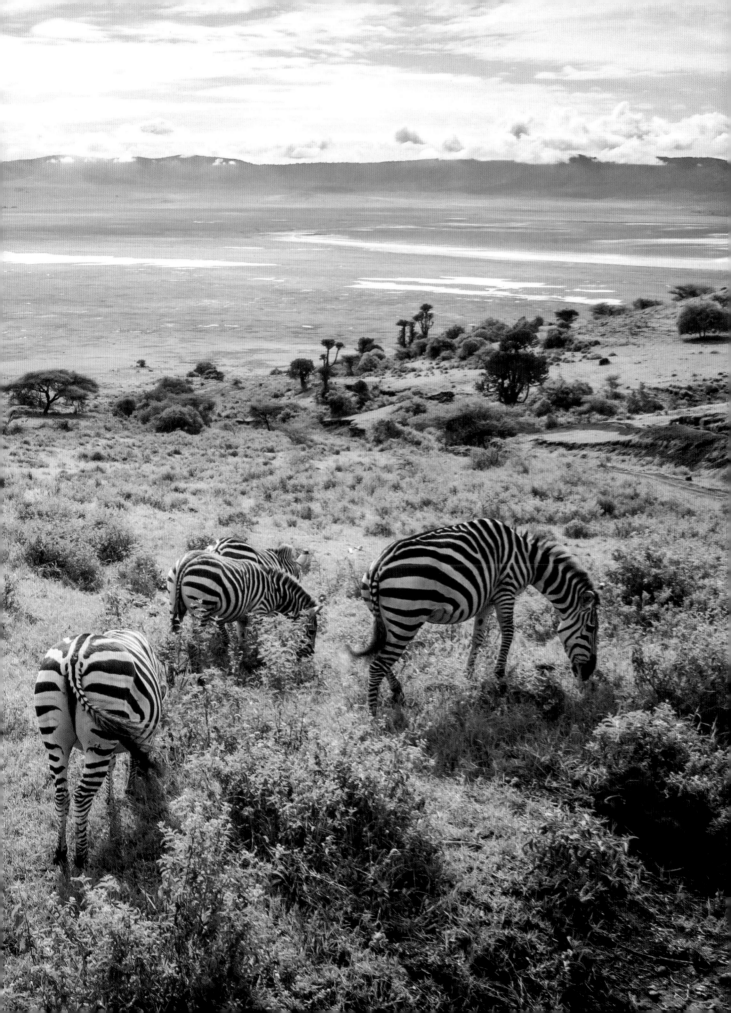

Great Mosque of Kilwa Kisiwani, Lindi, Tanzania
One of the earliest surviving mosques on the Swahili Coast, the Great Mosque was constructed in the 12th and 13th centuries. Rainfall and creeping vegetation present an ongoing threat to its survival. Now with a population of fewer than 1,000, the island of Kilwa was once the centre of the Kilwa Sultanate, its power peaking in the 13th to 15th centuries.

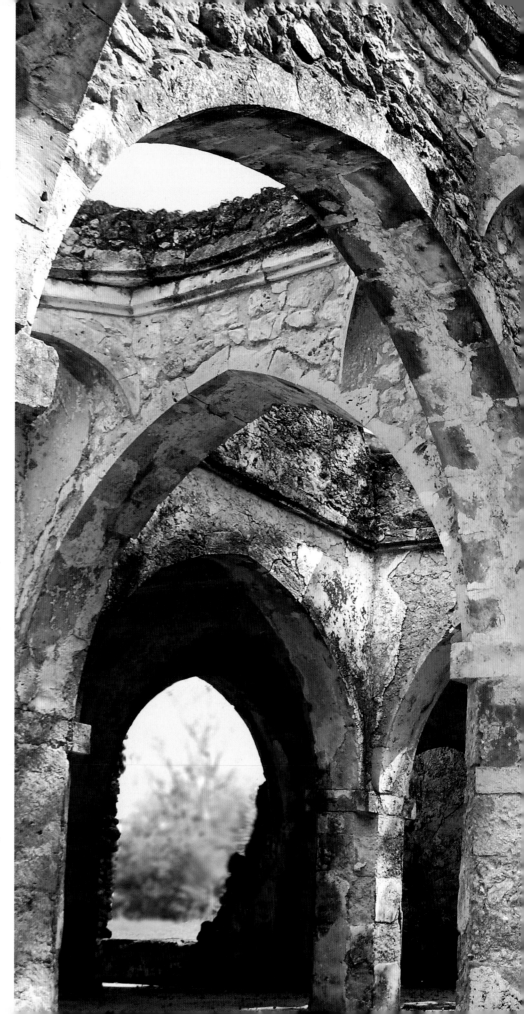

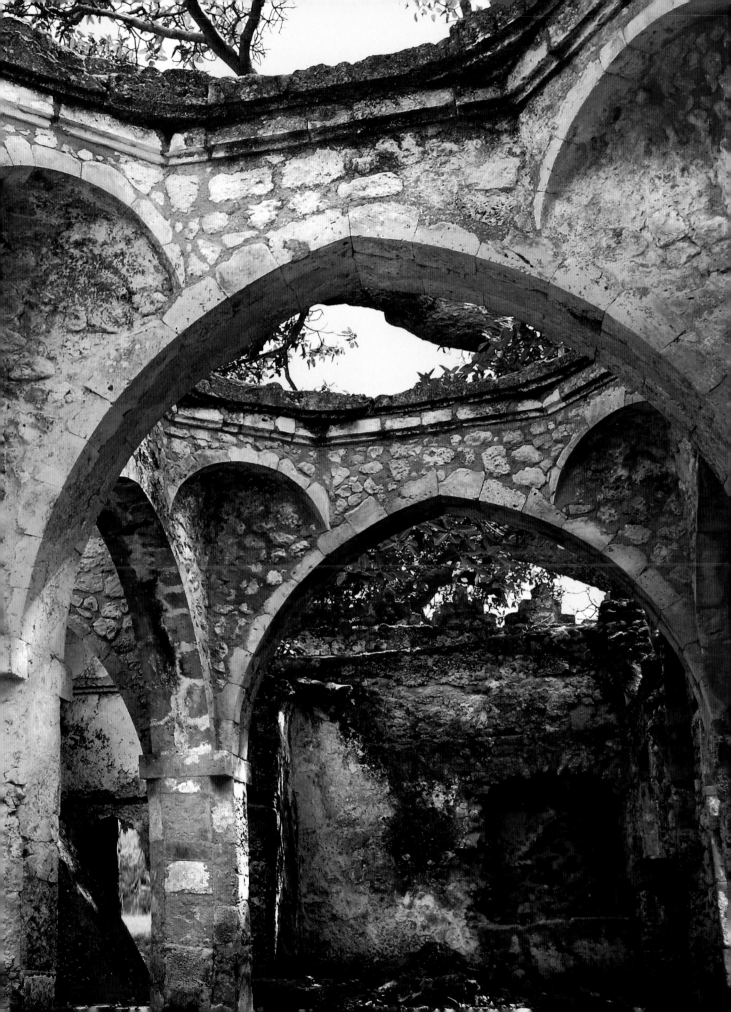

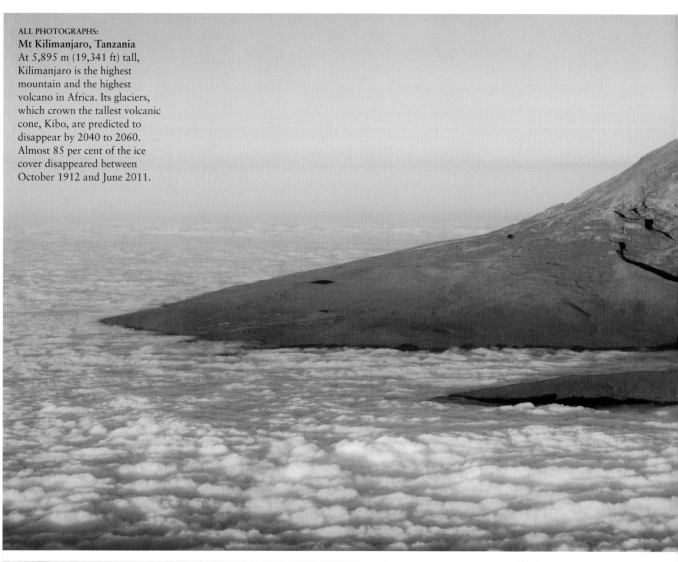

ALL PHOTOGRAPHS:
Mt Kilimanjaro, Tanzania
At 5,895 m (19,341 ft) tall,
Kilimanjaro is the highest
mountain and the highest
volcano in Africa. Its glaciers,
which crown the tallest volcanic
cone, Kibo, are predicted to
disappear by 2040 to 2060.
Almost 85 per cent of the ice
cover disappeared between
October 1912 and June 2011.

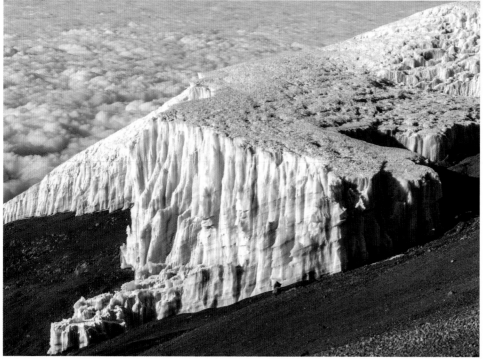

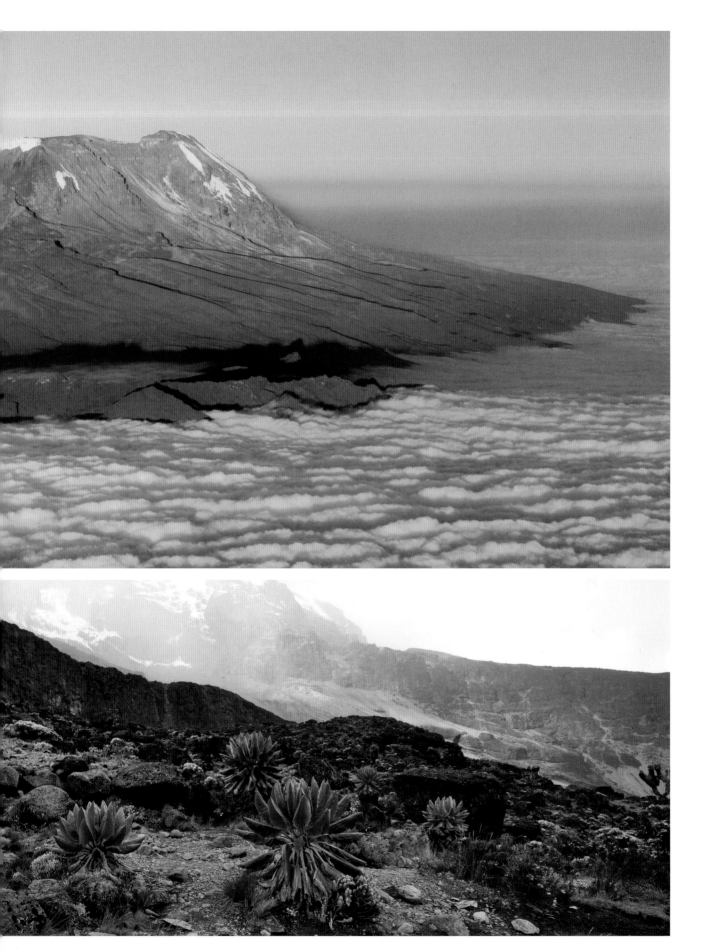

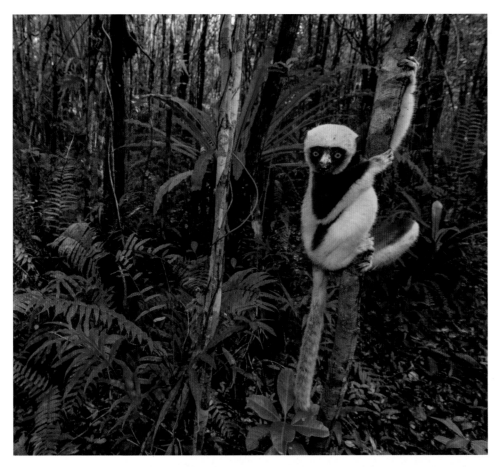

ALL PHOTOGRAPHS:

Forests of Madagascar

The rainforests of Madagascar are suffering from illegal logging of endemic rosewoods and ebony, while the tapia tree is now found only in isolated stands in the central highlands (far right). Although it was often considered taboo to hunt lemurs, including the critically endangered Coquerel's sifaka (above), famine and cultural changes have led to their hunting for bushmeat. Further investment in food security, healthcare and sustainable economic growth is urgently required.

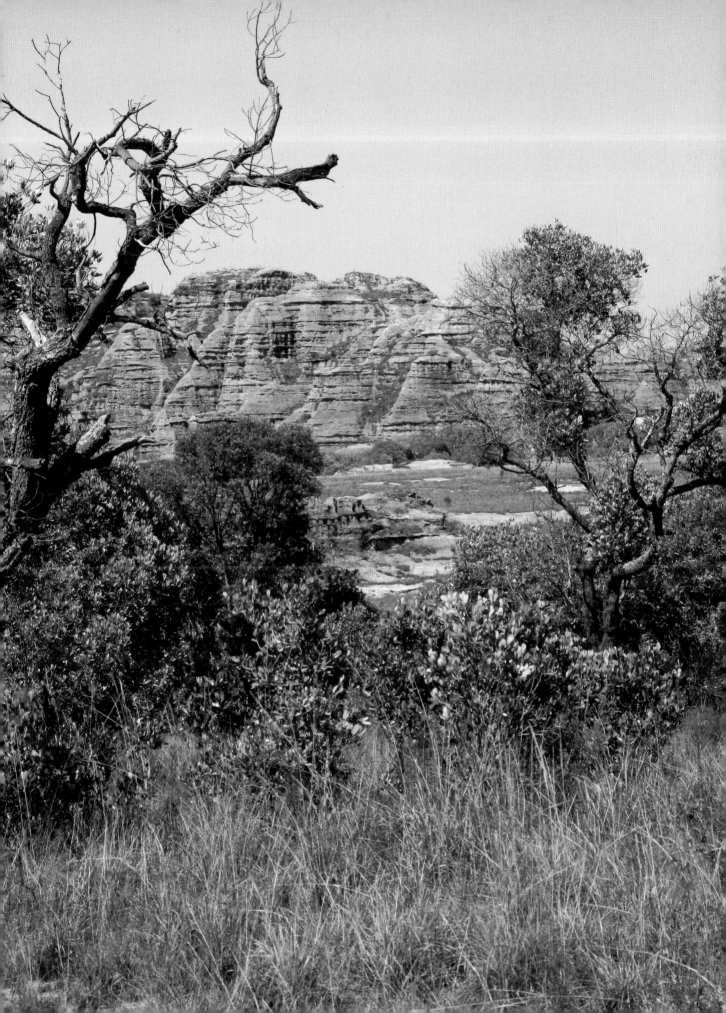

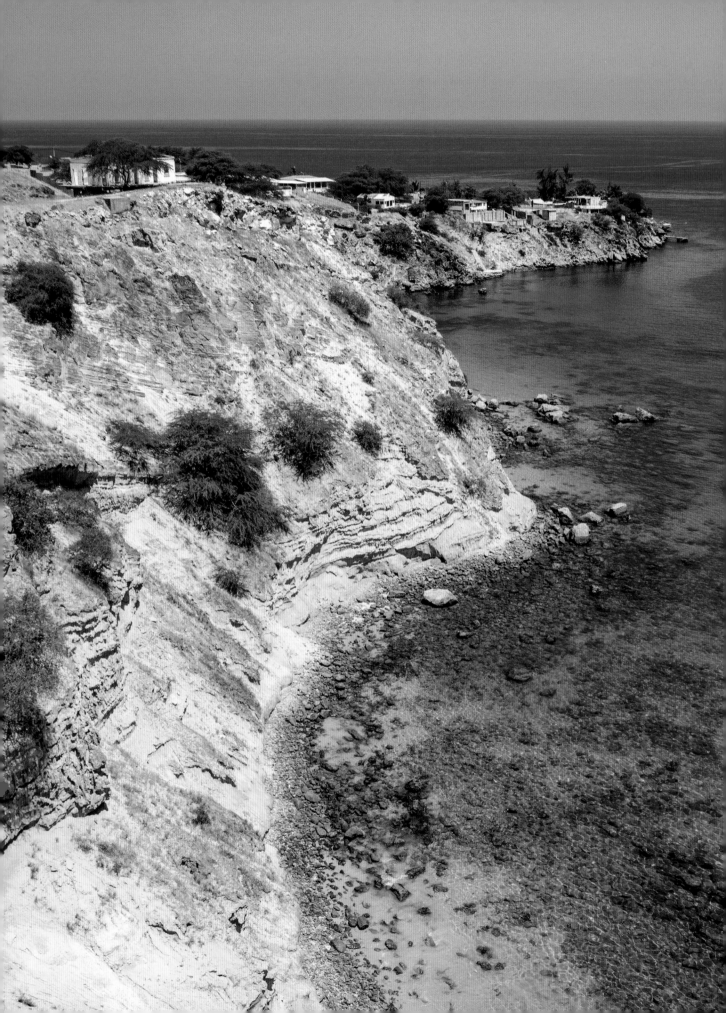

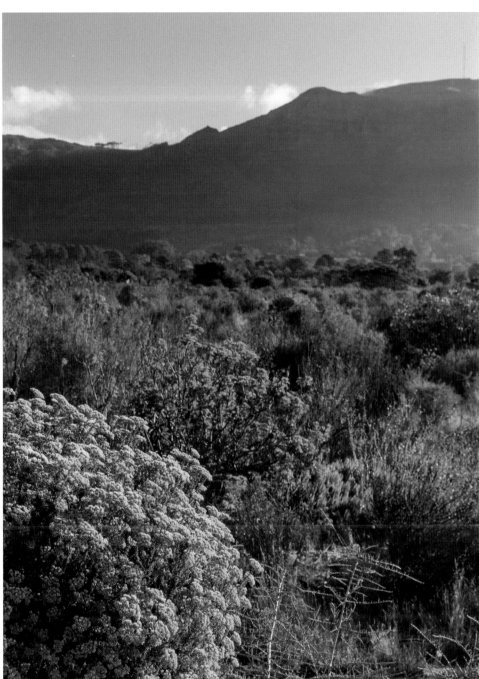

LEFT:

Cape of Caotinha, Benguela, Angola

The Benguela upwelling, off the coast of southwestern Africa, creates one of the world's most productive marine ecosystems. The upwelling is associated with the Benguela Current, which is driven by the southeasterly trade winds. Global warming is likely to affect both winds and upwelling over the next decades.

ABOVE:

Table Mountain National Park, Western Cape, South Africa

This national park protects the fynbos, a band of coastal shrubland that is home to around 6,000 endemic plants, including around 600 ericas (often called heathers). Invasive plants, including wattles, hakeas and pines, are threatening the ecological balance, but clearance teams are at work year round.

Etosha National Park, Kunene, Namibia
Covering some 22,270 sq km (8,600 sq miles), Etosha encompasses vast salt pans, grassland and mopane woodland. There are around 114 mammal species here, including plains zebras, springboks, bush elephants, Angolan giraffes, lions, leopards and meerkats. Despite custodianship efforts, poaching impacts the park's animals, including the critically endangered black rhino.

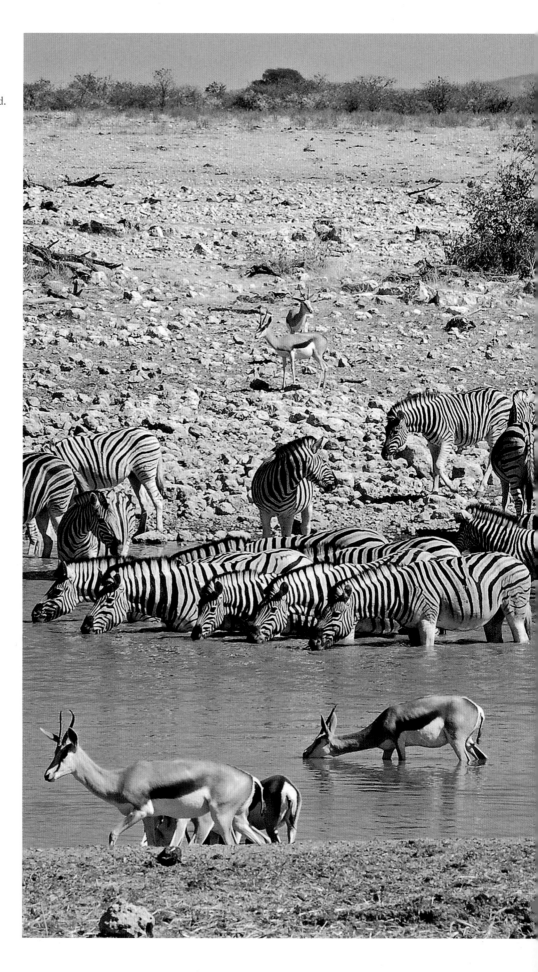

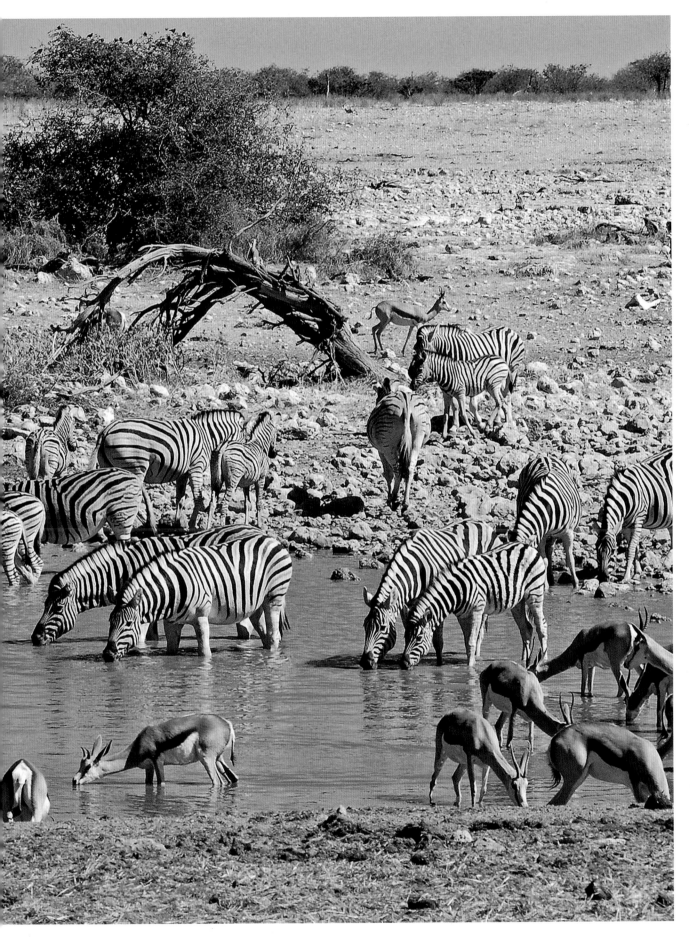

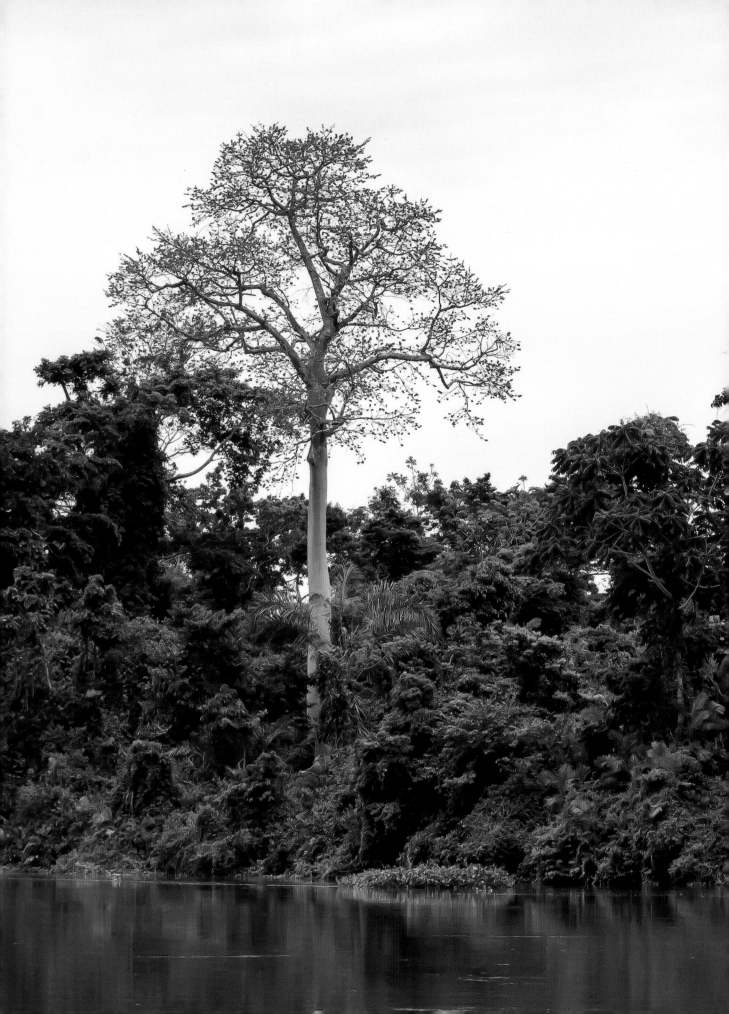

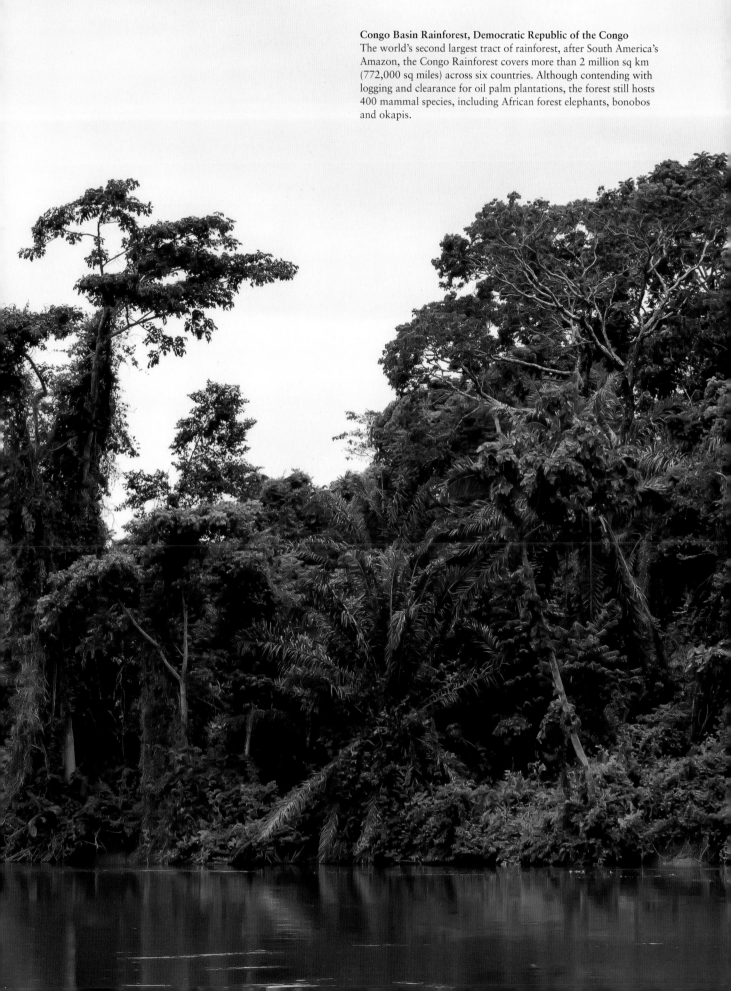

Congo Basin Rainforest, Democratic Republic of the Congo
The world's second largest tract of rainforest, after South America's Amazon, the Congo Rainforest covers more than 2 million sq km (772,000 sq miles) across six countries. Although contending with logging and clearance for oil palm plantations, the forest still hosts 400 mammal species, including African forest elephants, bonobos and okapis.

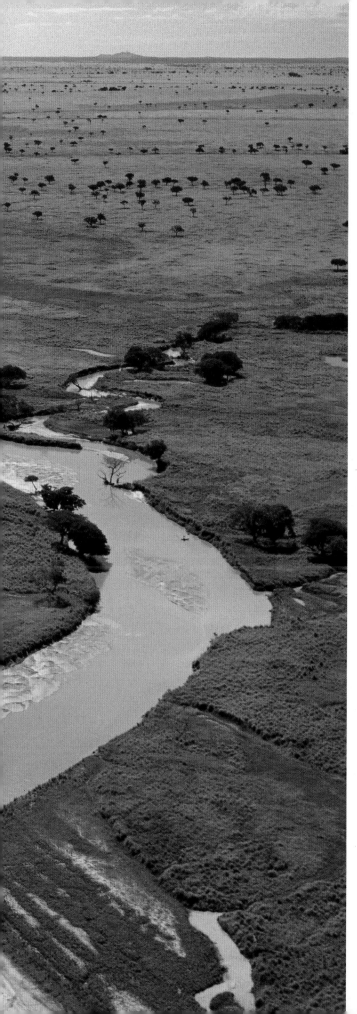

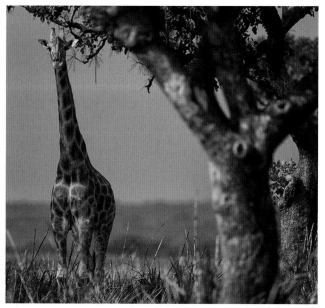

ALL PHOTOGRAPHS:
**Garamba National Park,
Haut-Uélé, Democratic
Republic of the Congo**
The Garamba grasslands cloak
the plains around the Garamba
River (left). Impacted by
poaching, animals here include
Kordofan giraffes as well as
critically endangered northern
white rhinos and elephants,
which are a hybrid of the African
savanna and forest species.

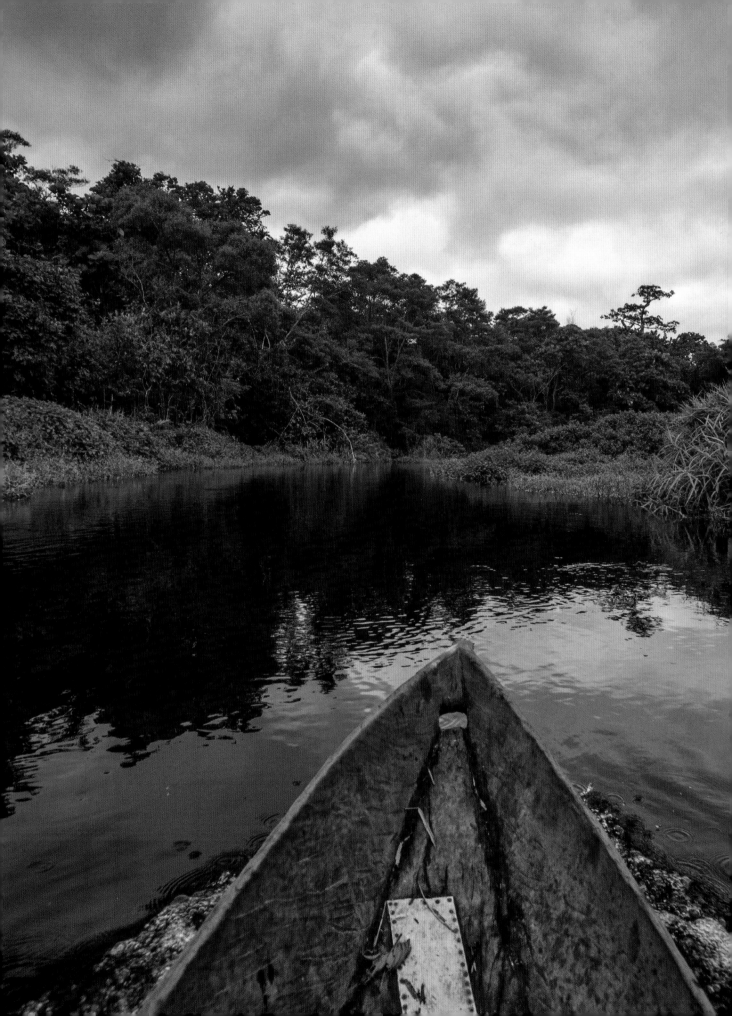

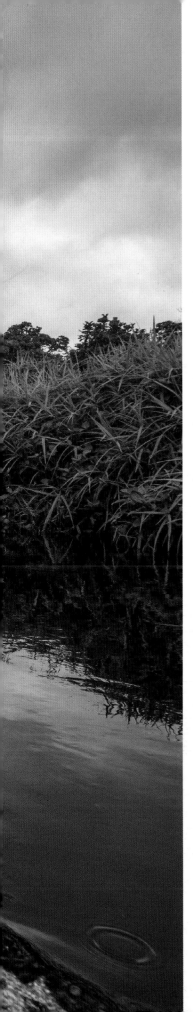

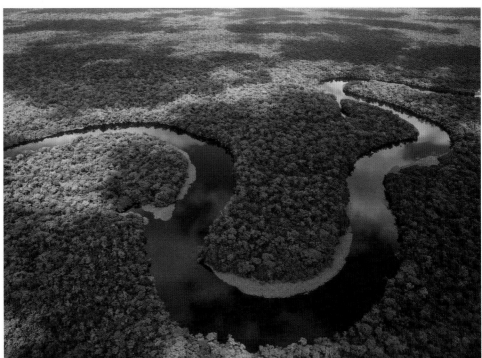

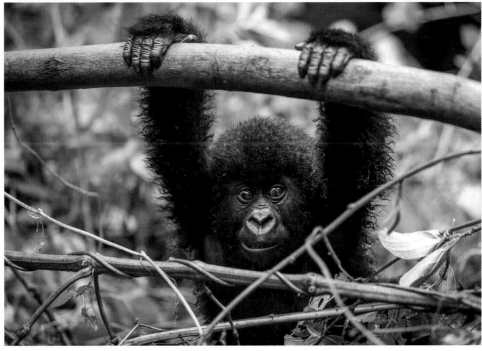

LEFT AND ABOVE TOP:

Salonga National Park, Democratic Republic of Congo
Africa's largest rainforest reserve covers some 36,000 sq km (13,900 sq miles) around the Salonga and Lokoro Rivers. The park's threatened animals include the African golden cat, black crested mangabey, Dryas monkey, giant pangolin and the rarely seen aquatic genet, which is a catlike animal that is related to meerkats.

ABOVE BOTTOM:

Young eastern lowland gorilla, Democratic Republic of the Congo
There are fewer than 3,800 eastern lowland gorillas left in the wild, where they live in large groups bonded by female relationships. Young gorillas are usually breastfed for three years, remaining with their mother until around the age of eight, when they may join another group.

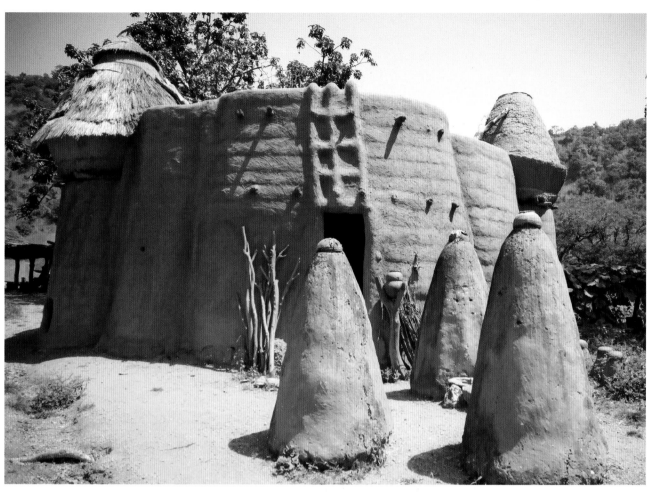

ABOVE:

Batammariba home, Koutammakou, Togo

The mud tower houses, known as *takienta*, and cone-shaped altars of the Batammariba people have become a symbol of Togo. This cultural landscape is at risk due to overexploitation of natural resources, resulting in a wood shortage that is affecting the required regular reconstruction.

RIGHT:

La Maison du Peuple, Ouagadougou, Burkina Faso

French architect René Faublée designed this Brutalist government building influenced by vernacular mud structures. Activists urge legal protection for the masterpiece, which is in need of maintenance.

OPPOSITE:

Comoé National Park, Côte d'Ivoire

At the forefront of the battle with climate change, this park covers savannah and gallery forest. It forms the northern limit for many species, such as the bongo.

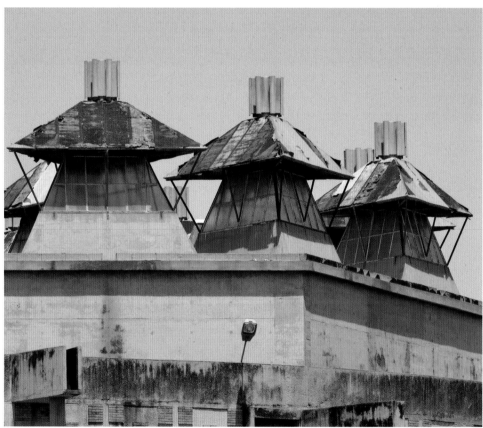

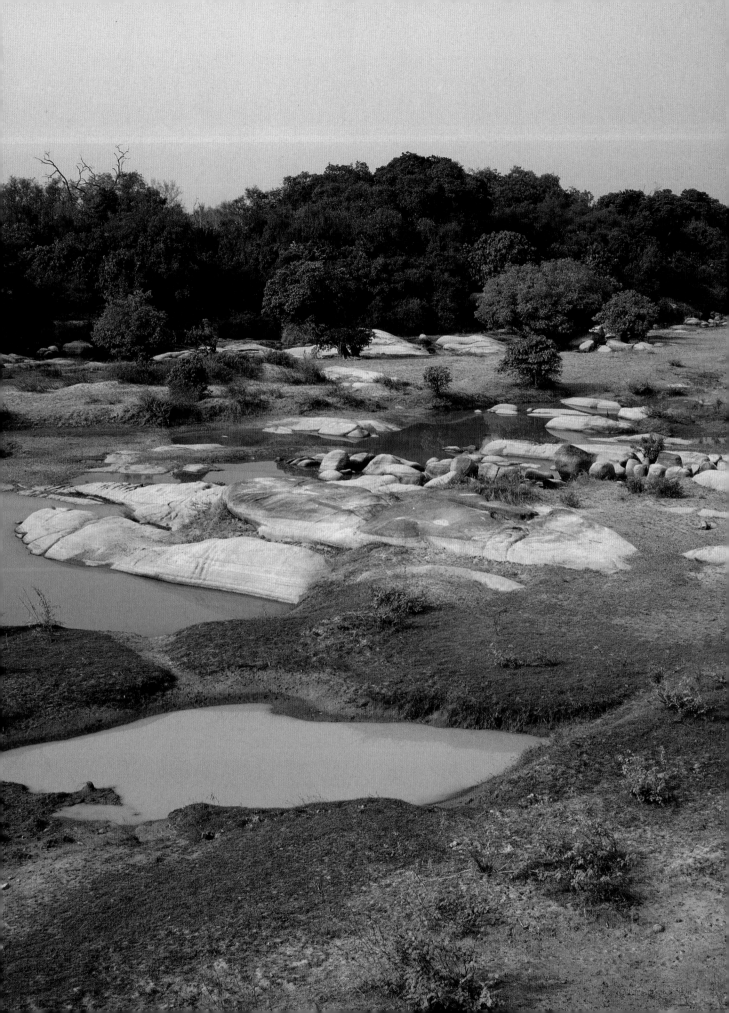

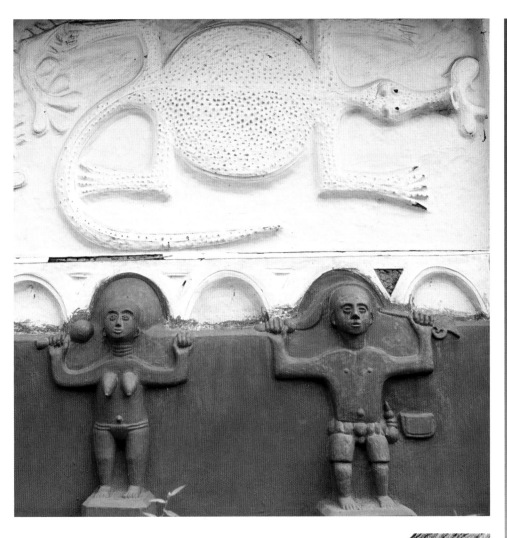

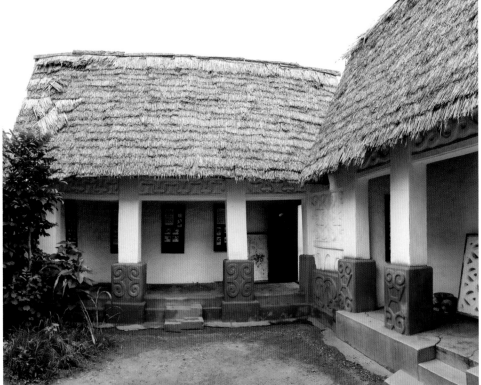

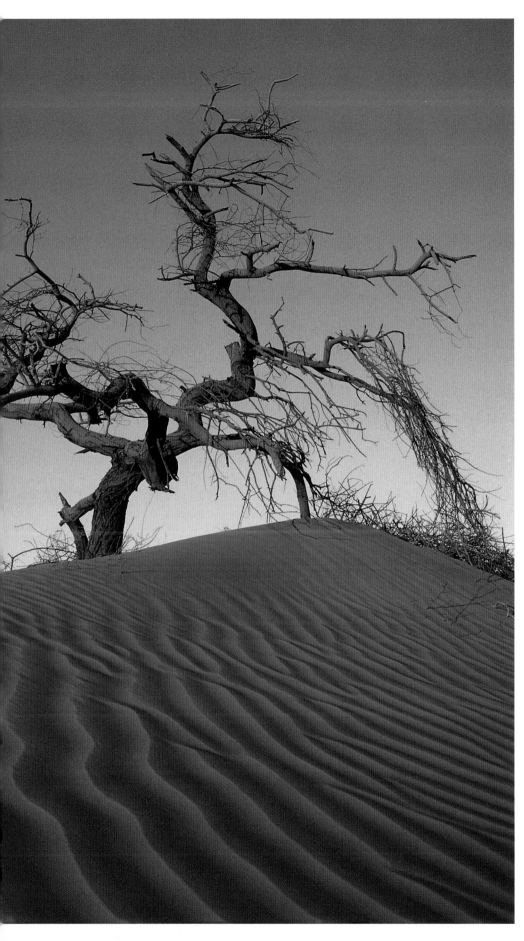

OPPOSITE TOP AND BOTTOM:

Ashanti shrine, Ashanti, Ghana
Northeast of the city of Kumasi
are the last remaining shrines
built in the traditional style of
the Ashanti Empire (1701–1901).
The buildings were constructed
from thatch, bamboo and mud
plaster. Symbolic bas-reliefs
decorate the walls. The shrines
are at the mercy of termites,
heavy rainfall and high humidity.

LEFT:

**Aïr and Ténéré Natural
Reserves, Arlit, Niger**
The Ténéré Desert is roamed by
endangered animals, including
the Dorcas gazelle and addax.
Much of the desert, where
temperatures can reach 50 °C
(122 °F) and rainfall is around
12 mm (0.5 in) per year, is
a featureless ocean of sand.
Conservation of this reserve
depends on investment in local
communities to curtail hunting
and wood collection.

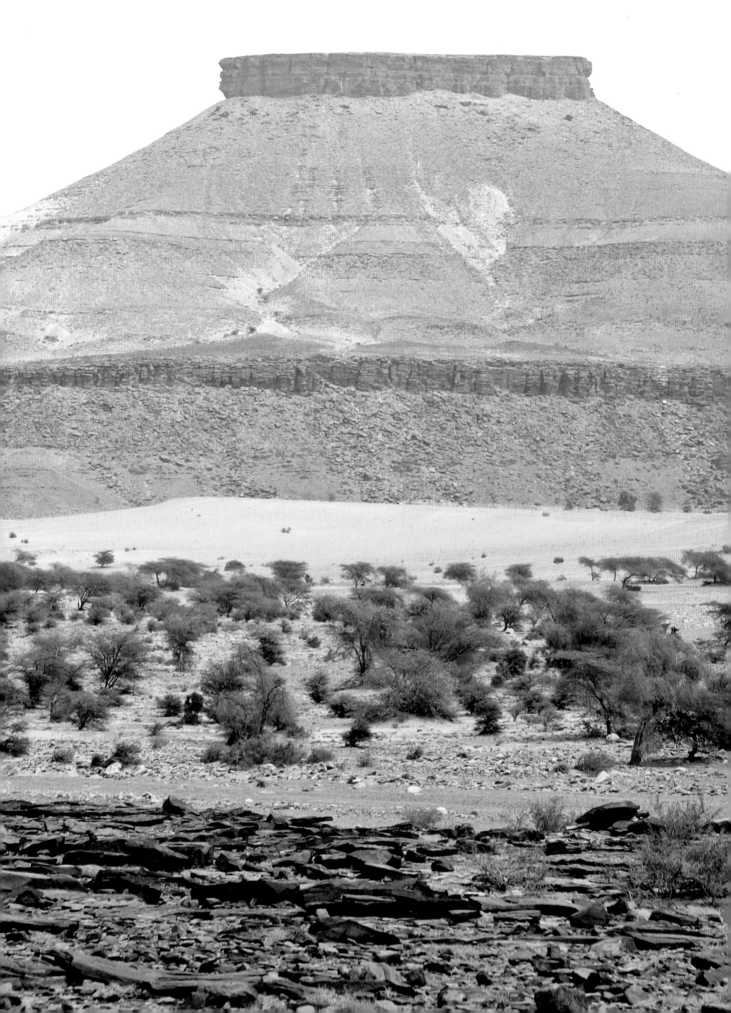

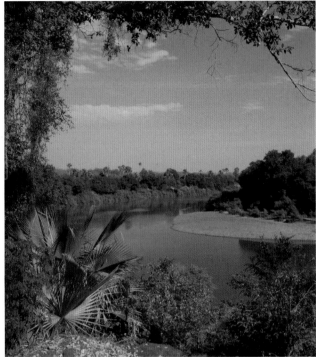

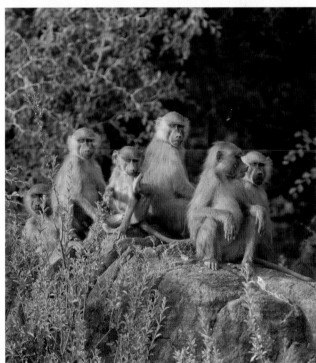

LEFT:

Adrar Plateau, Mauritania
Over the past 30 years, Mauritania has been hit hard by desertification. Droughts led to a steep drop in its production of gum arabic, used in food and pharmaceuticals, which flows from acacia trees (pictured). Today, drought-resistant acacias are being replanted to hold back desertification and stimulate rural economies.

ABOVE TOP AND BOTTOM:

Niokolo-Koba National Park, Senegal
Along the Gambia River, this national park is home to Guinea baboons (pictured), chimpanzees, lions and forest elephants. Although Senegal is not a major contributor of greenhouse gases, it is highly vulnerable to climate change. Drought is taking its toll, with drying waterholes and more frequent wildfires.

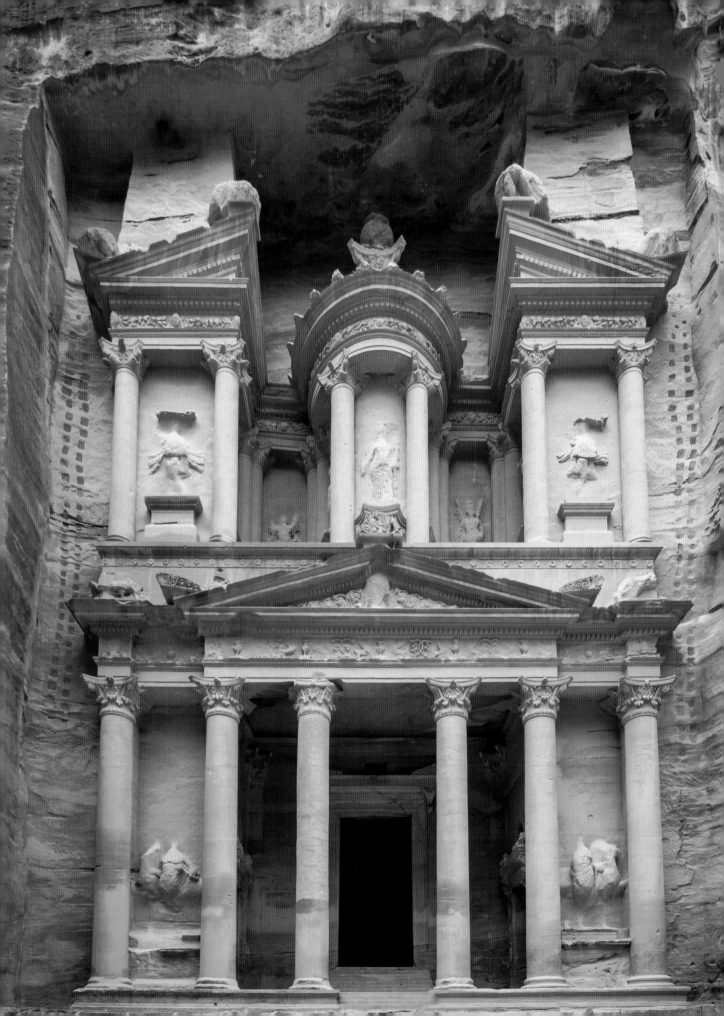

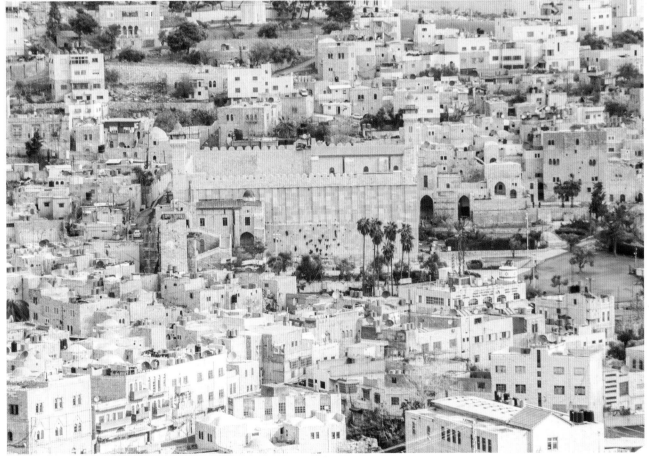

OPPOSITE AND ABOVE TOP:
Petra, Ma'an, Jordan
Petra's Nabataean rock-cut temples, including the 1st-century CE Al-Khazneh (left), as well as its later Byzantine Church (above), are waging a centuries-long battle with erosion caused by wind, rain and flash floods.

ABOVE BOTTOM:
Hebron Old Town, West Bank
Settled in the early Bronze Age, Hebron is a place of pilgrimage for Jews, Christians and Muslims. At the heart of the city is the Cave of the Patriarchs, also known as the Cave of Machpelah and Ibrahimi Mosque.

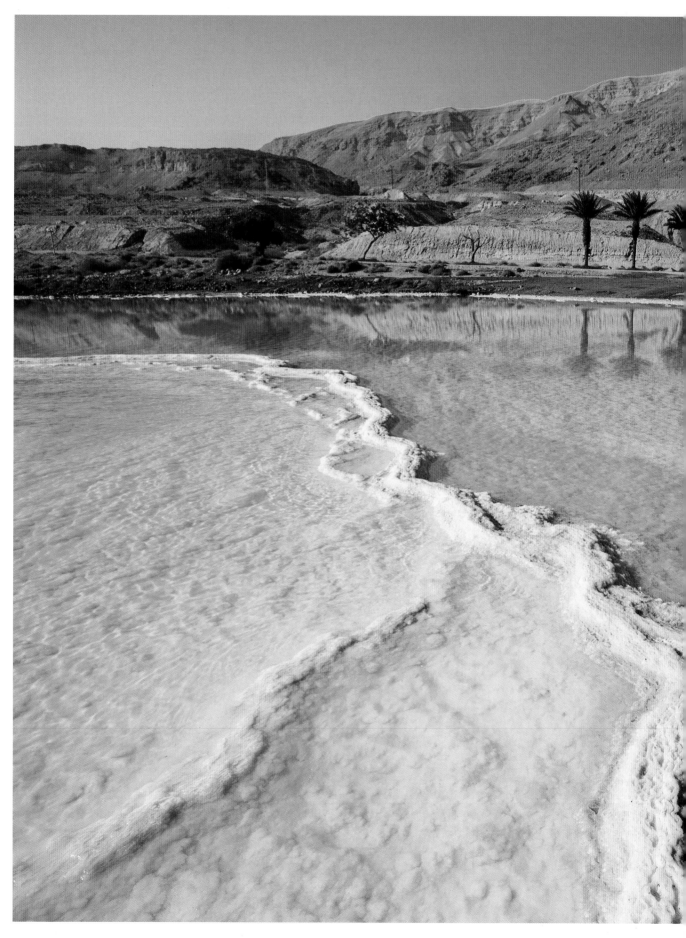

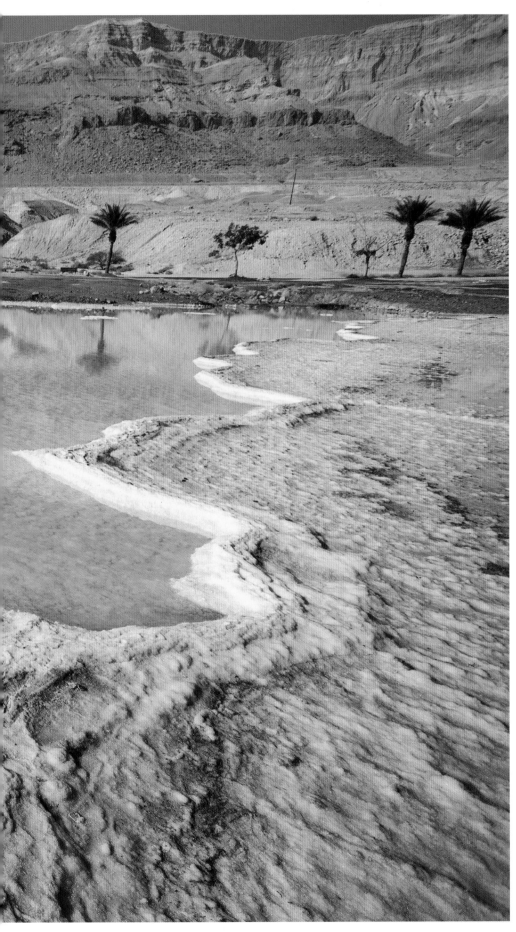

**Dead Sea,
Jordan–Israel–West Bank**
At 304 m (997 ft) deep, the
Dead Sea is the world's deepest
hypersaline lake. The lake is
shrinking due to changing
rainfall patterns and diversion
of incoming water for drinking
and irrigation. In 1930, the lake's
surface was 390 m (1,280 ft)
below sea level, but today it is
430.5 m (1,412 ft) below – both
measurements making its shores
the lowest land-based elevation
on Earth.

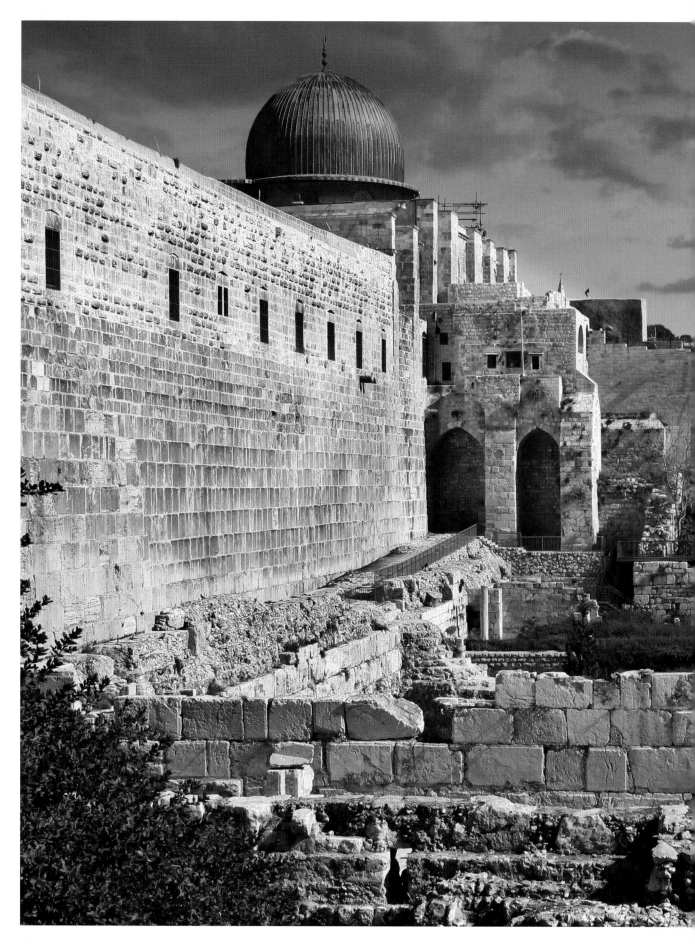

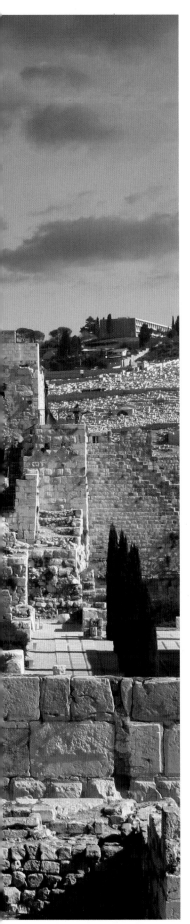

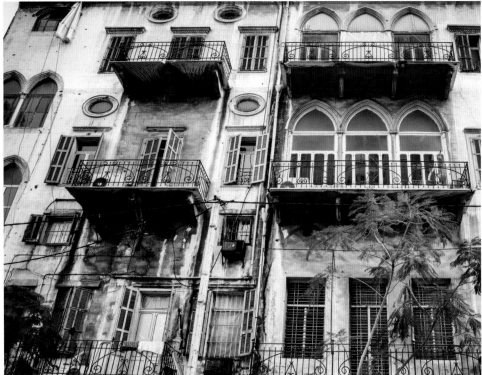

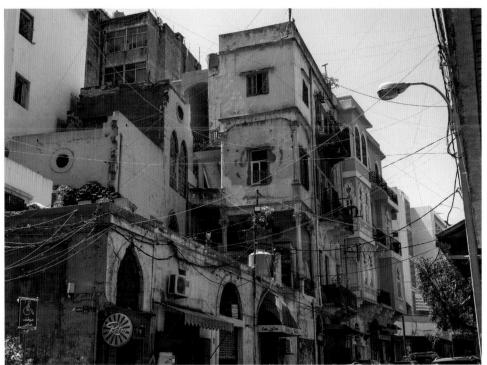

LEFT:

Old City, Jerusalem
Jerusalem's Old City is sacred to
Jews, Christians and Muslims.
The ancient structures, some
dating back 3,000 years, nestle
at the heart of the modern city,
a location that gives them both
continued life and draws the risks
posed by urban encroachment,
including leaks from water pipes.

ABOVE TOP AND BOTTOM:

Beirut Central District, Lebanon
The architecture of downtown
Beirut shows the influence of
Ottoman, French and Venetian
Gothic styles. Many of the area's
souks, mosques, cathedrals and
Roman ruins are at risk from
developers as well as many years
of underinvestment as a result of
the Lebanese Civil War.

Damascus, Syria
Settled in the 3rd millennium BCE,
Damascus is one of the world's
oldest continuously inhabited
cities. Due to the declining
population of Old Damascus,
led both by infrastructure issues
and civil war, many homes are
abandoned and in disrepair.

BELOW:
Roman Theatre, Bosra, Syria
This basalt theatre was built
under the reign of Trajan in the
2nd century CE. The damaged
site testifies to the devastating
violence suffered by the citizens
of Bosra during the Syrian Civil
War in the 20th century. Artefacts
looted from Bosra have entered
the international art markets.

OPPOSITE:
Citadel of Aleppo, Syria
Much of the current Citadel of
Aleppo dates to the Ayyubids,
when Aleppo was ruled by
Az-Zahir Ghazi, son of Saladin,
from 1193 to 1215. Az-Zahir
added the prominent entrance
block in 1213. The citadel was
damaged during the Battle of
Aleppo (2012–16) but repairs
are ongoing.

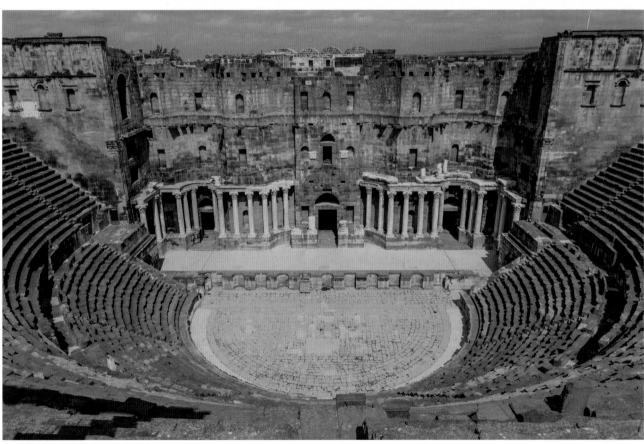

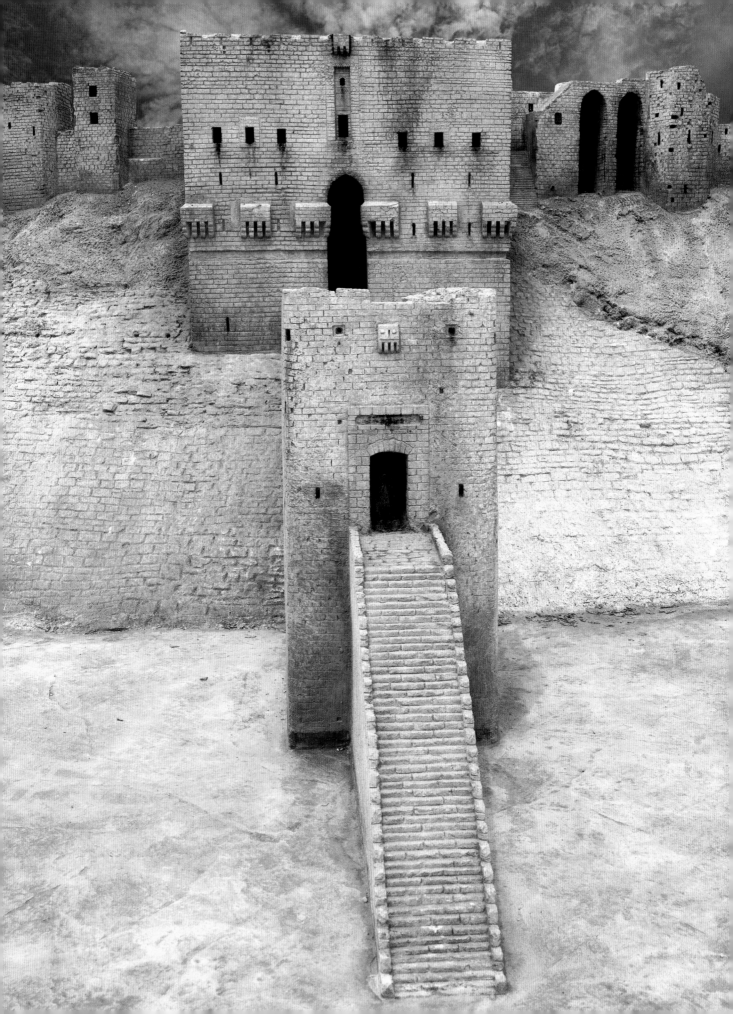

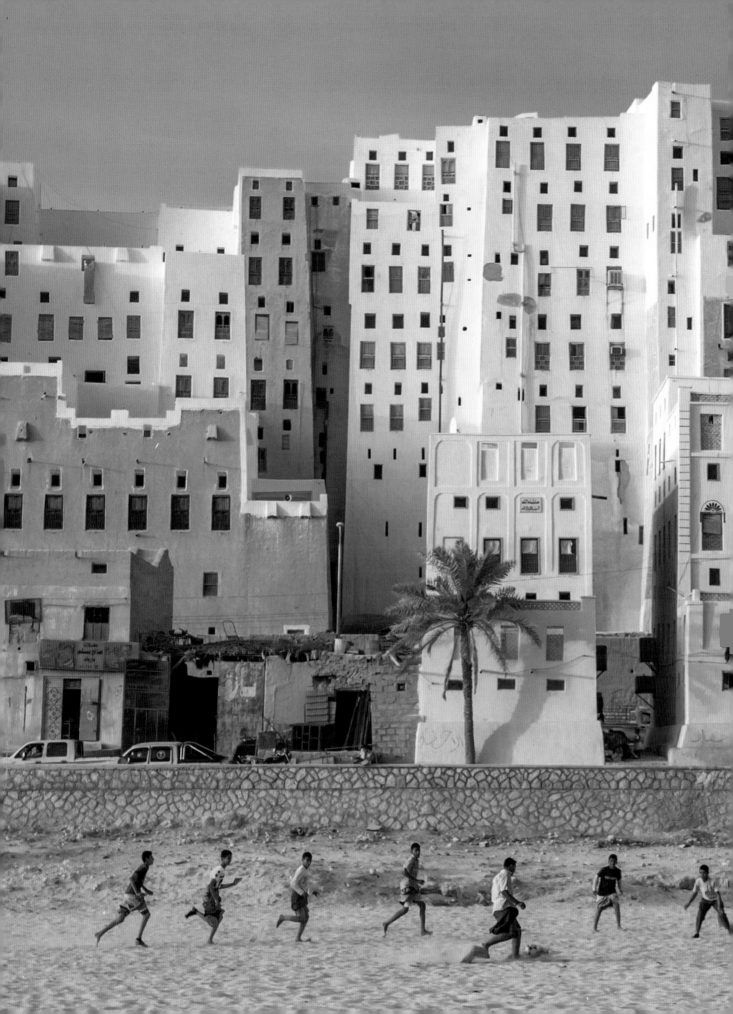

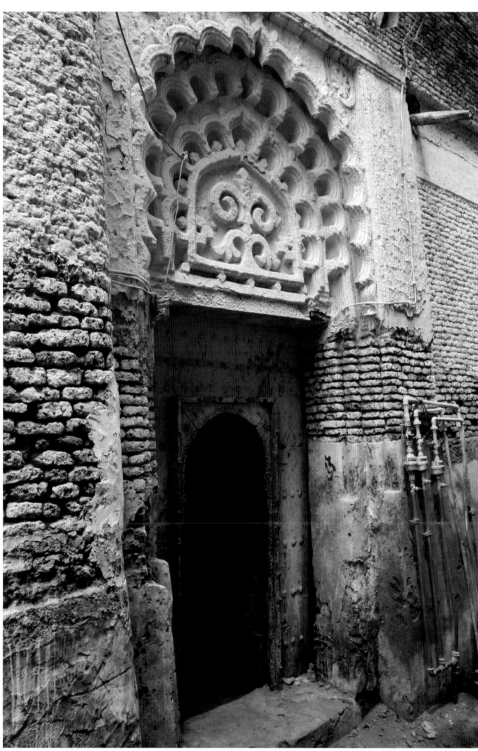

LEFT:

Shibam, Hadhramaut, Yemen
Sometimes called 'Manhattan of the Desert', Shibam has around 500 mud-brick, high-rise dwellings. The oldest date from the 16th century but have been partly or wholly rebuilt many times since then. They must withstand constant attack from rain and wind, and subsidence from flooding.

ABOVE:

Zabid, Al-Hudaydah, Yemen
Capital of Yemen from the 13th to 15th centuries, Zabid's old town is a maze of narrow, winding streets lined with homes and mosques of burned brick, decorated with carved brick or stucco. Conflict, as well as residents' desire to modernise, have put Zabid on the list of Heritage Sites in Danger.

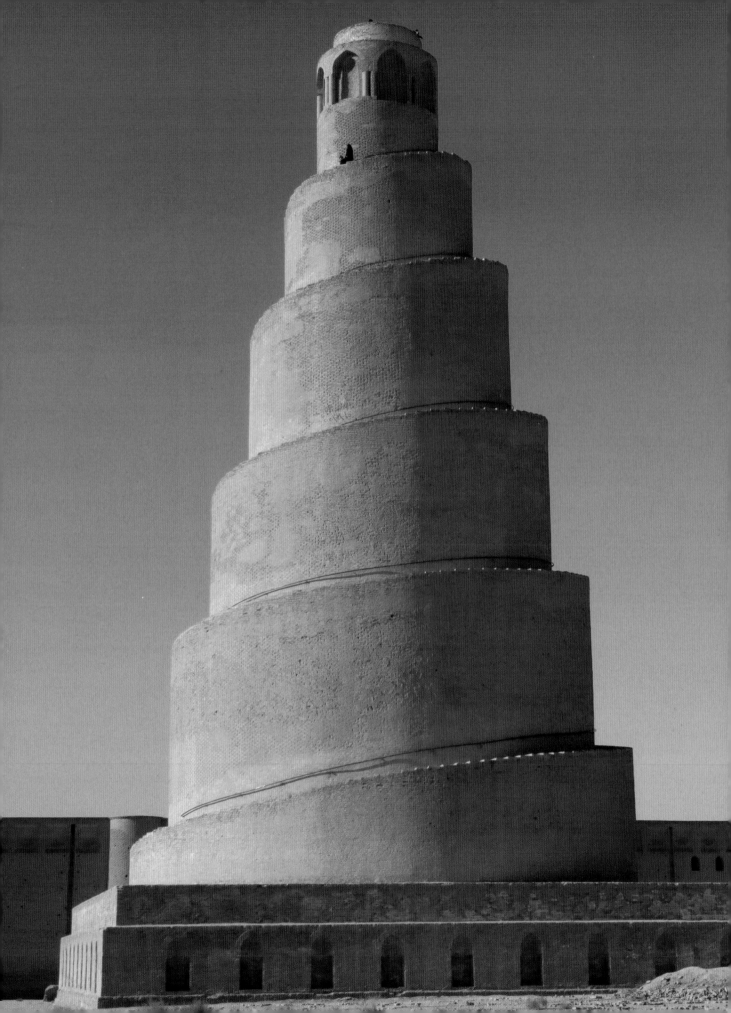

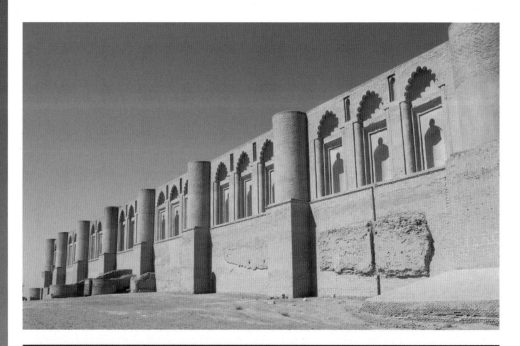

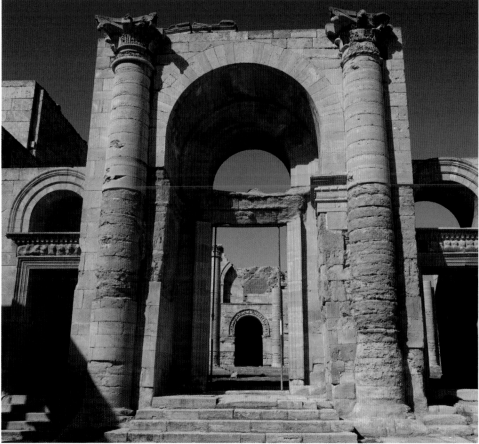

LEFT AND ABOVE TOP:
Samarra, Saladin, Iraq
The great Abbasid monuments
of Samarra, including the 9th-
century spiralling minaret of
the Great Mosque (left) and the
palace of Qasr al-'Ashiq (above),
have unavoidably suffered from
reduced maintenance during
years of devastating conflict.

ABOVE BOTTOM:
Hatra, Nineveh, Iraq
The city of Hatra was the capital
of the Arab Kingdom of Hatra in
the 2nd and early 3rd centuries.
In 2014 and 2015, the Islamic
State of Iraq and the Levant
(ISIL) destroyed statues and
carvings at the site. Restoration
work is continuing.

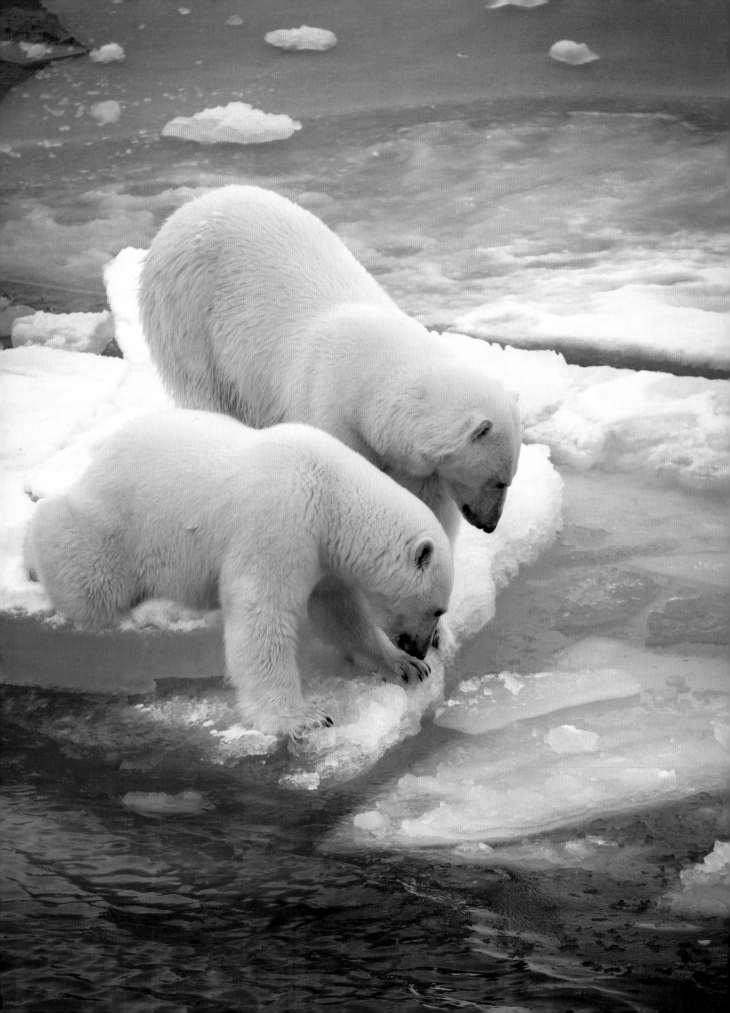

Asia, Pacific and the Poles

THE FACTS about global warming and its effects on these regions are well known, even if not well acted upon. In the second half of the 20th century, air temperatures in the Antarctic Peninsula rose by 3 °C (5.4 °F). Summer Arctic sea ice extent is shrinking by 12.6 per cent per decade. The combined effects of melting ice and rising sea temperatures (since warmer water has greater volume) are predicted to cause catastrophic worst-case sea level rises of 1.1 m (3.6 ft) by 2100. Rising sea temperatures also distress coral polyps, causing bleachings that have led to the Great Barrier Reef losing half its corals since 1985.

These are the facts, but a true, deeply felt understanding of the effects of government inaction – and, often, personal inaction – cannot be gained from statistics but from feeling the beauty of the places, plants, animals and people in danger. The fishing cats of the Sundarbans, polar bears of Spitsbergen and 'snow monsters' of Japan can still be saved if knowing what we are losing spurs us to action. Shrinking reefs can be rescued, along with their sharp-spined surgeonfish and majestic turtles. The Maldives and Torres Strait Islands can be spared the worst-case sea levels, preserving their islands, unique cultural heritage and people's homes, livelihoods and futures.

OPPOSITE:
Polar bears, Arctic Ocean
Up to 3 m (9.8 ft) long, polar bears spend most of their lives on the Arctic sea ice, where they hunt for their favourite food, seals. Shrinking sea ice is forcing some populations to swim longer distances and to spend more of the year ashore, which can lead to malnourishment.

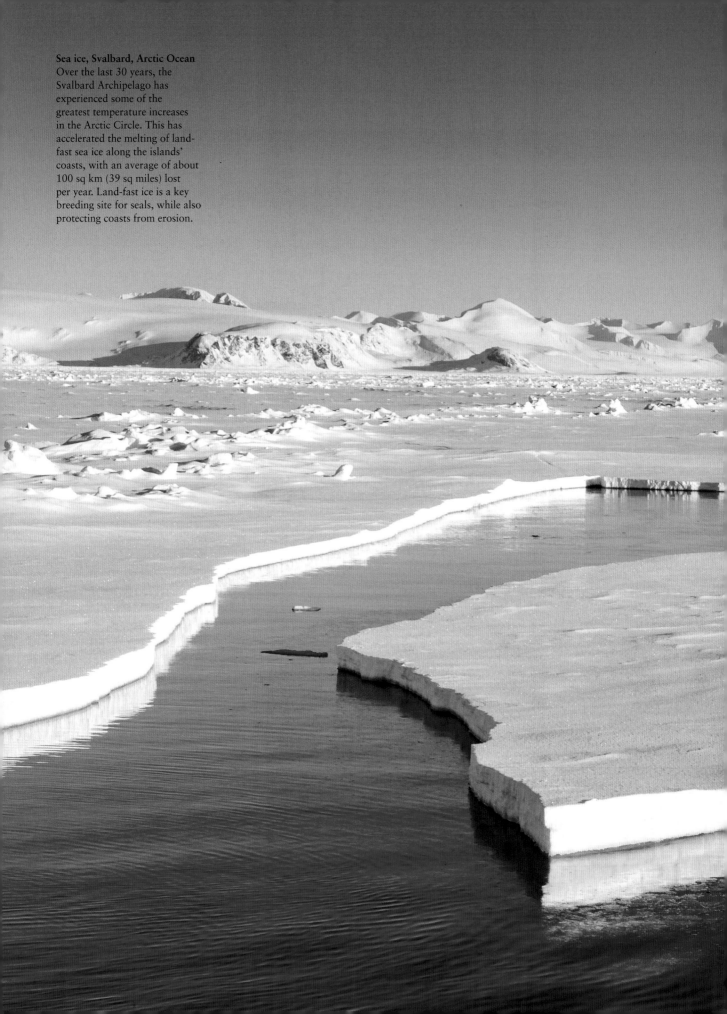

Sea ice, Svalbard, Arctic Ocean
Over the last 30 years, the
Svalbard Archipelago has
experienced some of the
greatest temperature increases
in the Arctic Circle. This has
accelerated the melting of land-
fast sea ice along the islands'
coasts, with an average of about
100 sq km (39 sq miles) lost
per year. Land-fast ice is a key
breeding site for seals, while also
protecting coasts from erosion.

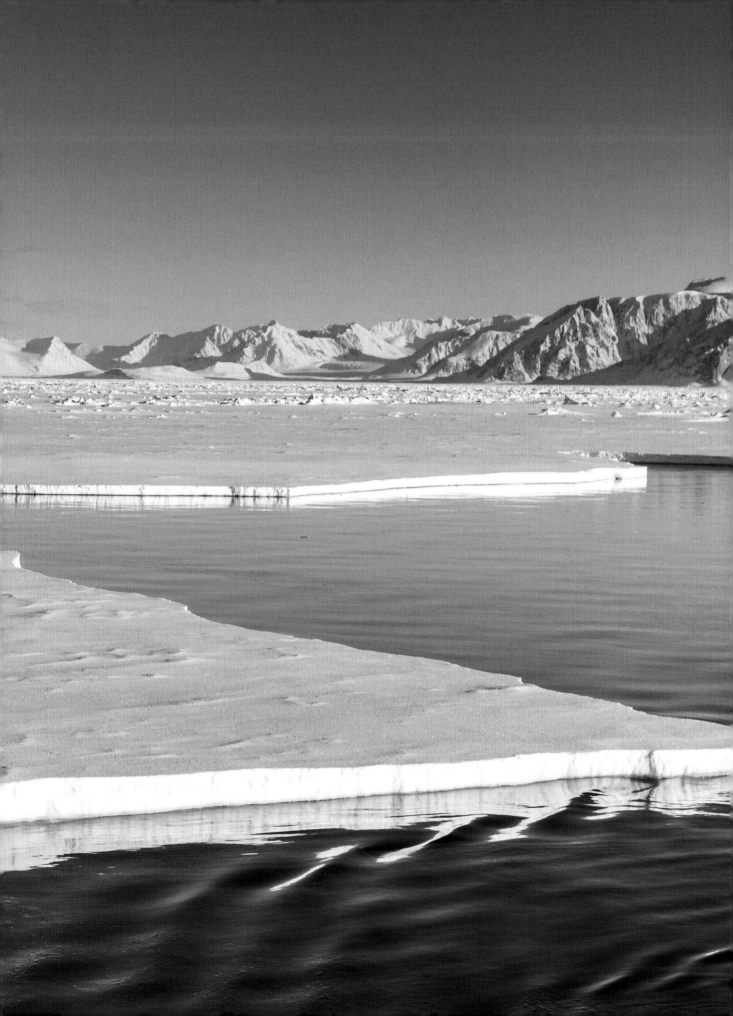

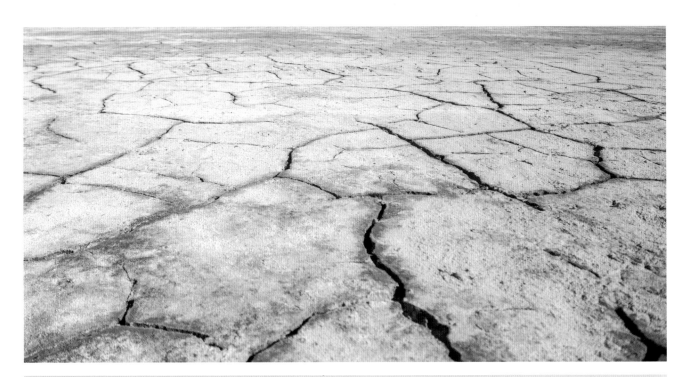

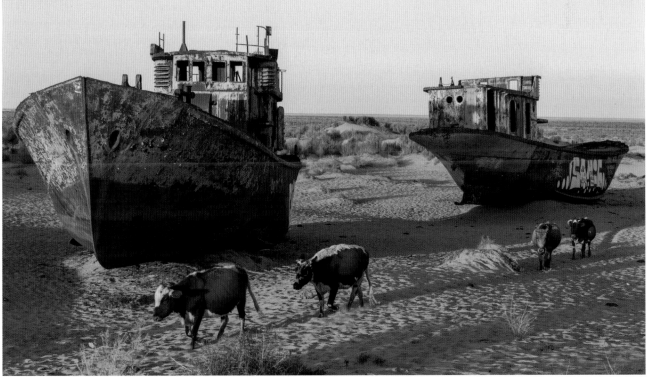

ALL PHOTOGRAPHS:
Aral Sea,
Kazakhstan–Uzbekistan
Once the world's fourth largest
lake, with an area of 68,000 sq km
(26,300 sq miles), the Aral Sea
began shrinking in the 1960s
when its inflows were diverted
for Soviet irrigation projects.
Today, the 'sea' is split into three
small basins, destroying the
fishing industry and leaving a
salt- and toxin-covered plain.

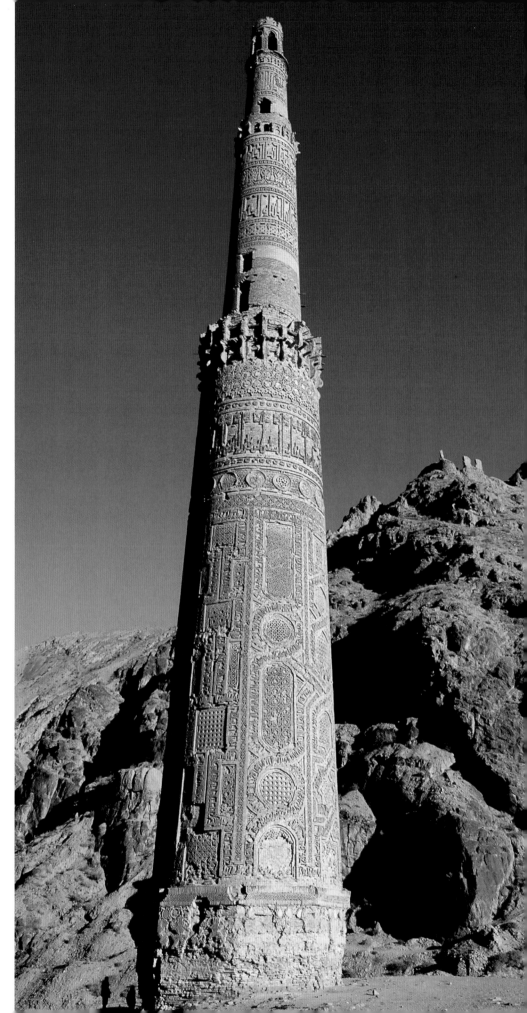

BOTH PHOTOGRAPHS:
Minaret of Jam, Ghor, Afghanistan
Constructed in about 1190, this 62-m (203-ft) baked-brick minaret is gloriously decorated with brick, stucco and tile. Geometric patterns intertwine with calligraphy in two styles: angular *kufic* and smaller, rounder *naskhi*. Due to its proximity to the Hari and Jam Rivers, the minaret is frequently flooded, the subsidence worsened by earthquakes, leaving it in need of stabilization.

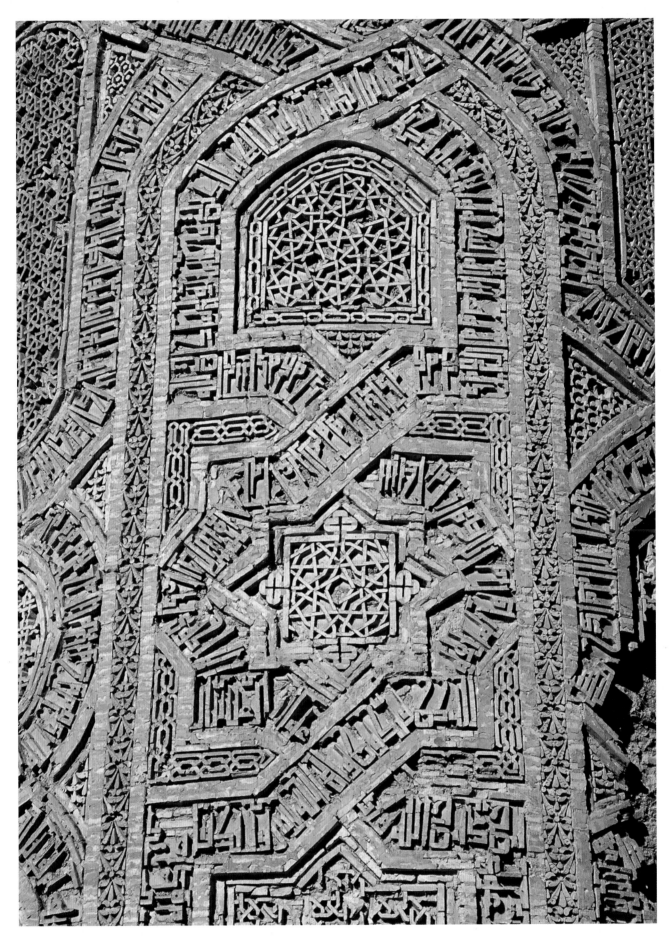

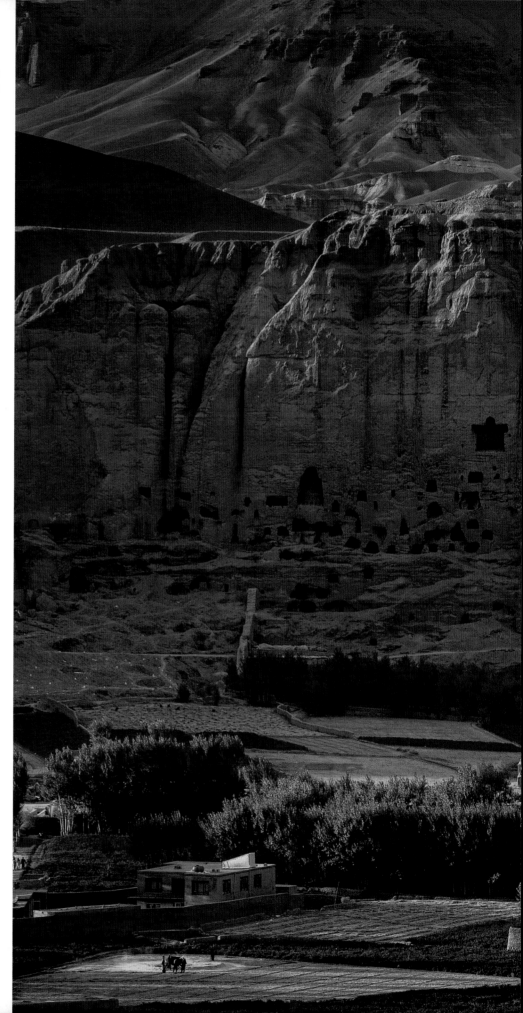

Bamyan Valley, Afghanistan
The two Buddhas of Bamyan, the largest of them 55 m (180 ft) tall, were carved into these cliffs in the 6th and 7th centuries. Prayer halls, many with wall paintings, were hewn into the surrounding rock. In 2001, the Taliban destroyed the Buddhas. After the overthrow of the Taliban, the local and international communities explored methods of reconstruction, but the return of the Taliban brought work to a halt in 2021.

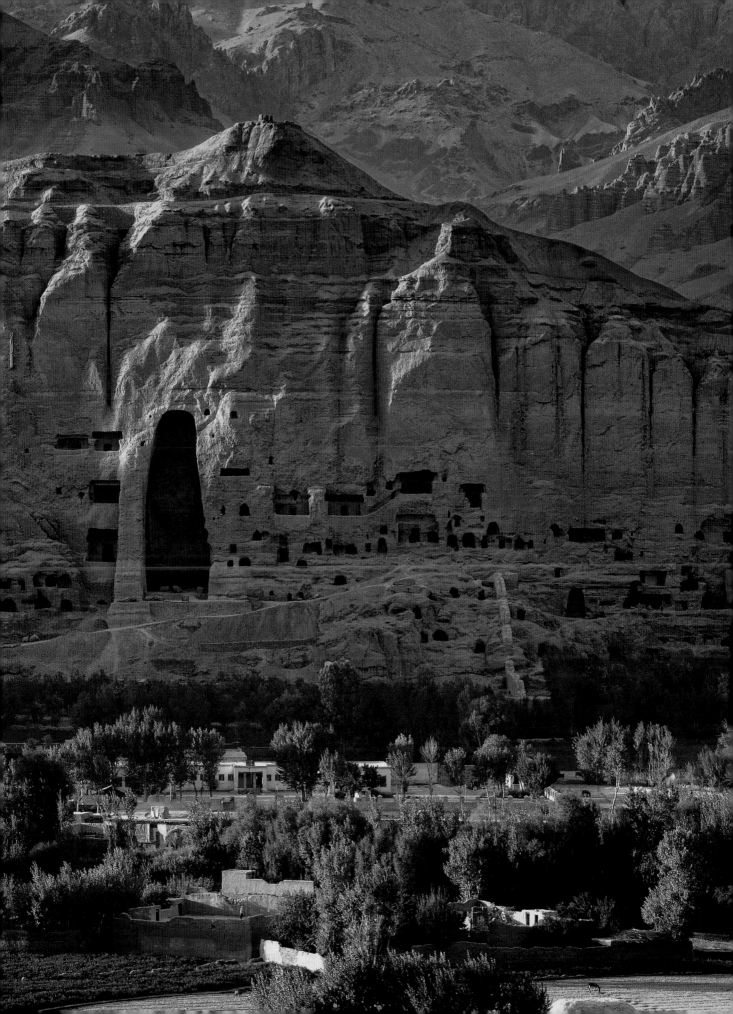

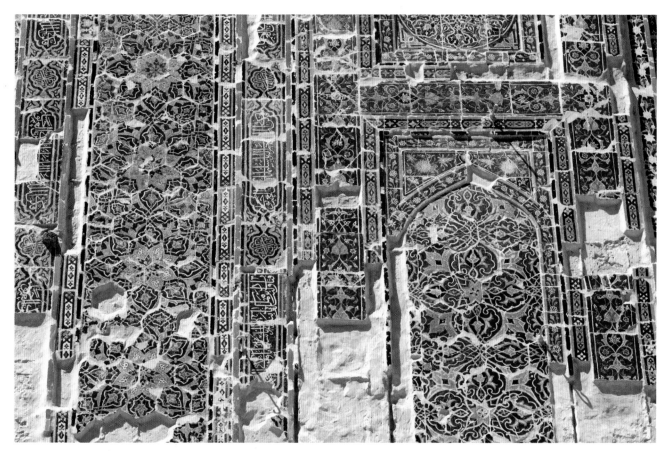

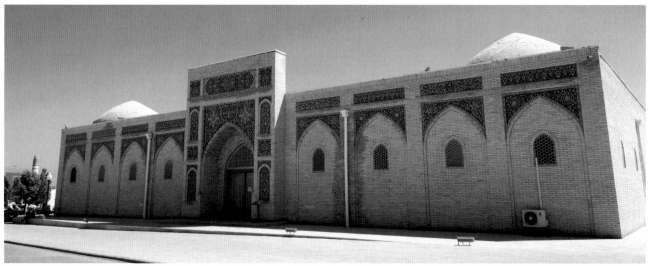

ALL PHOTOGRAPHS:
Shakhrisabz, Qashqadaryo, Uzbekistan
The birthplace of Turco-Mongol conqueror Timur in 1336, this ancient city boasts an assemblage of intricately decorated Timurid monuments, including the Ak-Saray Palace (above top and right) and Koba caravanserai (above). All the monuments are affected by rising groundwater, necessitating drainage works.

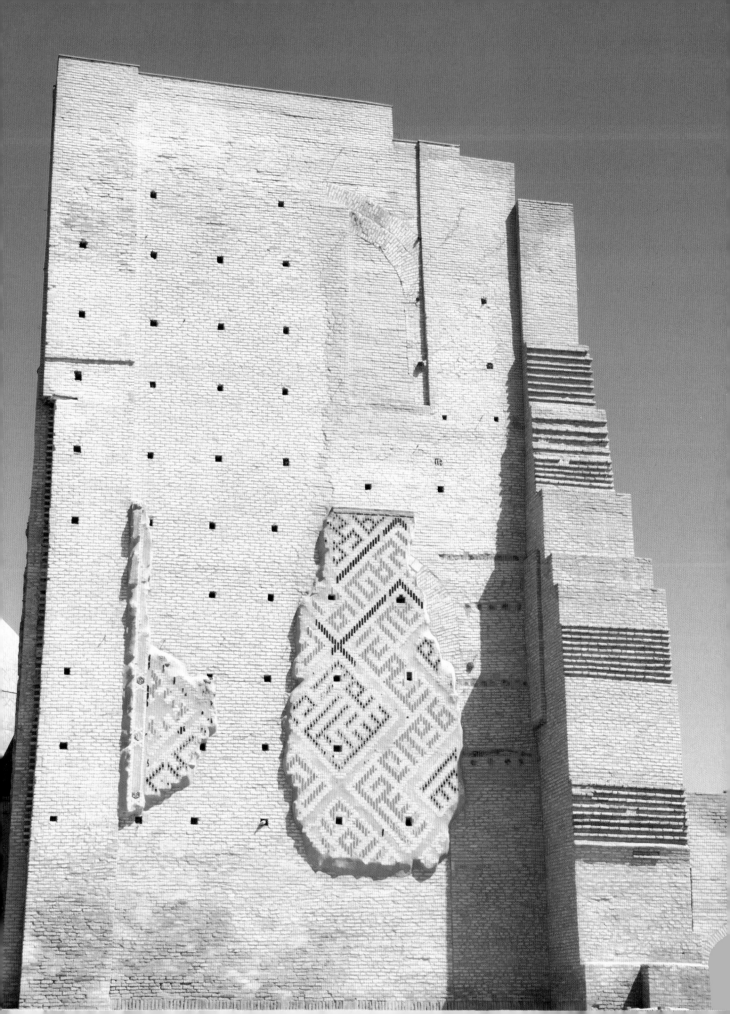

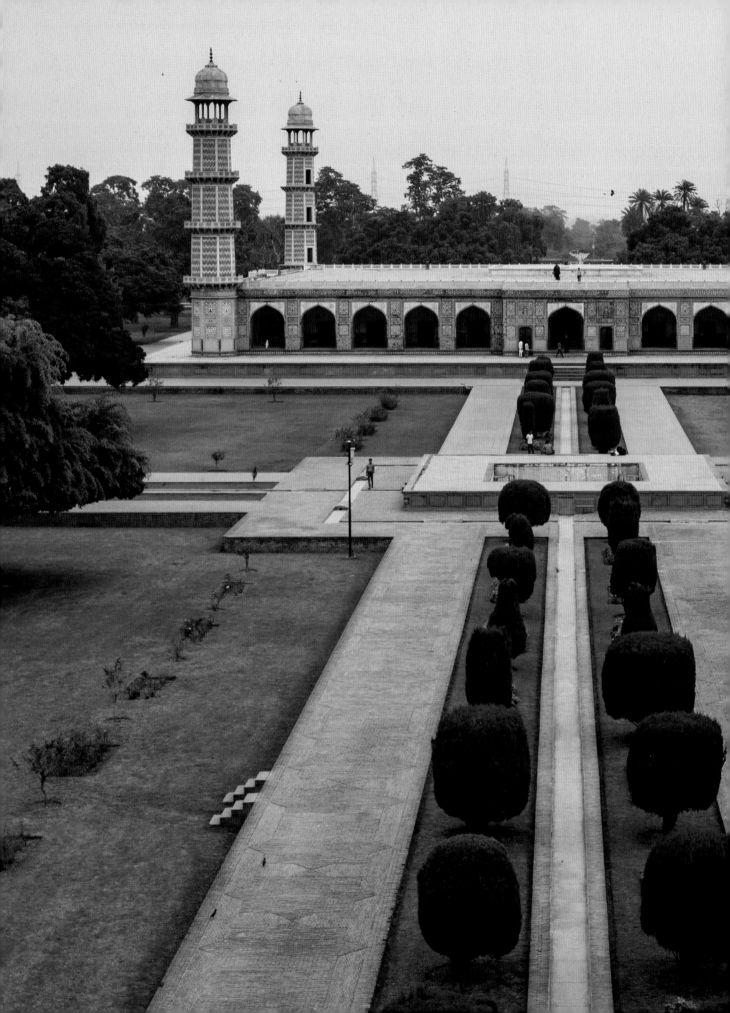

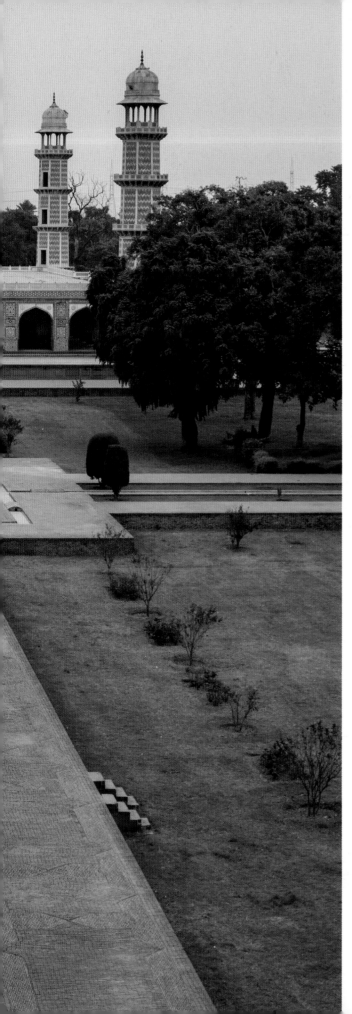

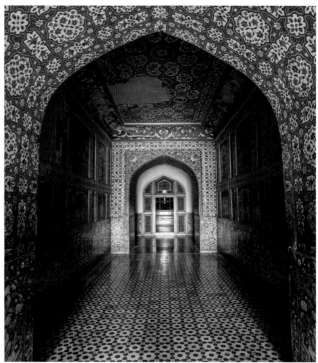

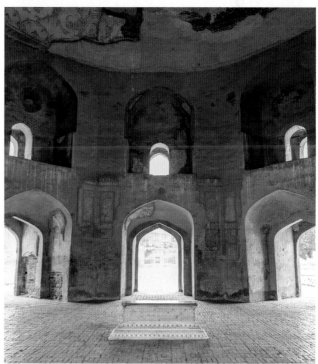

ALL PHOTOGRAPHS:
Shahdara Bagh, Lahore, Pakistan
The Shahdara Bagh quarter is the site of several 16th- and 17th-century Mughal monuments, including the Tomb of Jahangir (left and above top) and the Tomb of Asif Khan (above). Conservationists are dismayed that, despite laws prohibiting building within 60 m (200 ft) of the monuments, homes have been built close to the boundary walls.

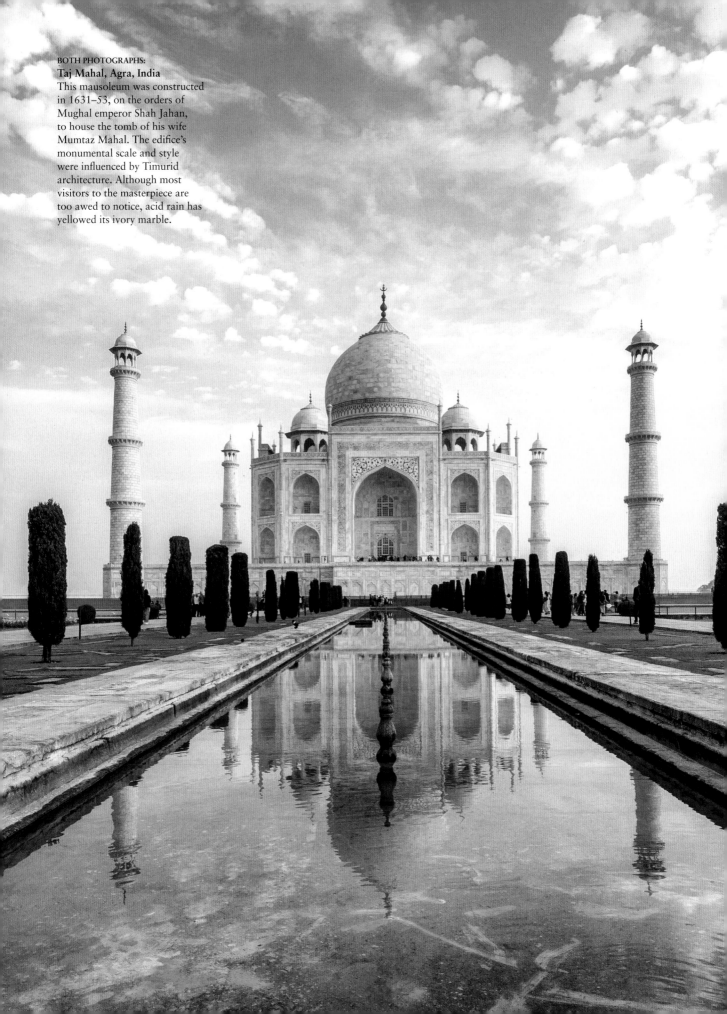

BOTH PHOTOGRAPHS:
Taj Mahal, Agra, India
This mausoleum was constructed in 1631–53, on the orders of Mughal emperor Shah Jahan, to house the tomb of his wife Mumtaz Mahal. The edifice's monumental scale and style were influenced by Timurid architecture. Although most visitors to the masterpiece are too awed to notice, acid rain has yellowed its ivory marble.

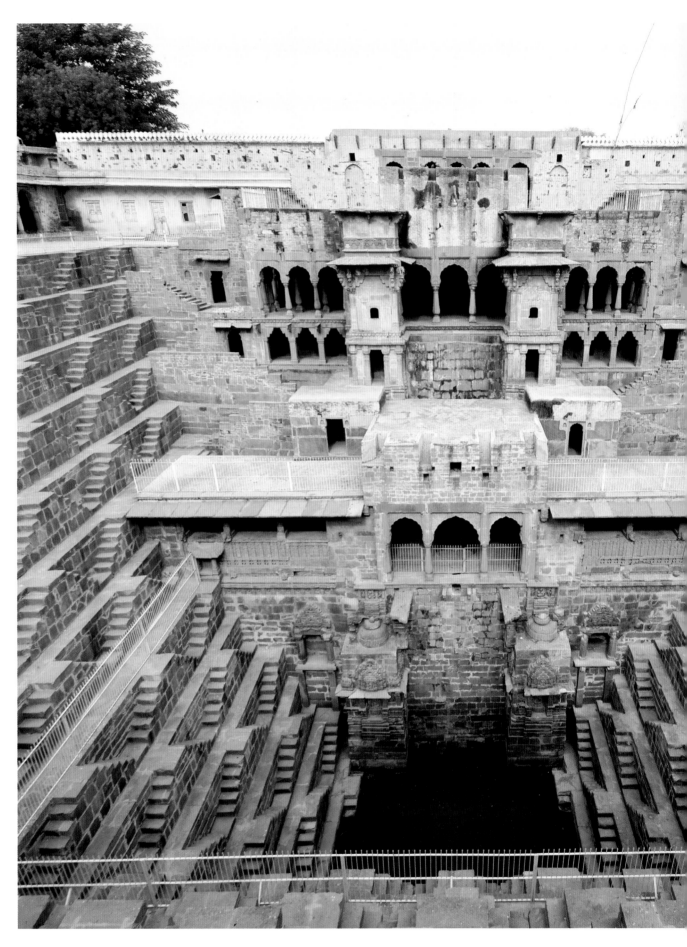

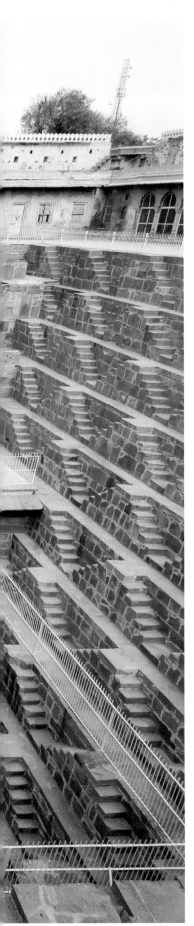

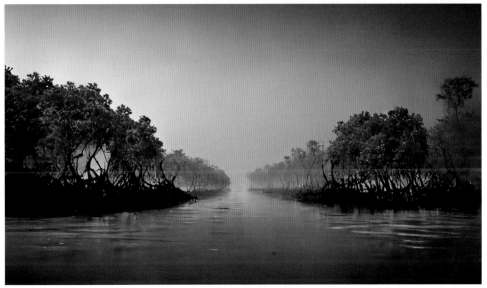

LEFT:

Chand Baori, Abhaneri, India
The oldest parts of this stepwell date from the 8th century, but the upper storeys, complete with columned arcade, were built during the Mughal era. The World Monuments Fund has added India's historic water systems to its list of endangered sites. In the face of the looming global water crisis, the upkeep of these sustainable systems has become yet more essential.

ABOVE TOP:

Western Ghats, Karnataka, India
The Western Ghats run parallel to India's west coast for 1,600 km (990 miles). The range's montane forest has exceptional biodiversity and endemism, with at least 325 threatened species. This ecosystem is at risk from deforestation and land degradation, leading to local and international partnerships seeking a new balance between development and conservation.

ABOVE BOTTOM:

Sundarbans, India–Bangladesh
The world's largest mangrove forest spans the delta of the Padma, Brahmaputra and Meghna Rivers. Despite an increase in salinity caused by rising sea levels and reduced freshwater, this liminal ecosystem is home to 450 animals species. Many of them, such as fishing cats and the amphibious fish known as mudskippers, move freely between water and land.

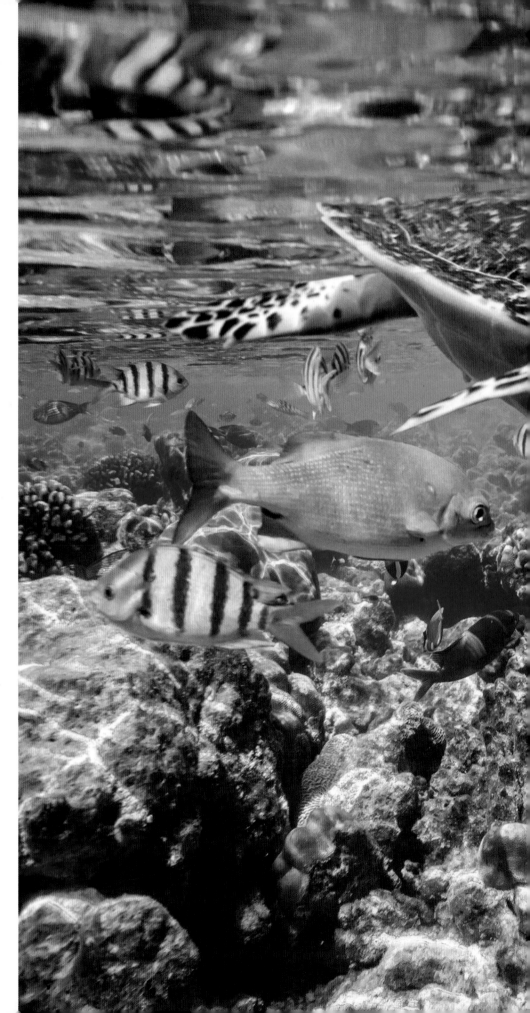

Hawksbill turtle, Maldives, Indian Ocean
The Maldives archipelago is fringed by coral reefs, boasting 187 species of hard and soft corals. The reefs have been affected by bleaching events, caused by El Niño-driven sea temperature rises. Nevertheless, these sheltered waters are visited by five species of sea turtles, 21 cetacean species and 1,100 fish species.

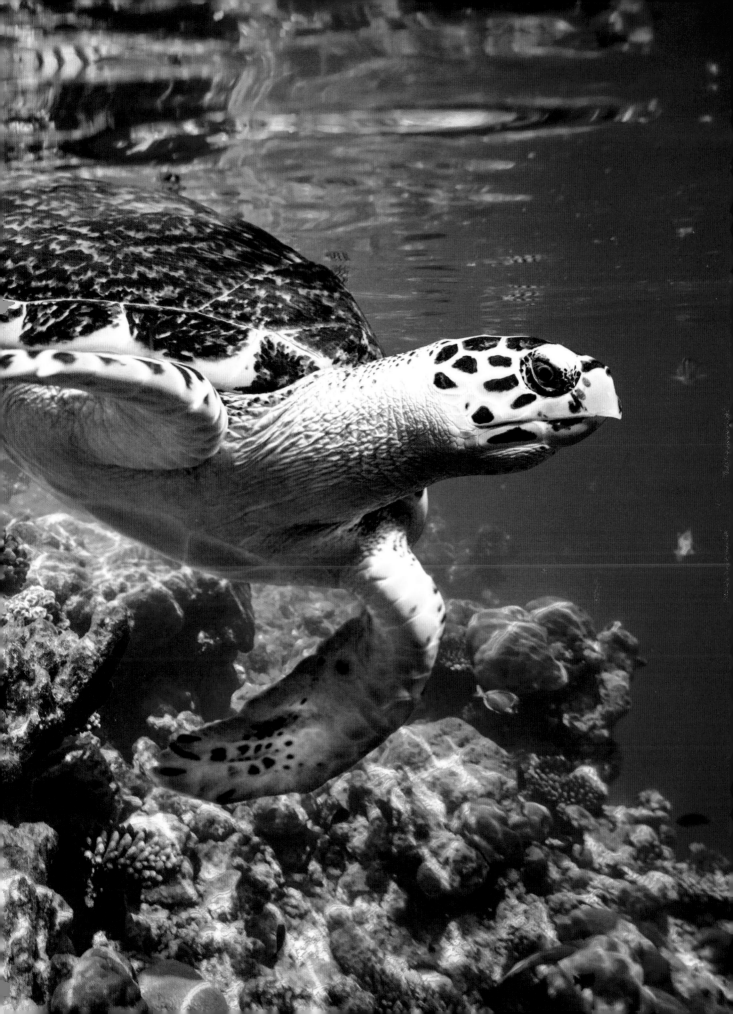

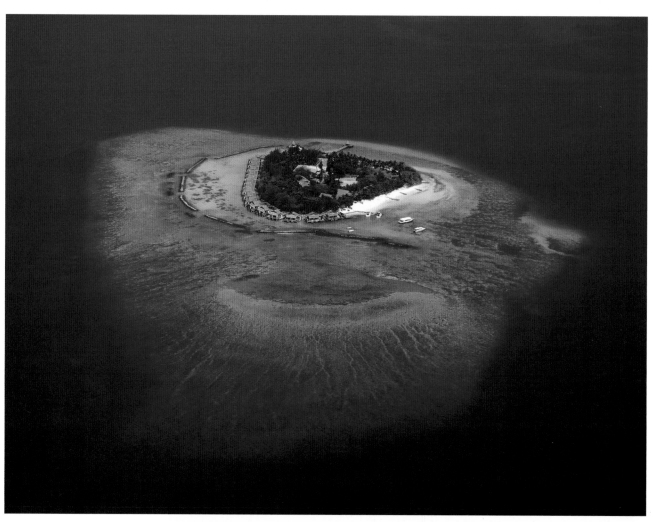

ABOVE AND RIGHT:

Maldives, Indian Ocean
According to the
Intergovernmental Panel on
Climate Change, rising sea levels
will make most of the Maldives'
200 inhabited islands unliveable
by 2100. This will result in the
displacement of around 500,000
people. To draw attention to the
plight of the Maldivians and their
heritage, the World Monuments
Fund has placed Addu Atoll's
coral-stone Koagannu mosques
and cemetery on its watch list.

OPPOSITE:

**Panam Nagar, Narayanganj,
Bangladesh**
Panam Nagar was capital of
the Sultanate of Bengal between
1390 and 1411. This part-ruined,
often-flooded old city has fine
examples of forts, mosques,
textile merchants' homes and
offices dating from the Sultanate
to the British colonial period.

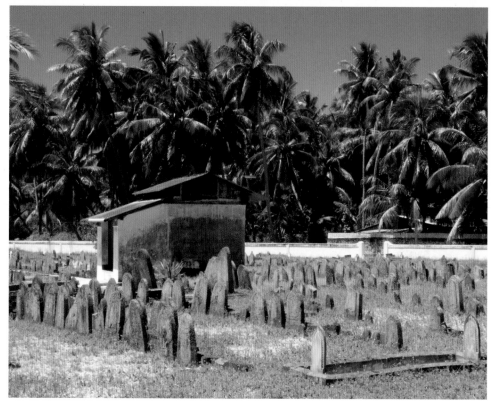

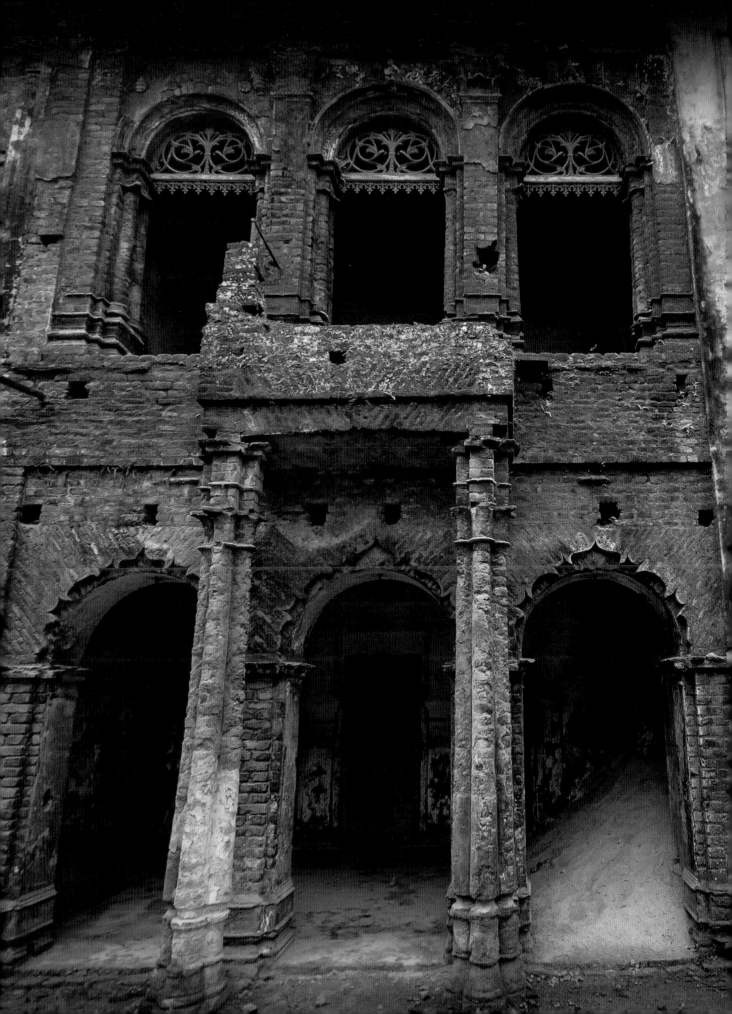

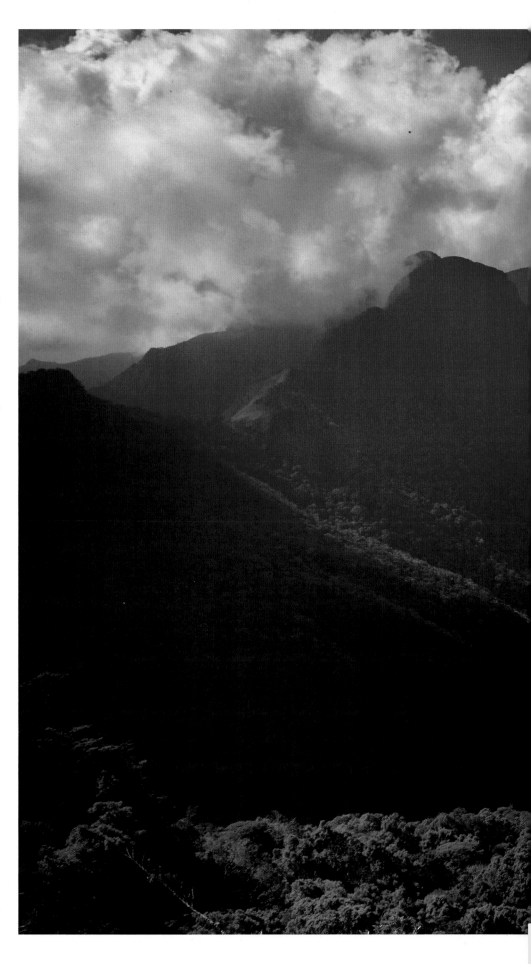

RIGHT:

Horton Plains National Park, Central Province, Sri Lanka
With an average elevation of 2,200 m (7,220 ft), this park protects montane grassland and cloud forest. The park's threatened species include Kelaart's long-clawed shrews, toque macaques and Sri Lankan leopards. This ecosystem is threatened by mysterious forest dieback, perhaps caused by increasingly frequent droughts.

OVERLEAF:

Great Wall, China
Built to keep out invaders to the north, the Great Wall extends for approximately 8,850 km (5,500 miles), including defences such as trenches, hills and rivers. Most of the wall we see today was built under the Ming dynasty (1368–1644). Portions north of Beijing and near tourist centres have been well preserved and renovated, but remoter sections are at risk from erosion, vandalism and theft of bricks.

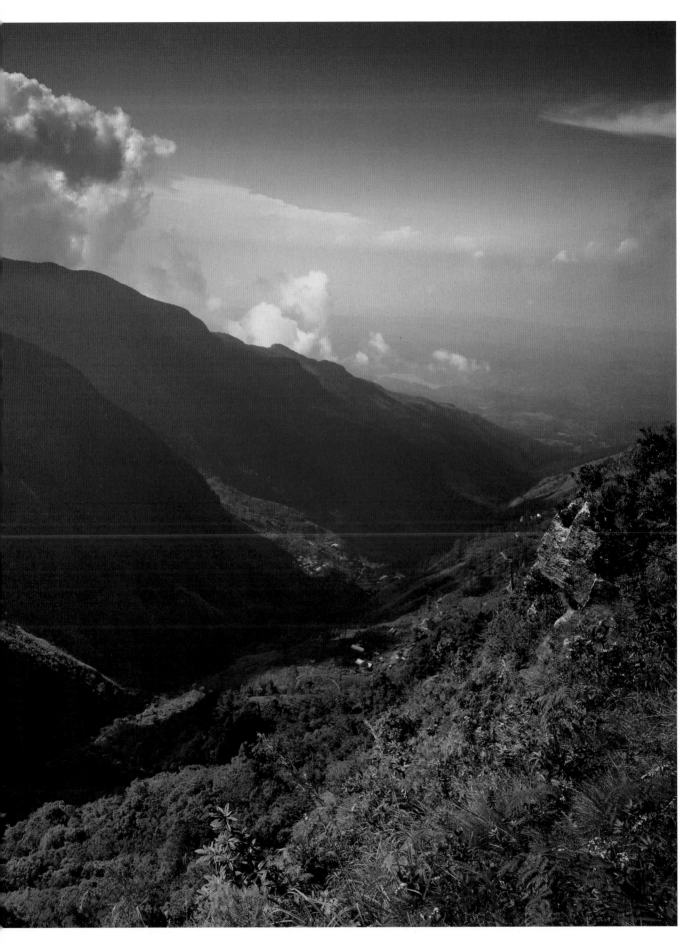

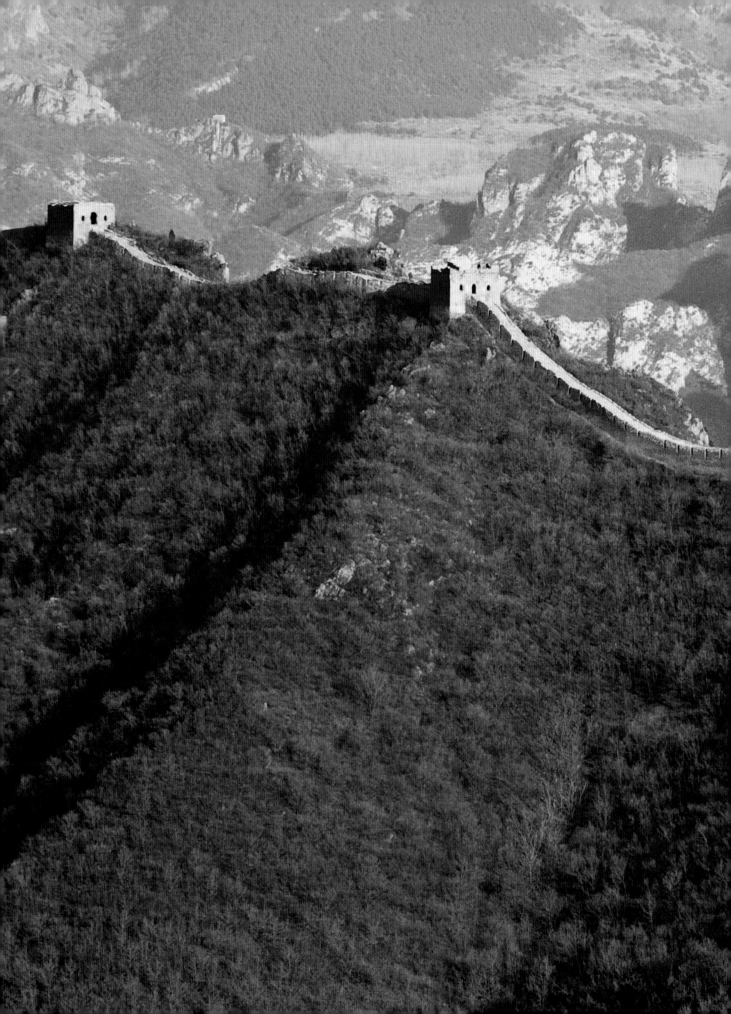

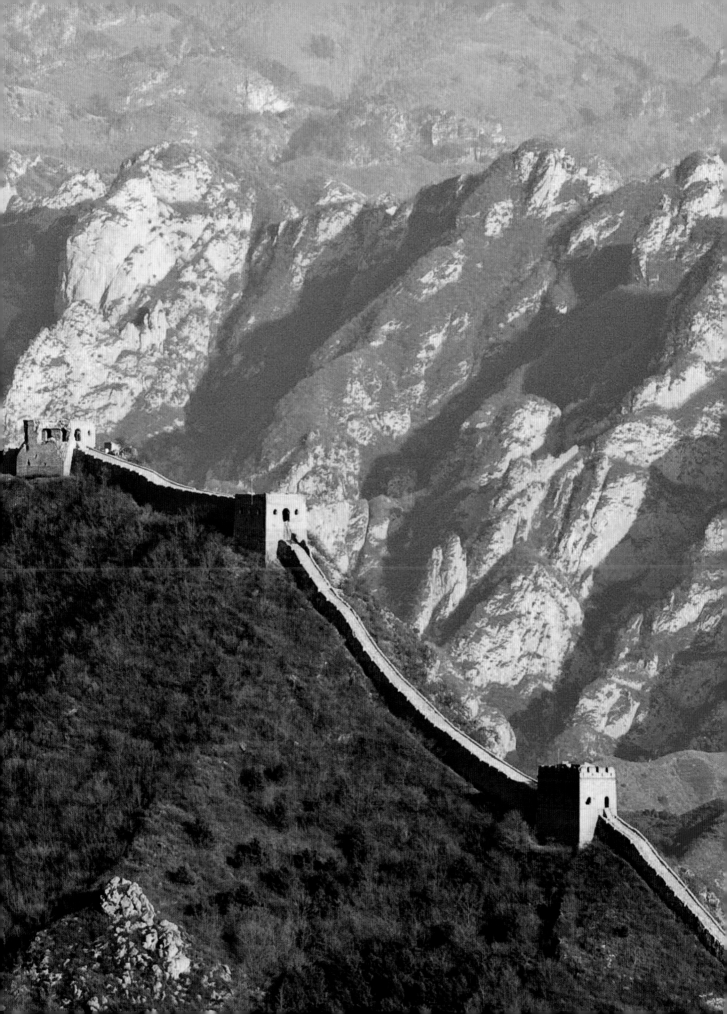

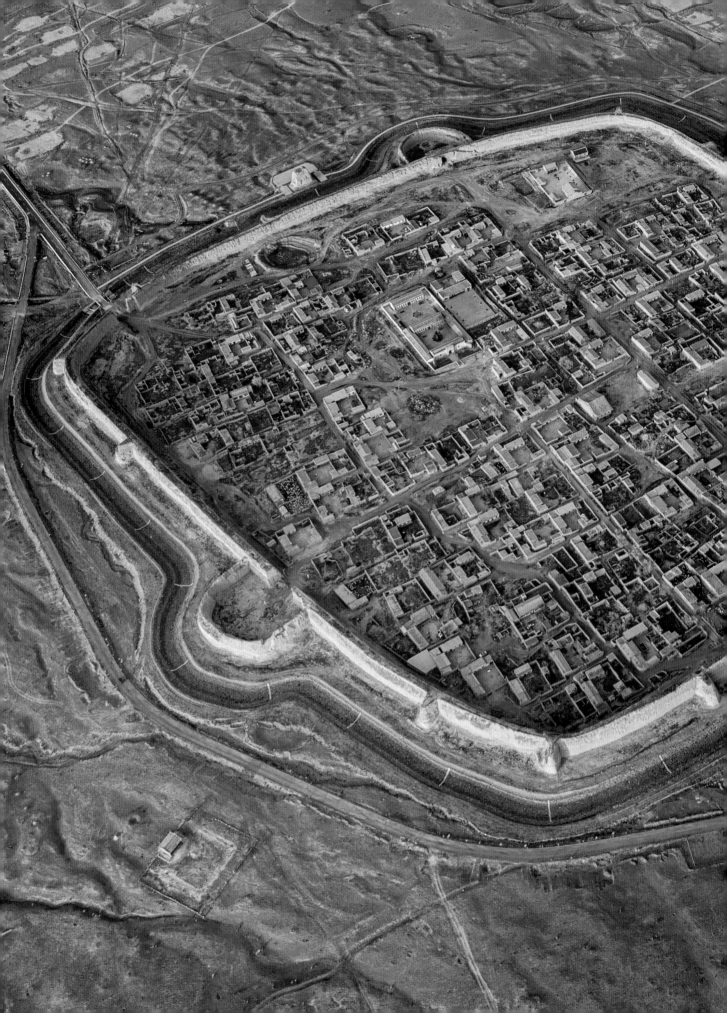

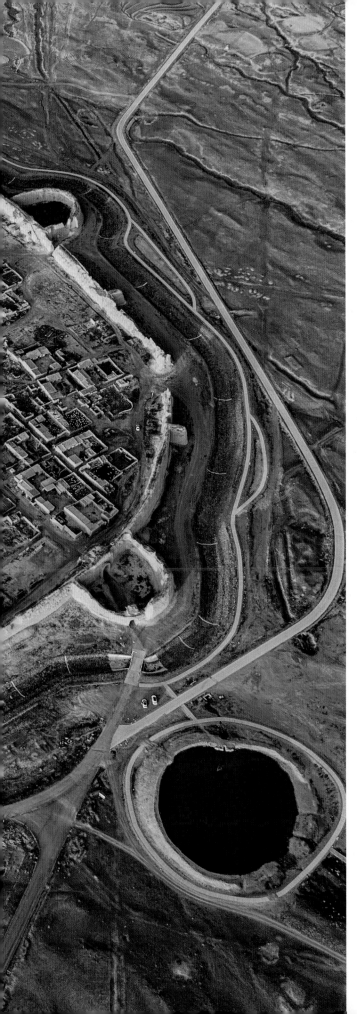

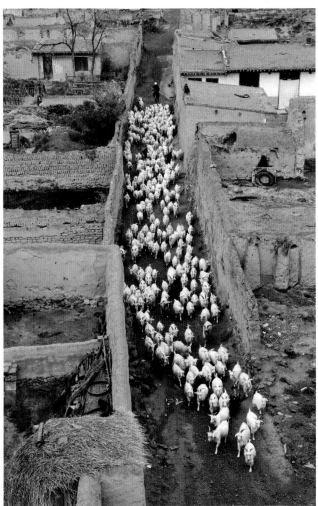

BOTH PHOTOGRAPHS:
Yongtai Fortress, Gansu, China
This turtle-shaped fortress, surrounded by double rammed-earth walls and a moat, was built as a garrison in around 1608. In the 1950s, there were 1,500 residents, but local desertification has led most people of working age to depart. Around 100 remaining residents are sustaining the crumbling earth walls.

Zhuangzhai, Fujian, China
In the forested mountain region of Yongtai, fortified manor houses, known as zhuangzhai, were built between the 12th and 20th centuries. These protected whole clans behind rammed-earth walls that are up to 1.8 m (6 ft) thick and topped with defensive towers. Social change has led many zhuangzhai to be abandoned. The remaining 150 zhuangzhai have attracted the attention of conservationists.

**Choijin Lama Temple,
Ulaanbaatar, Mongolia**
One of Mongolia's few surviving
historic Buddhist buildings, this
temple complex was completed
in 1908. Buddhism was
suppressed in Mongolia for much
of the 20th century, making the
temple's museum of religious
artefacts, including *cham* dance
masks, invaluable. Restoration of
the temples is under way.

OPPOSITE:
**Kaathe Swayambhu Shree Gha
Chaitya, Kathmandu, Nepal**
In Nepal, *chaityas* such as Kaathe
Swyambhu (pictured back left)
take the form of a shrine-like
monument with a stupa-shaped
structure on a plinth, often
adorned with carvings. Increasing
urbanization has led to many
chaityas being encroached on or
even destroyed.

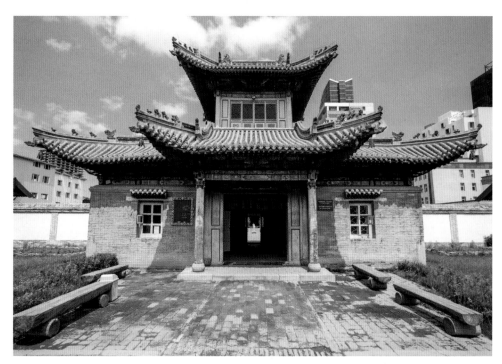

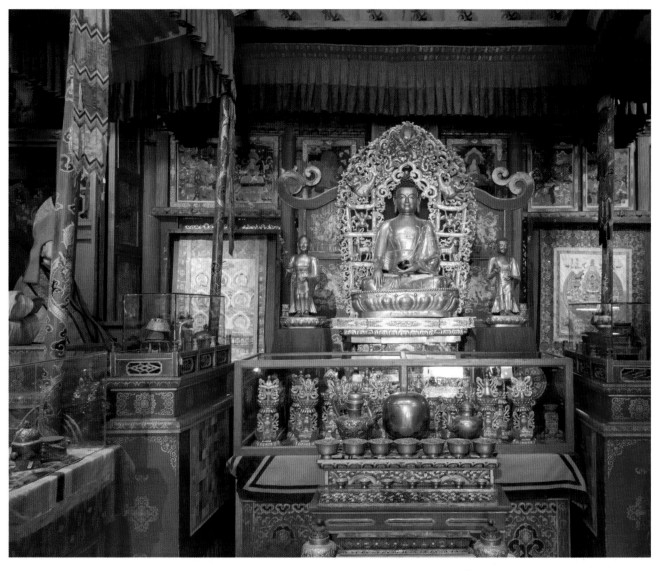

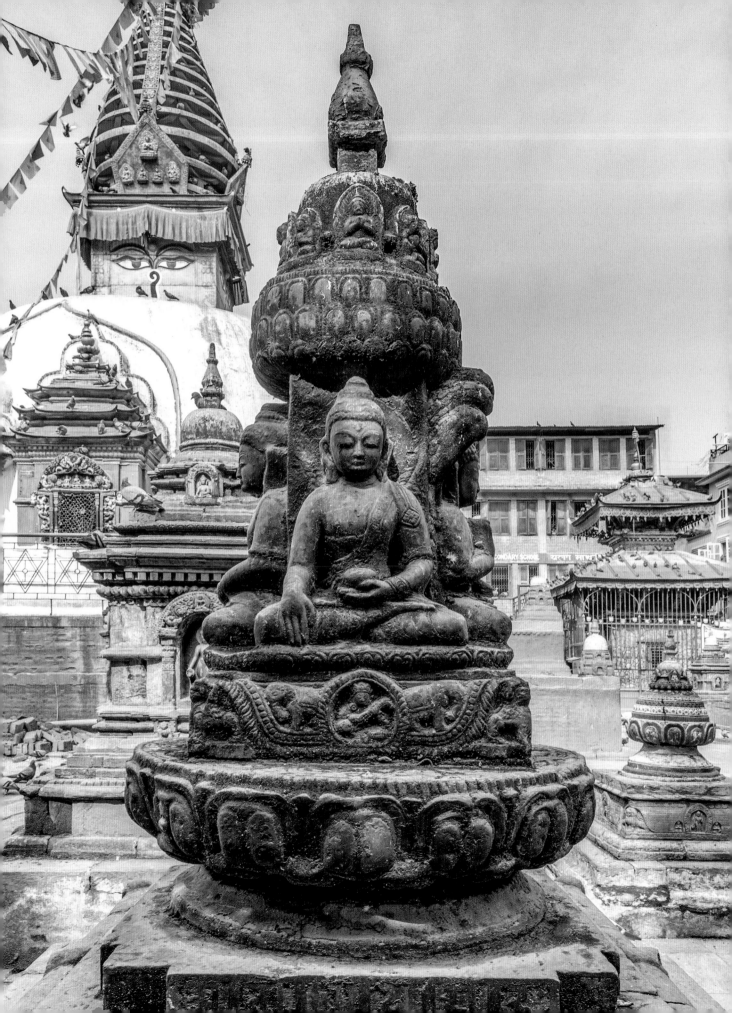

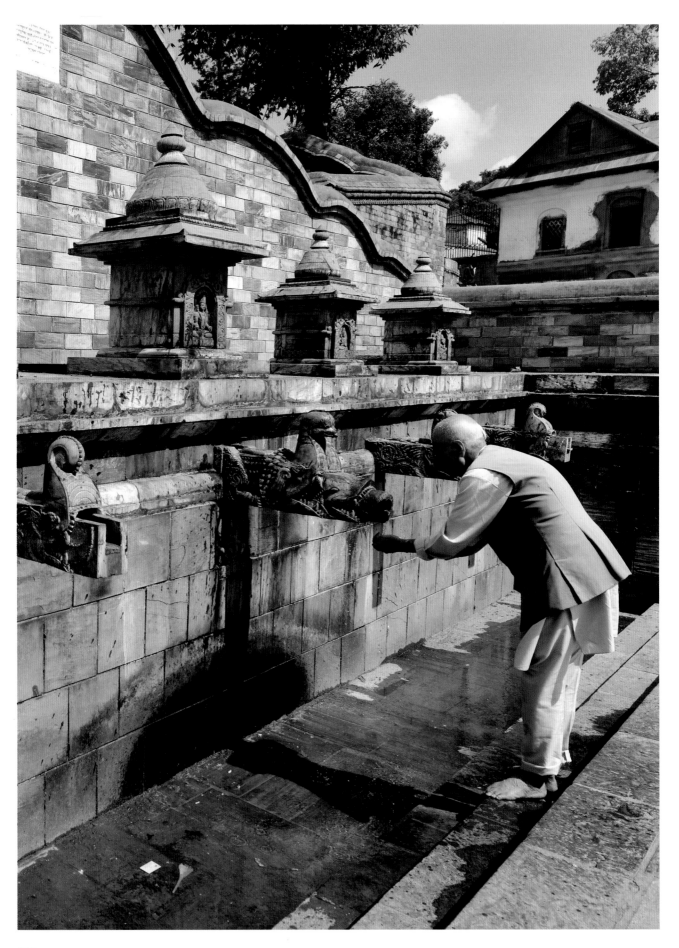

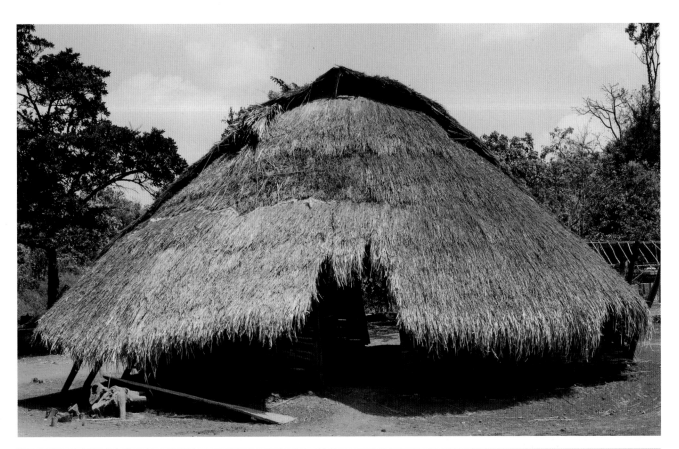

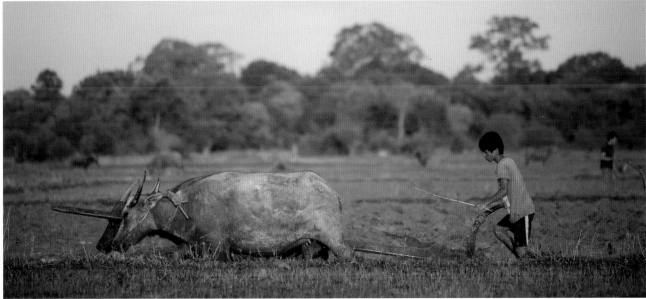

OPPOSITE:

Hitis, Kathmandu, Nepal

In Kathmandu, 20 per cent of homes do not have running water, relying instead on *hitis*, which are public water fountains connected to aquifers. The spouts, often hundreds of years old, take the form of powerful animals such as elephants and crocodiles. A dwindling water table has left only a fraction of *hitis* in working order.

ABOVE TOP AND BOTTOM:

Bunong Village, Mondulkiri, Cambodia

In the Cambodian highlands, the Bunong people have maintained their styles of building, agriculture and forest management for generations. Their cultural landscape is at risk from development, mining and social change. The Bunong are increasingly advocating for their rights and cultural heritage.

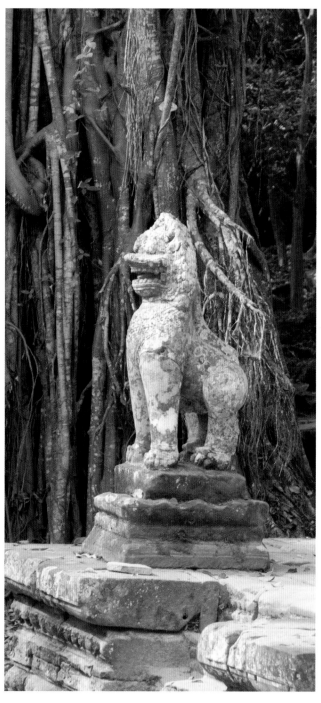

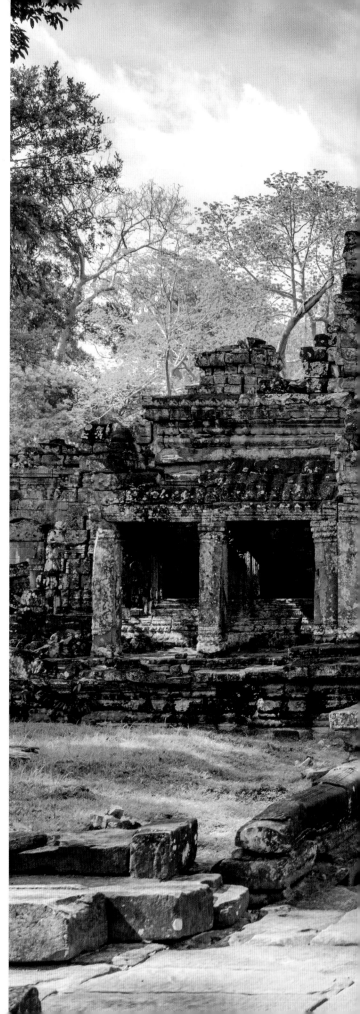

BOTH PHOTOGRAPHS:
Preah Khan, Siem Reap, Cambodia
This temple, originally Buddhist but later converted to Hinduism, was built on the site of Khmer king Jayavarman VII's victory over the invading Chams in 1191. Maintenance of the ruins is a continuous battle with jungle vegetation and stone-degrading cyanobacteria – balanced with the risks of falsifying history through guesswork.

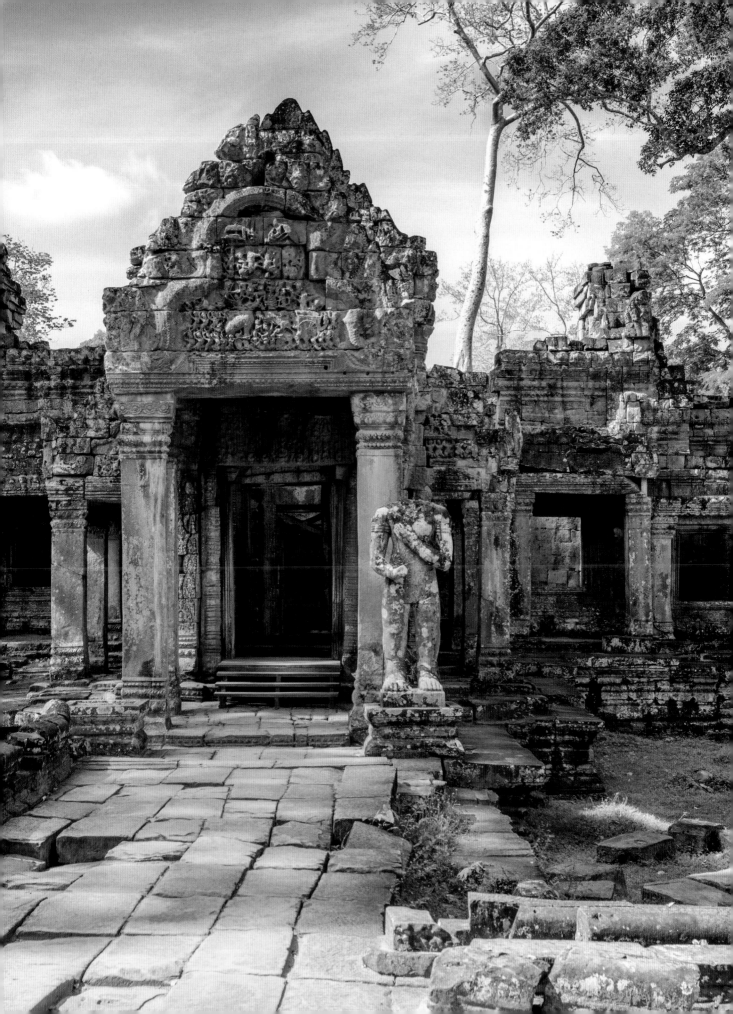

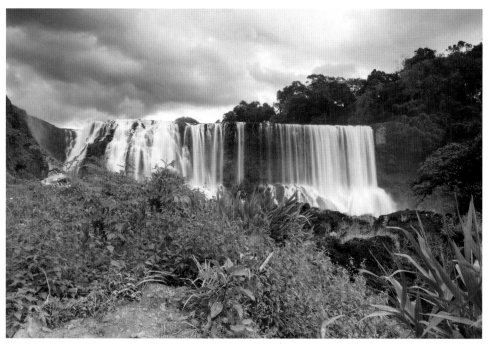

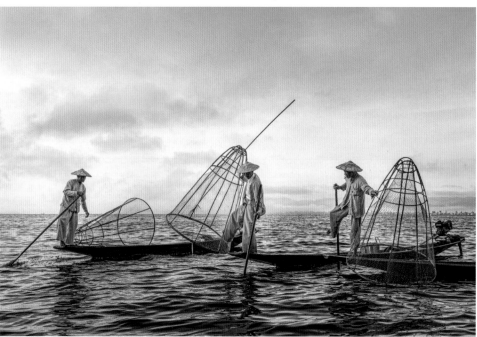

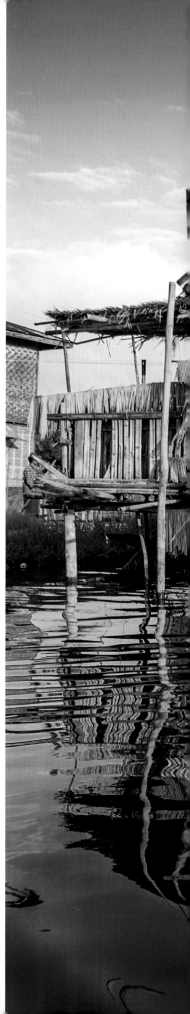

ABOVE TOP:
**Sea Pong Lai Waterfall,
Bolaven Plateau, Laos**
The beautiful Bolaven Plateau is
where the needs of local Laven,
Alak and Suay peoples butt up
against those of coffee planters,
tourists and hydroelectricity
engineers. The plateau is home to
a number of endangered species,
such as the yellow-cheeked
gibbon, Siamese crocodile and
green peafowl.

ABOVE BOTTOM AND RIGHT:
Inle Lake, Myanmar
Traditional fishermen on Inle
Lake control their oar with one
leg and hand, leaving the other
hand and leg free to place a
conical net on the water. Yet the
lake's ecosystem is threatened
by pollution, siltation and
introduced species, leaving many
of its endemic fish endangered,
including the Inle carp, Sawbwa
barb and Lake Inle danio.

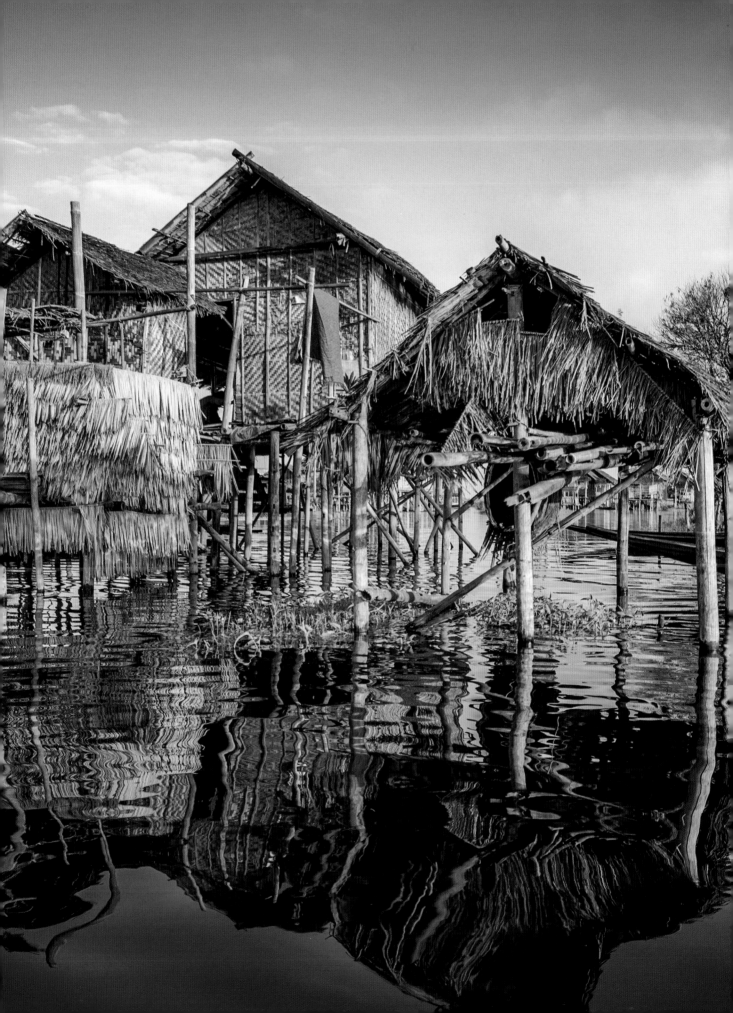

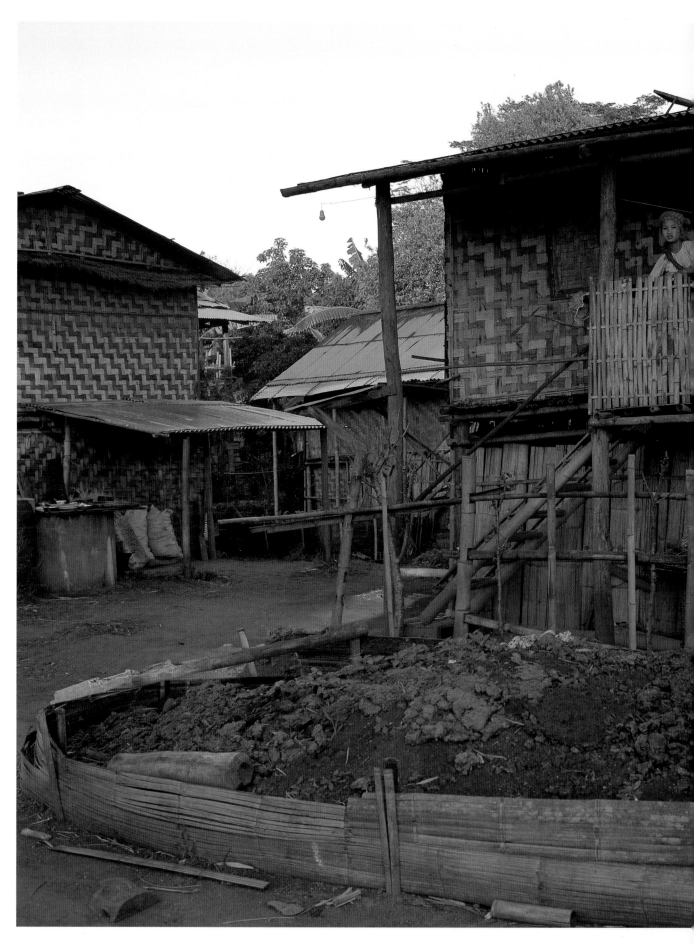

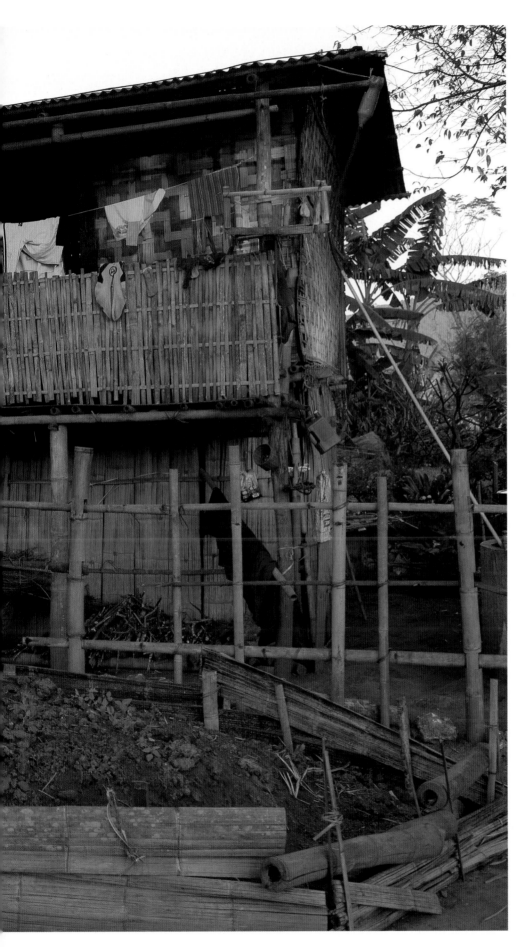

Farmhouse, Myanmar
In Myanmar, traditional
farmhouse building techniques
are at risk of disappearing. A
desire for greater comfort is
replacing materials such as teak
and bamboo – now commanding
high prices on the international
market – with concrete.
Traditional homes are elevated
above the ground, with space
beneath for livestock and tools.

OVERLEAF:
**Huai Mae Khamin Waterfall,
Khuean Srinagarindra National
Park, Thailand**
This seven-tiered waterfall used
to flow year round, but changing
rainfall patterns have caused the
water level to fall so low during
the dry season that it slows to a
trickle. The mountain forests of
the surrounding park are roamed
by leopard cats and civets.

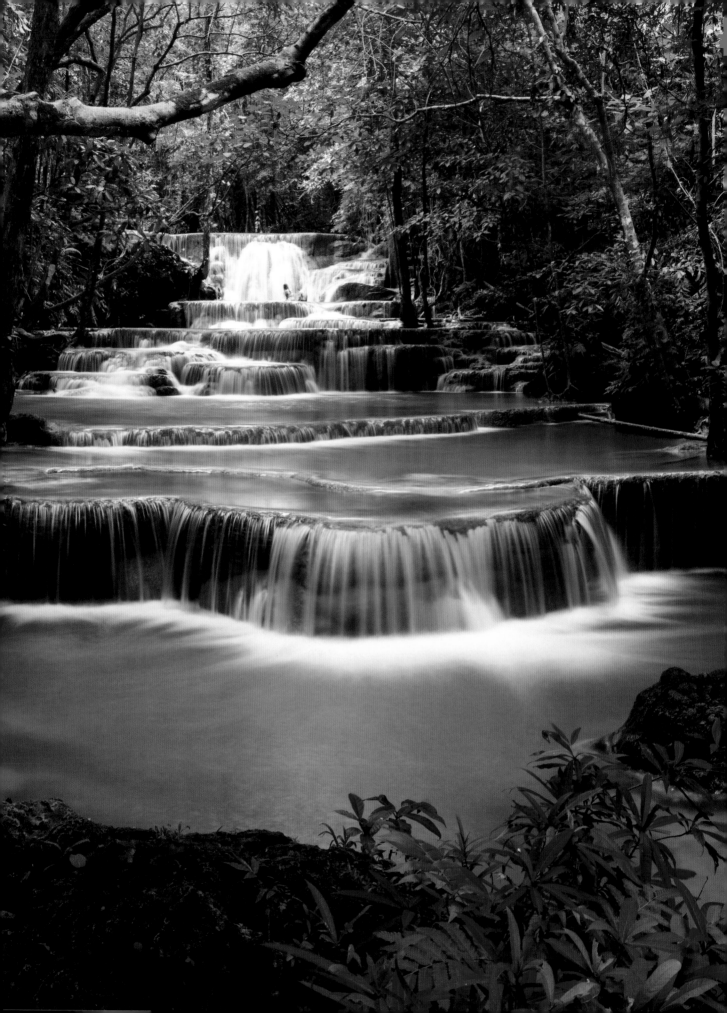

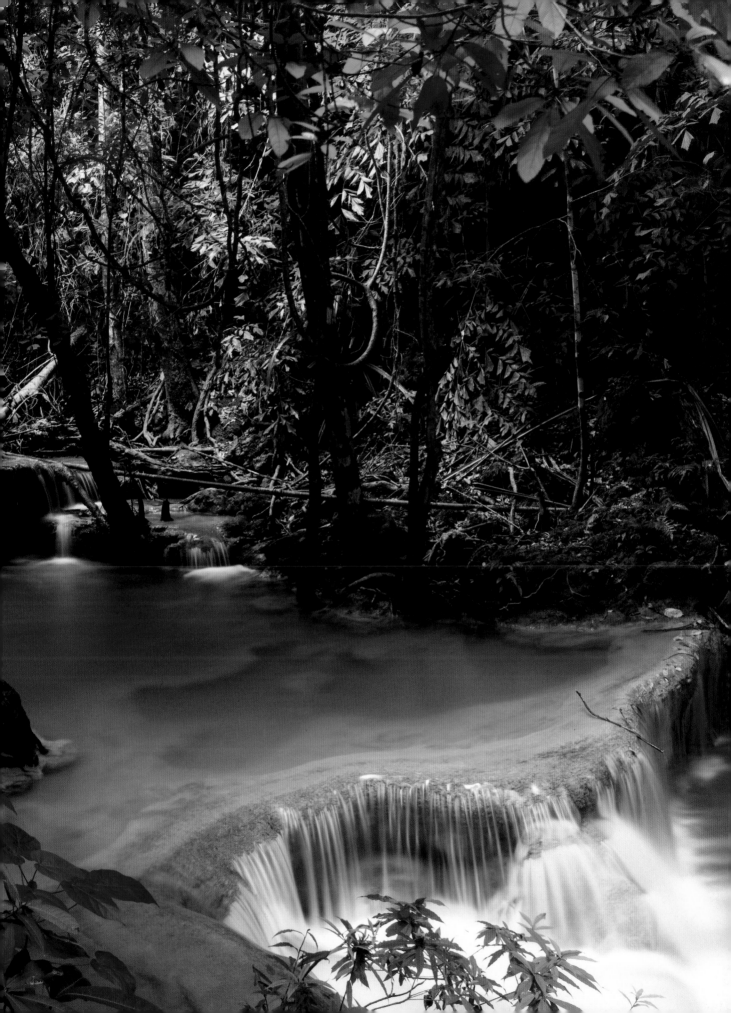

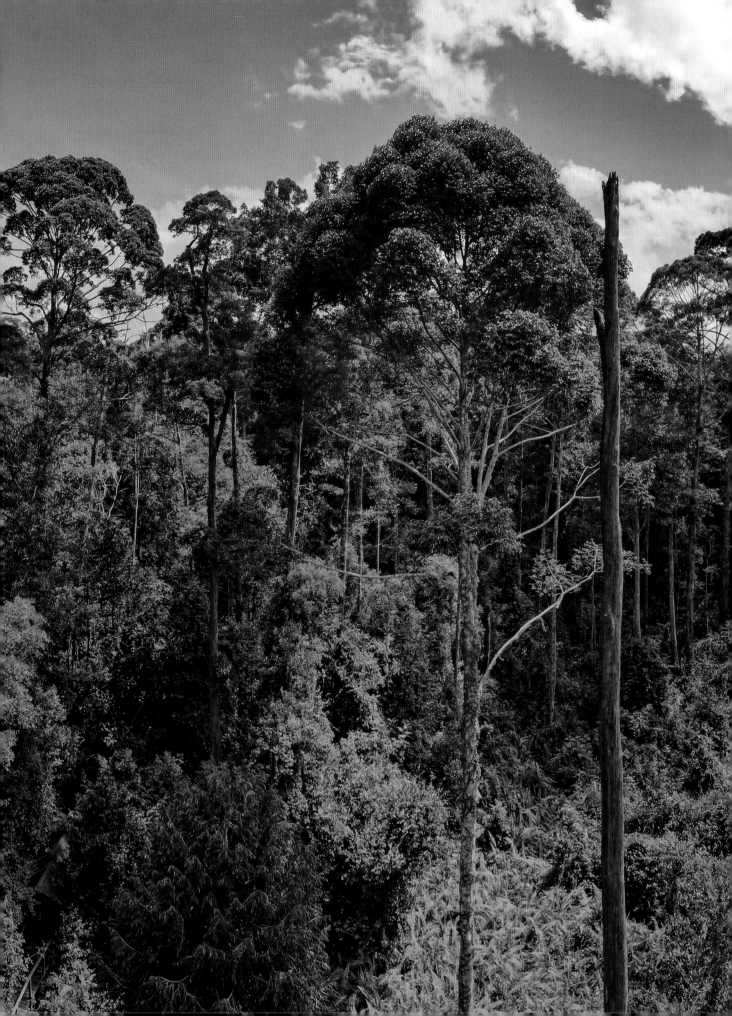

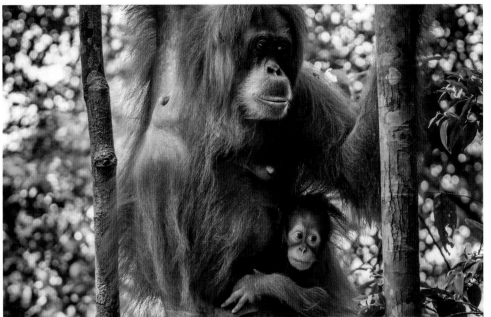

**Rainforest of Borneo,
Indonesia–Malaysia–Brunei**
Although the rate of loss has
slowed since the late 20th
century, Borneo's rainforest is
still shrinking due to logging
for timber, clearance for oil
palm and rubber plantations,
and conversion to agriculture.
In addition, fires started for
land clearance have spread out
of control. Around half of the
island's original forest remains.

**Sumatran Orangutan, Sumatra,
Indonesia**
The critically endangered
Sumatran orangutan is found
only in the shrinking and
fragmented rainforest at the
northernmost tip of Sumatra.
The Sumatran is more arboreal
than the Bornean orangutan,
possibly due to the presence of
the Sumatran tiger. Its diet is
mainly fruit and insects.

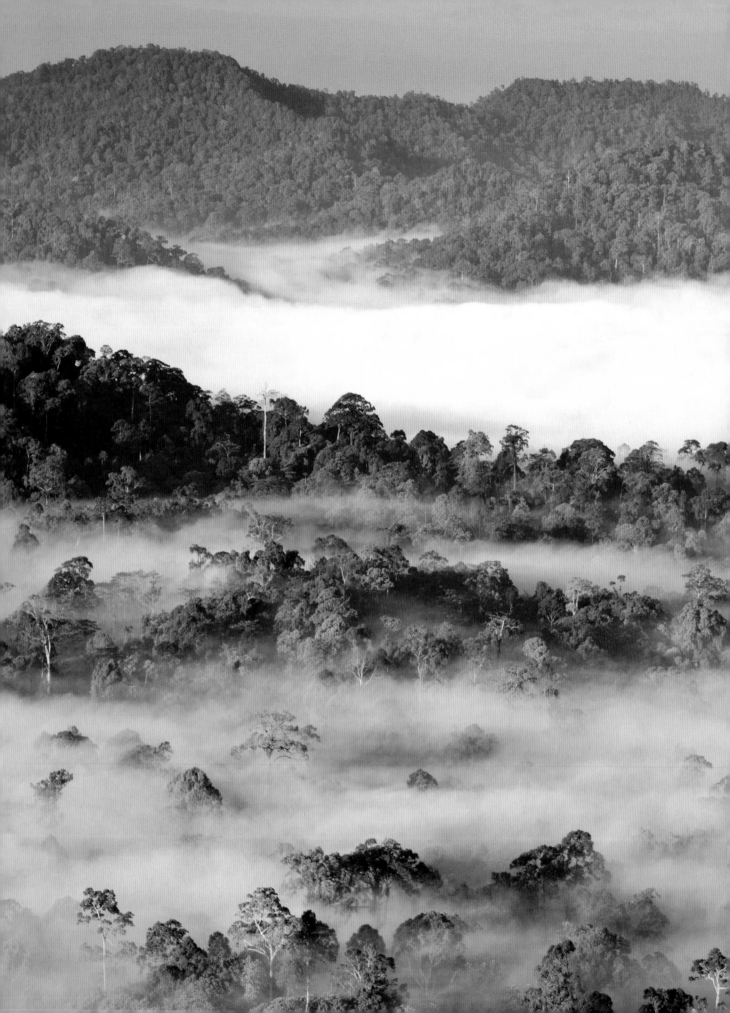

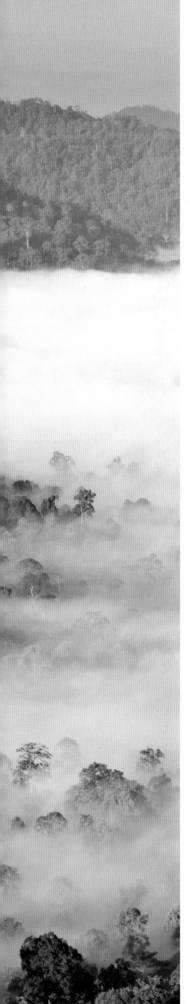

LEFT:

Danum Valley, Sabah, Borneo, Malaysia
The Danum Valley hosts a lowland dipterocarp forest, where more than 90 per cent of plants are in the *Dipterocarpus* genus of tropical trees. The valley is home to the tallest known flowering trees, yellow meranti, which grow to more than 98 m (322 ft) high.

ABOVE TOP AND BOTTOM:

Mt Kinabalu, Sabah, Borneo, Malaysia
The highest mountain in Malaysia, Kinabalu is 4,095 m (13,435 ft) tall. The mountain has exceptional biodiversity, with more than 5,000 species of animals and plants, including the Borneo anglehead lizard (top) and several species of endemic begonias (above).

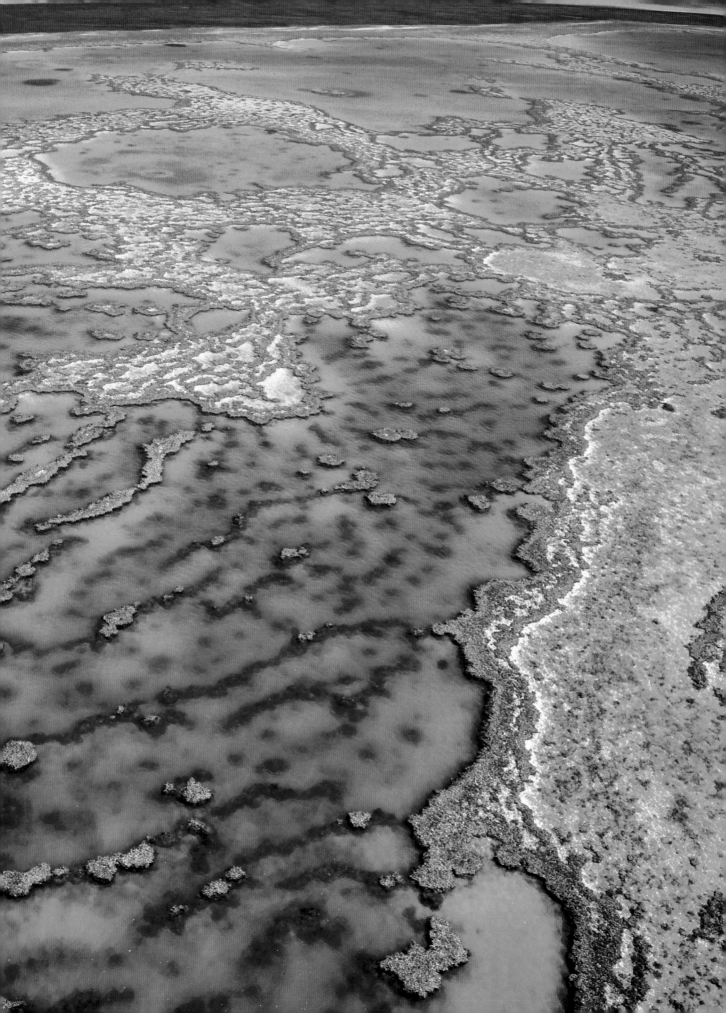

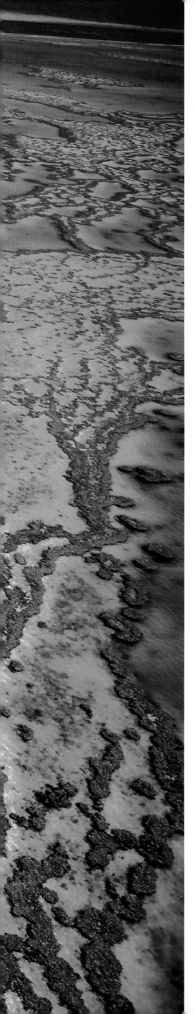

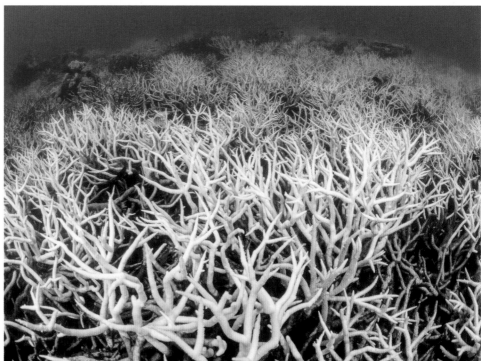

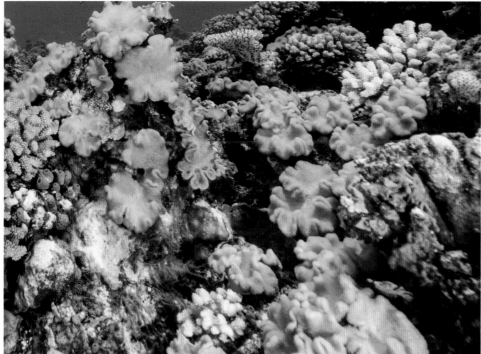

ALL PHOTOGRAPHS:
Great Barrier Reef, Queensland, Australia
The world's largest coral reef system is home to 400 species of hard and soft coral, as well as 500 species of algae. Ocean warming is causing coral bleaching events (above top), when the coral polyps become distressed and expel their symbiotic zooxanthellae, causing them to lose their colour.

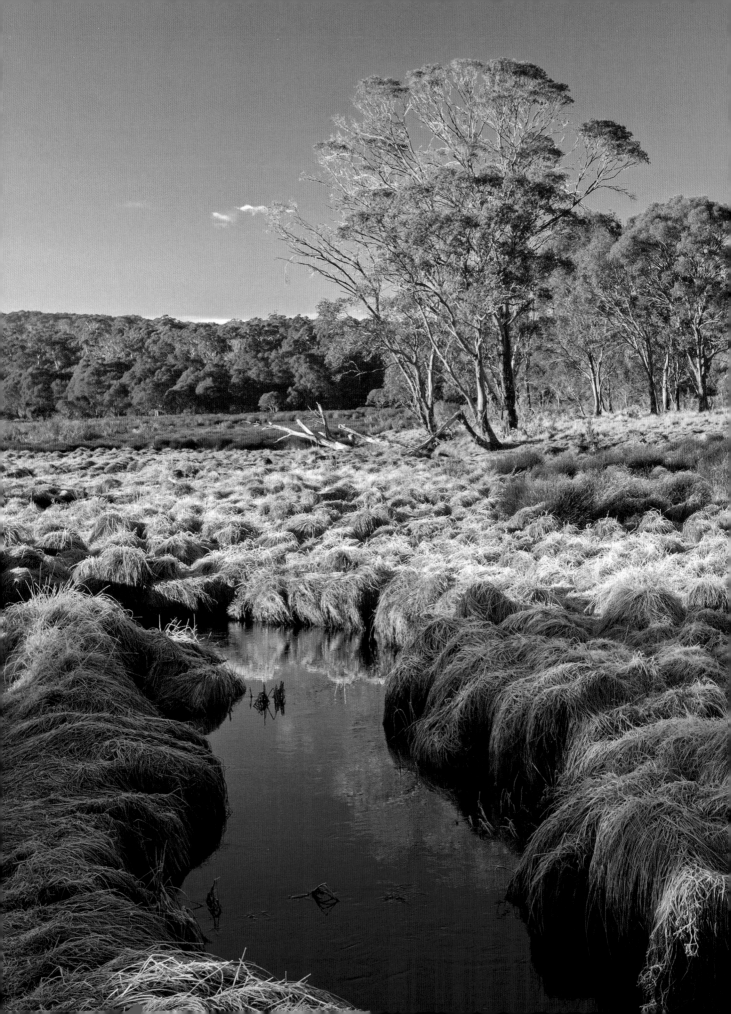

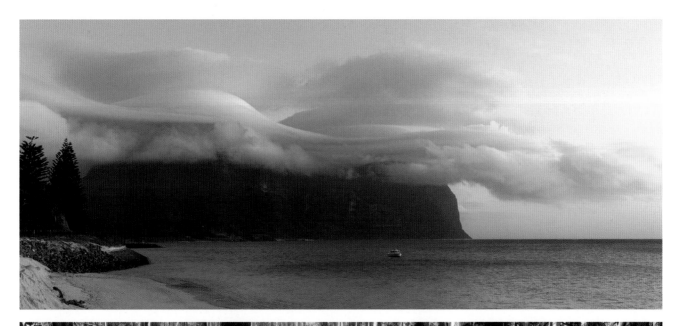

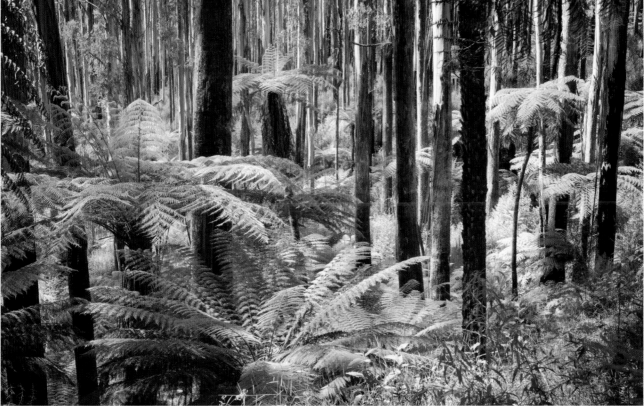

OPPOSITE:
Barrington Tops National Park,
New South Wales, Australia
On the Barrington Tops plateau
is the Polblue Swamp, where
dense sedges shelter threatened
species such as the broad-toothed
rat. The swamp is surrounded by
snow gum woodland. Climate
change is putting these habitats
at increased risk from wildfires.

ABOVE TOP:
Lord Howe Island,
New South Wales, Australia
Cloaked by subtropical
forest, this island is home to
five entire genera of endemic
plants. Decimated by invasive
species, the remaining endemic
animals include the critically
endangered Lord Howe Island
stick insect and four species of
birds. Conservationists wage a
painstaking battle to protect and
re-establish native species.

ABOVE BOTTOM:
Yarra Ranges National Park,
Victoria, Australia
This temperate rainforest is
crowded with towering mountain
ashes and lush ferns, including
the rare gully tree fern. Yet,
without the help of hard-working
rangers and local residents,
these native plants risk losing in
the competition with invasive
weeds that have spread from
neighbouring gardens, such as
ragwort and hawthorn.

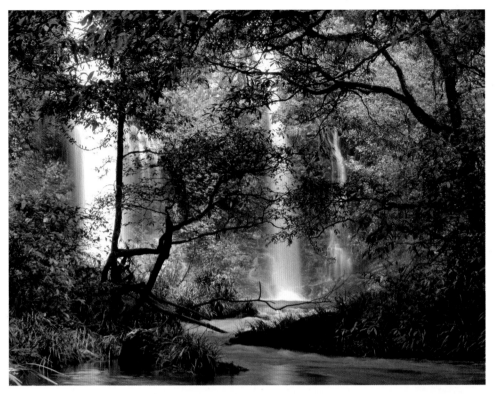

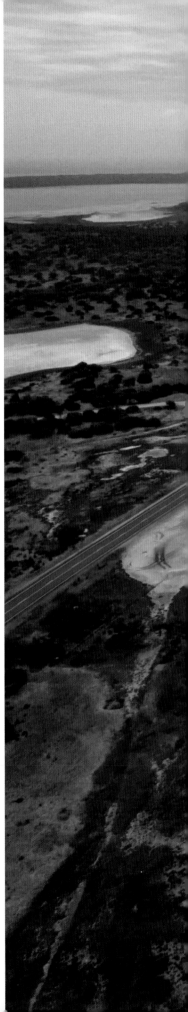

Cassowary Falls, Daintree, Queensland, Australia
Cassowary Falls lies in Daintree Rainforest, Australia's largest tropical rainforest and home to the southern cassowary. The rainforest has suffered from fragmentation and clearance, but today, much of it is a protected area, while organizations such as Rainforest Rescue have purchased privately owned land.

Stirling Range National Park, Western Australia
This park protects habitats from mallee heath to wetland, with 87 endemic plant species including several species of *Sphenotoma* (pictured). In 2020, a wildfire, caused by lightning striking dried-out vegetation, devastated 400 sq km (155 sq miles).

Coorong National Park, South Australia
This national park encompasses coastal lagoons that are critically endangered due to the loss of freshwater inflows and local extinction of aquatic plants. The Ngarrindjeri traditional owners are sharing their landcare practices with the Department for Environment and Water in a shared effort to rescue the site.

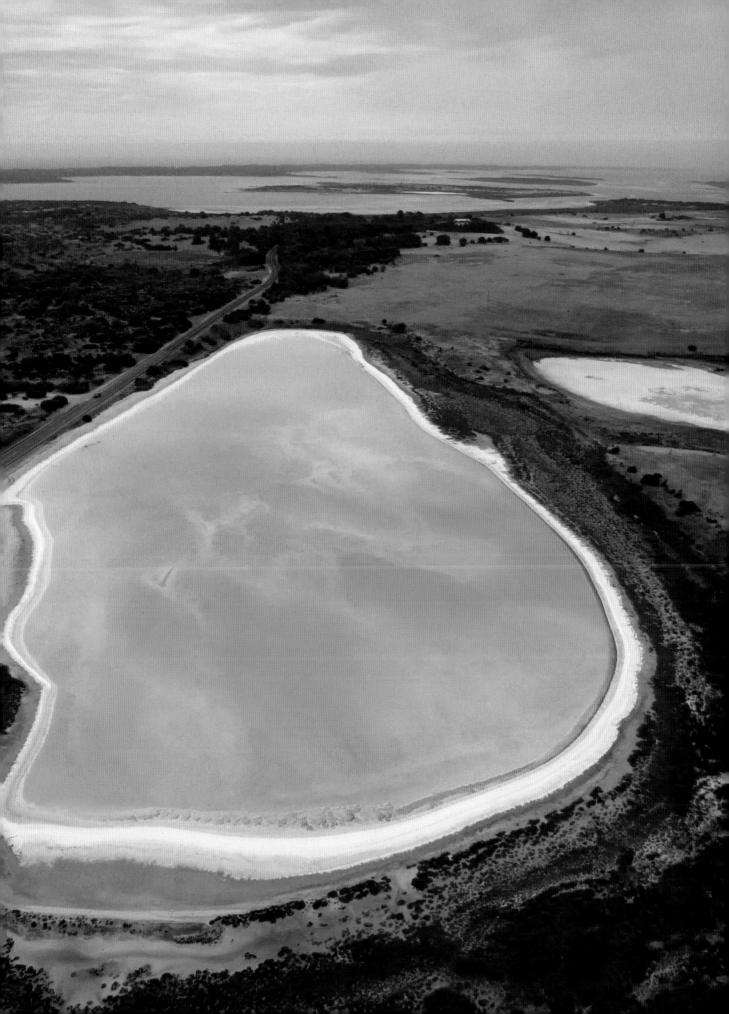

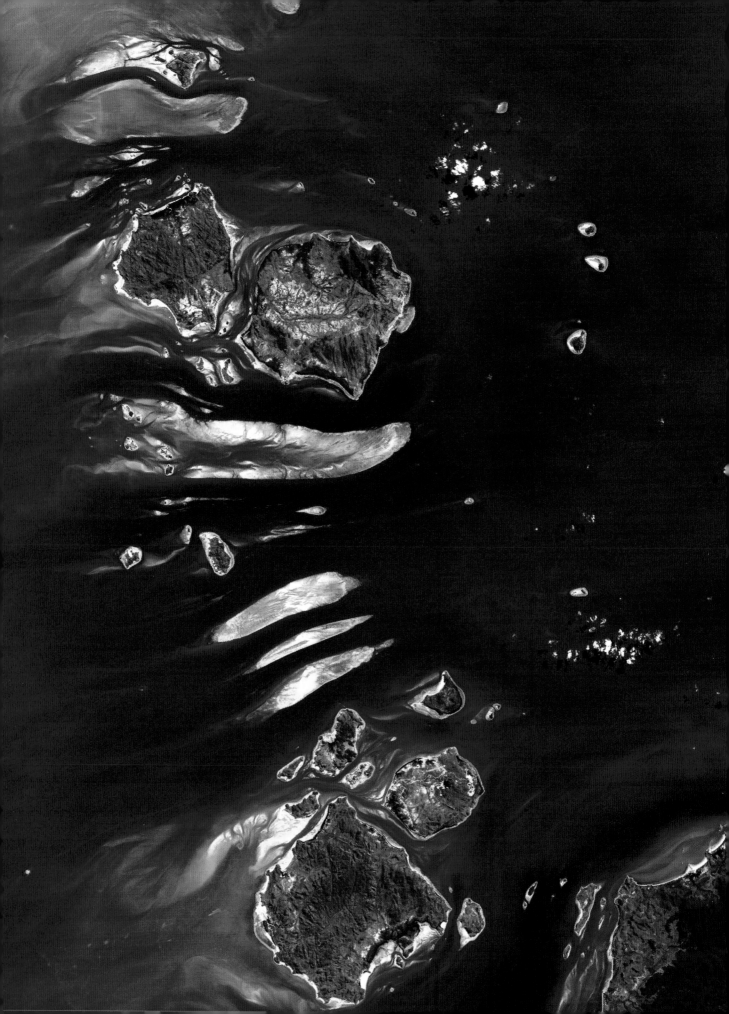

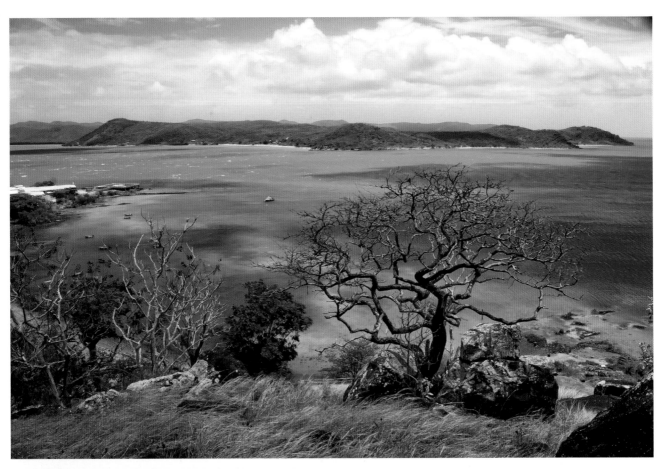

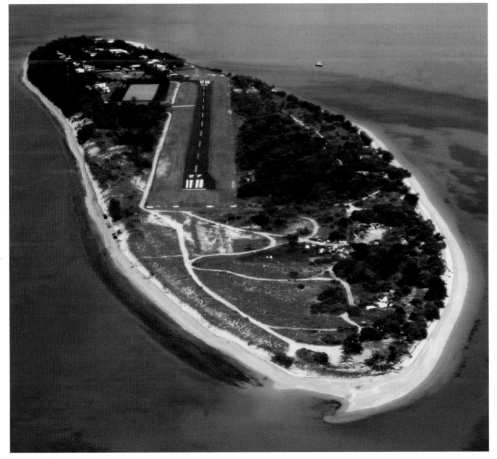

ALL PHOTOGRAPHS:
Torres Strait Islands, Queensland, Australia
The low-lying Torres Strait Islands are threatened by rising sea levels, causing erosion, property damage and drinking water contamination. In 2019, a group of islanders known as the Torres Strait 8 lodged a complaint with the UN Human Rights Committee that their rights were being violated by the Australian government's lack of efforts to protect them. The complaint was upheld and the government pledged to do more.

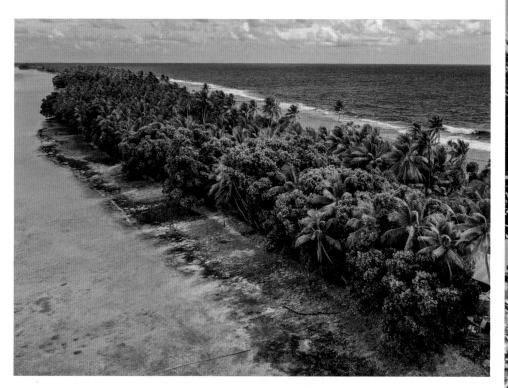

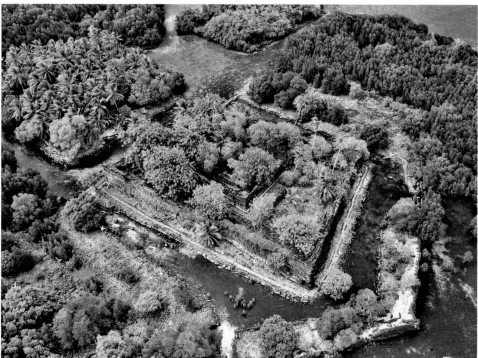

ABOVE TOP:
Tuvalu, Polynesia
With a population of 10,500, this coral island country is composed of just 26 sq km (10 sq miles) of land. The highest elevation is 4.6 m (15 ft) above sea level. The nation is extremely vulnerable to rising sea levels, with the worst-case prediction that the islands will become uninhabitable within the next century.

ABOVE BOTTOM AND RIGHT:
Nan Madol, Pohnpei, Federated States of Micronesia
These artificial islets, built from the 8th or 9th century using stone and coral, were the capital of the Saudeleur dynasty until 1628. Chiefs, priests and servants lived in stone buildings, with fresh water and food supplied by boat. The site is being eroded by tides and twining roots.

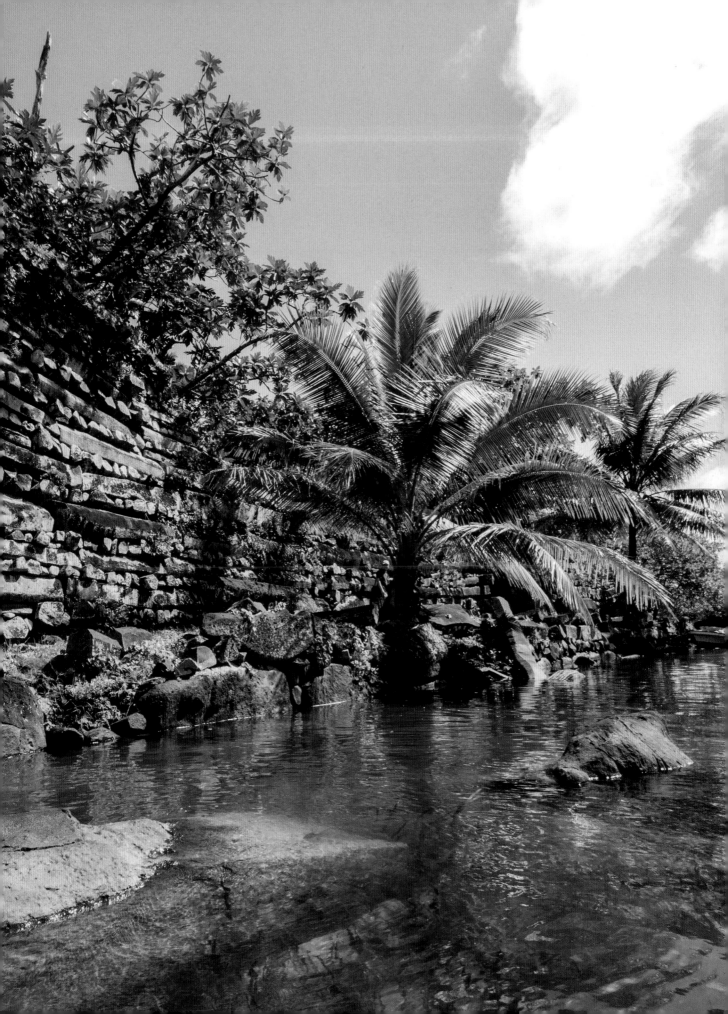

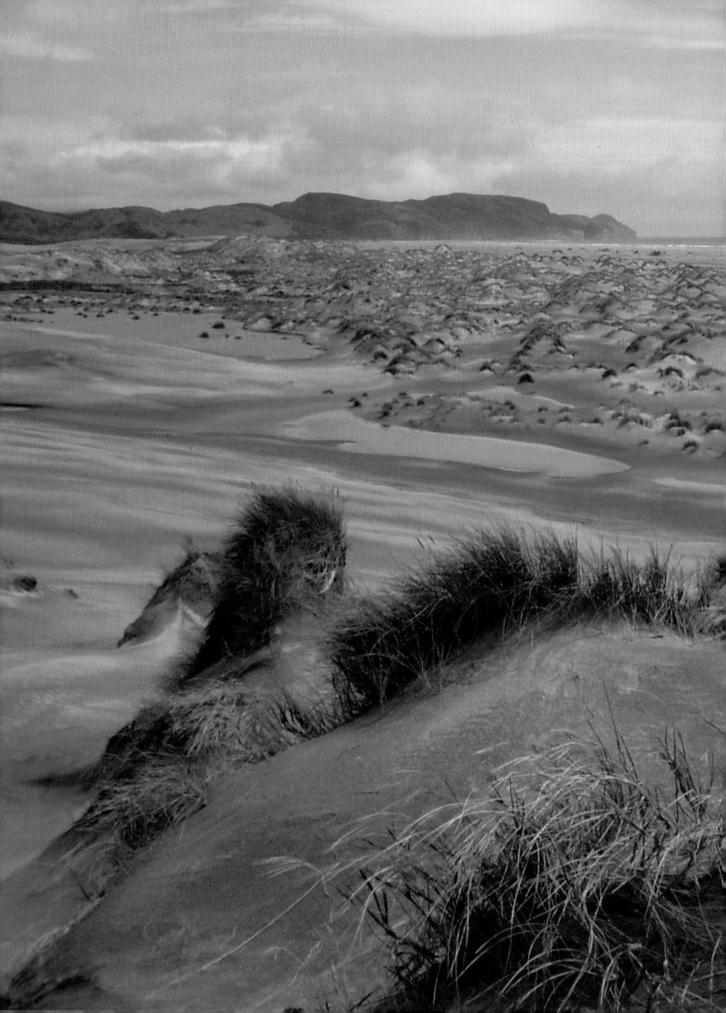

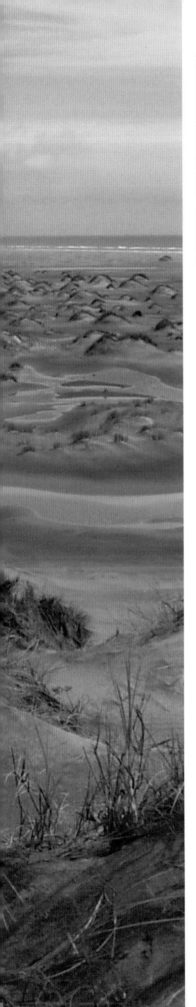

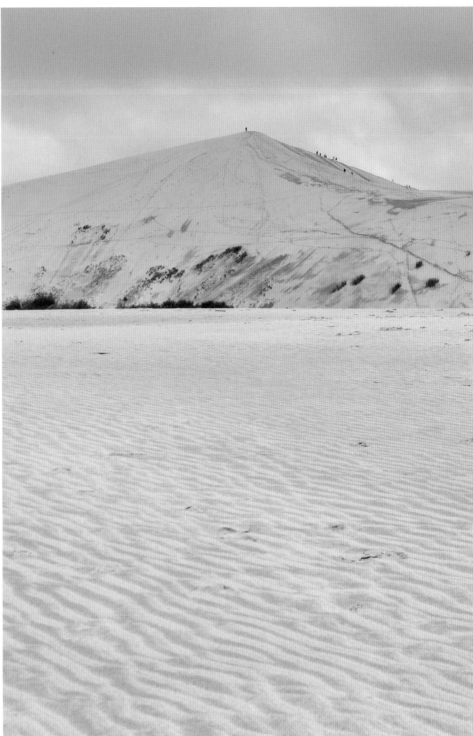

BOTH PHOTOGRAPHS:
Coastal dunes, New Zealand
Dunes line 1,100 km (680 miles)
of New Zealand's coast,
including South Island's Farewell
Spit (left) and North Island's
Cape Reinga (above). The sand
is stabilized by native pīngao and
spinifex. These plants, and dune
animals such as the katipō spider,
are threatened by introduced
species such as marram grass.

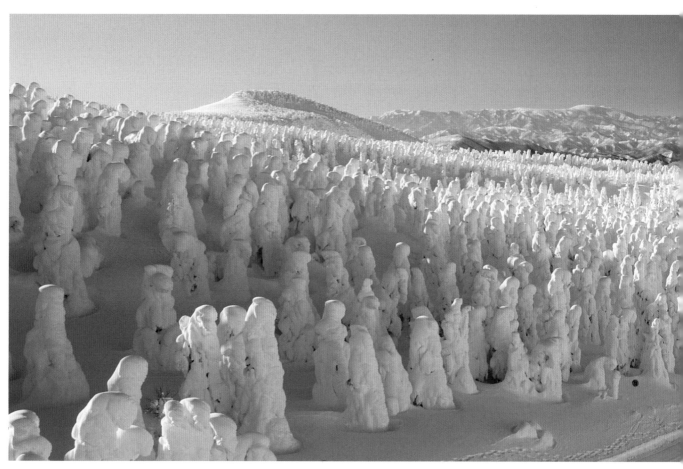

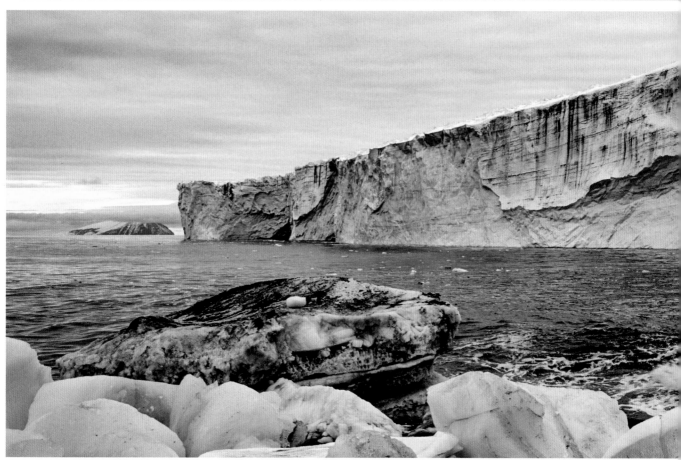

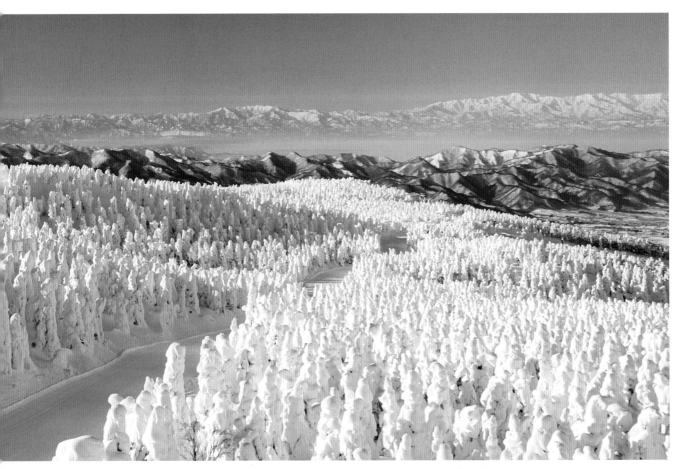

ABOVE:

Juhyo, Mt Zao, Yamagata, Japan
From December to March, *juhyo* ('snow monsters') can form on the snow- and ice-covered firs of the Zao volcano. The Zao Juhyo Festival celebrates these monster-like formations with fireworks and projections. Yet winter temperatures in Yamagata have risen by 2 °C (3.6 °F) since 1910, narrowing the window when *juhyo* can form.

LEFT:

Cape Bird, Ross Island, Antarctica
Ross Island lies in McMurdo Sound, at the edge of the Ross Ice Shelf. An ice shelf is a floating platform of ice that forms where glaciers flow on to the ocean, acting like a cork in a bottle to prevent uncontrolled outflow of ice – and resulting sea level rise. With an area the size of France, Ross is currently stable, but warmer sea surface temperatures are thinning its base.

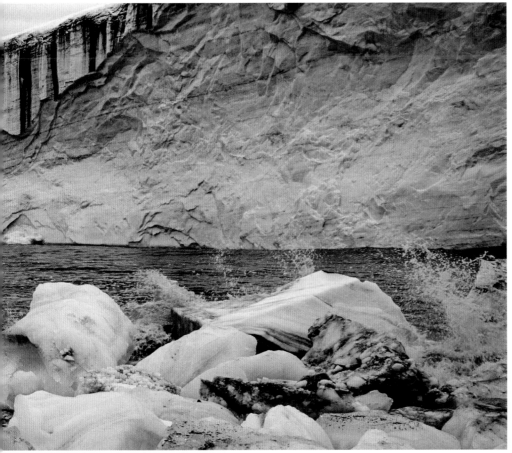

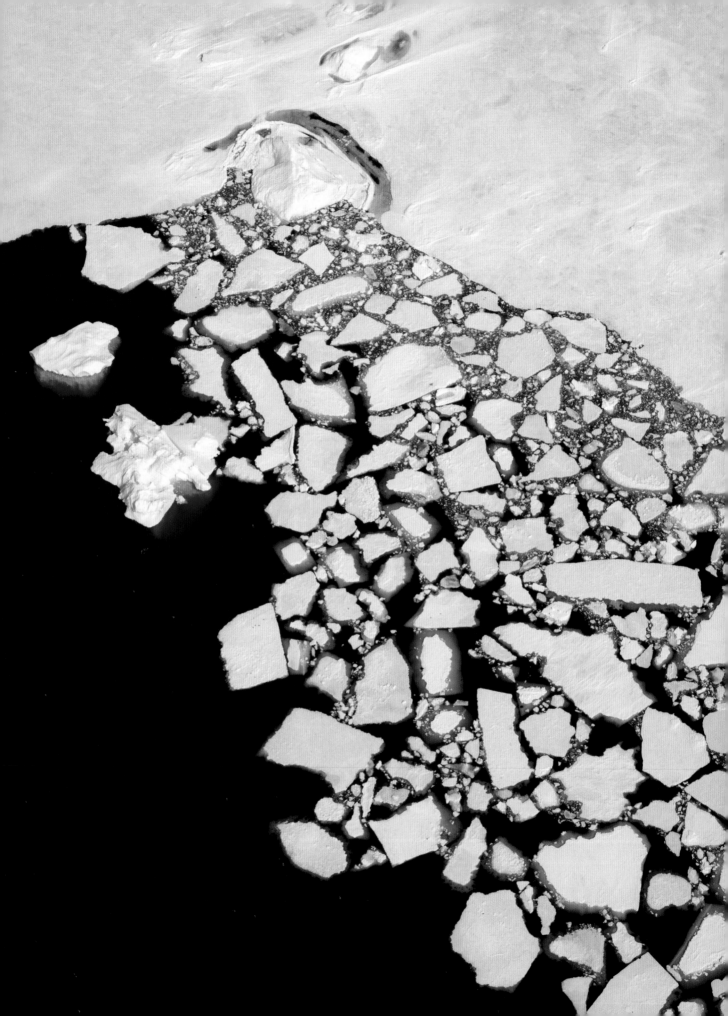

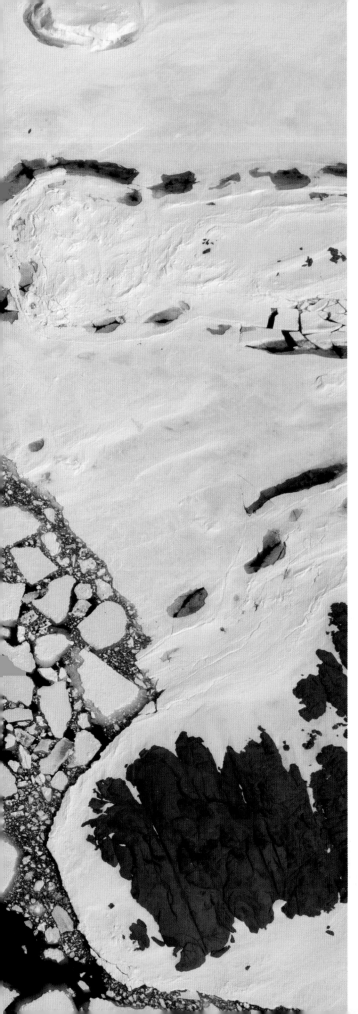

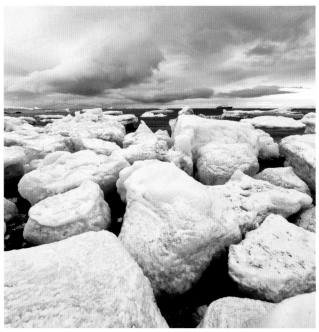

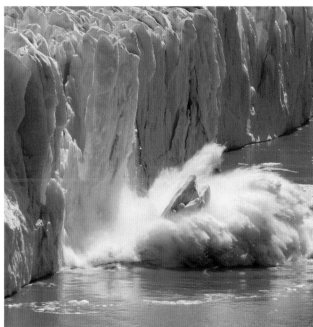

ALL PHOTOGRAPHS:

Antarctic ice sheet

Holding more than 60 per cent of all freshwater on Earth, the Antarctic ice sheet covers about 14 million sq km (5.4 million sq miles). Ice enters the sheet as falling snow, which is compacted into ice and moves under gravity towards the coast, often forming ice shelves that calve into icebergs, which eventually melt. Since 1957, the Antarctic surface temperature has risen by about 0.05 °C (0.09 °F) per decade. From 2009 to 2017, this caused a yearly net loss of ice weighing around 252 metric gigatonnes.

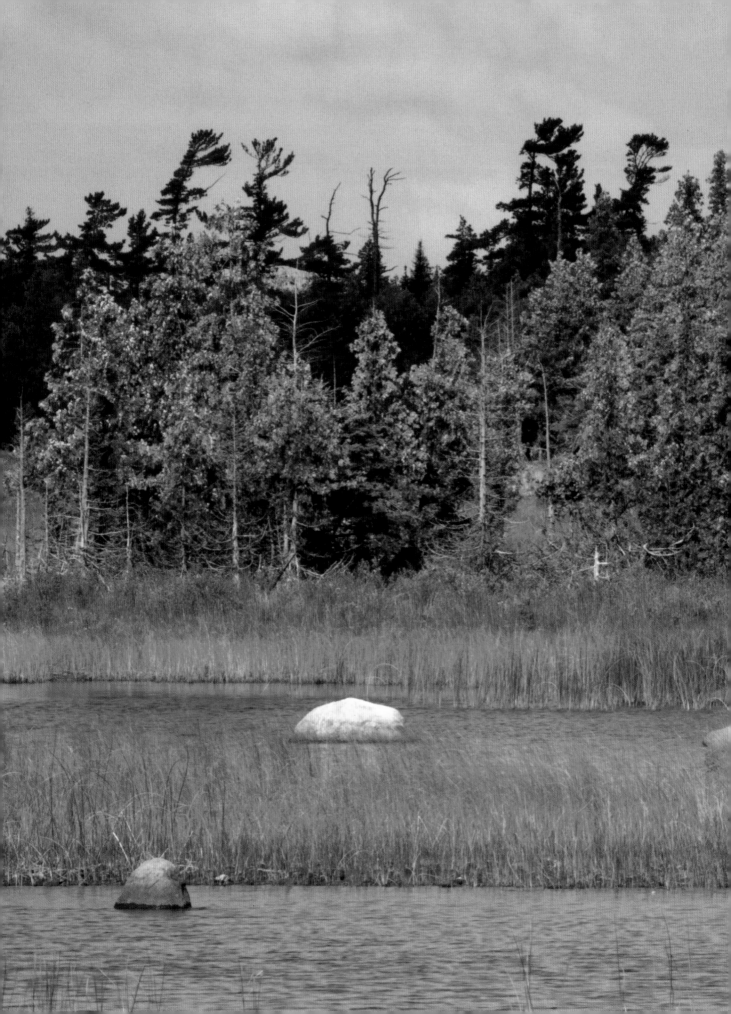

North America

A WARMER WORLD is a rainier world. As temperatures rise, evaporation from oceans, lakes and rivers increases. Warmer air can hold more moisture – around 7 per cent more with every 1 °C (1.8 °F) of increase, which is how much Earth has warmed since 1880. All this means that rainy places are seeing more rain, storms and flooding. Yet climate change is causing greater extremes, so while wet places become wetter, drier places are getting drier. Eastern North America is seeing rising rainfall, receiving more rain over the last 30 years than it did during the whole 20th century. However, the southwest of the region is seeing much drier weather, resulting in droughts that affect plants, animals and drinking water supplies. The 2011–17 California drought alone killed 102 million trees. Along with rising temperatures, long dry spells are increasing the risks posed by wildfires.

These changes in climate are turning the ingenuity of conservationists, biologists, archaeologists and many others to protecting the wonders of this region, both cultural and natural. Perhaps it is human nature to be driven to protect what we love only when we are at risk of losing it: from prehistoric Clovis culture sites to history-steeped 19th-century graveyards, from glaciers to alvars, tundra to sawgrass marsh.

OPPOSITE:
Alvar Ponds, Manitoulin Island, Lake Huron, Ontario, Canada
Covering 2,766 sq km (1,068 sq miles), Manitoulin is the world's largest lake island, with 108 lakes of its own. The low island also hosts some of the last remaining examples of alvars, frequently flooded limestone plains with thin soil and sparse, prairie-like plants.

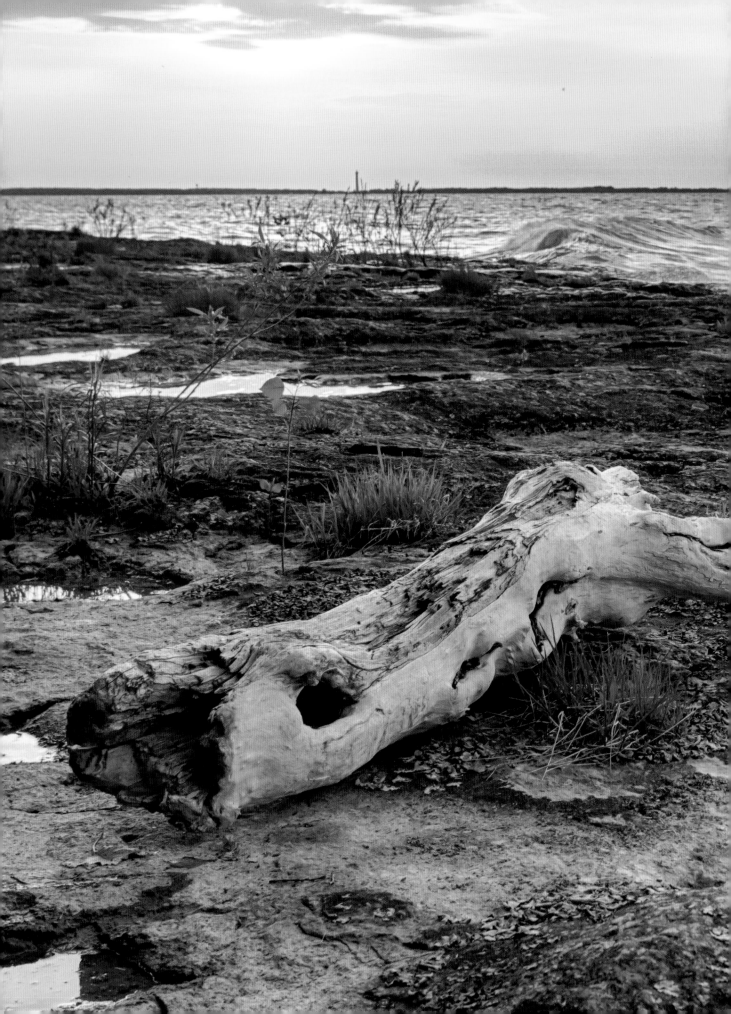

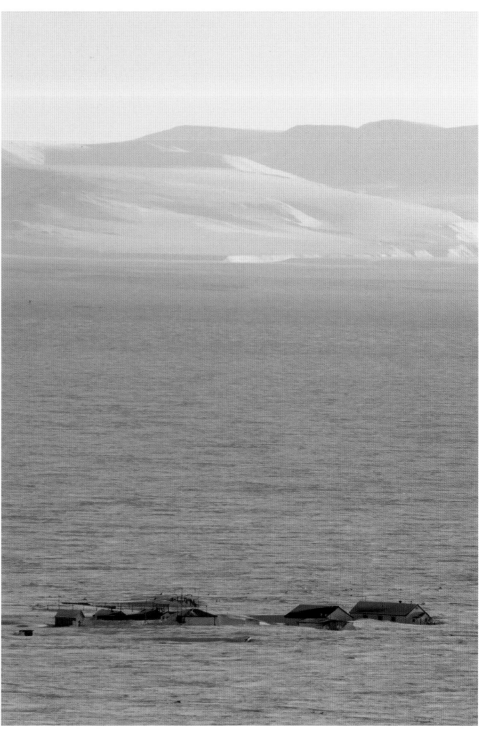

LEFT:

North Shore Alvar State Nature Preserve, Kelleys Island, USA
Most of the world's remaining alvars are found around the Great Lakes and northern Europe. This rare habitat is under threat from development and recreation. In an alvar, the formation of soil and growth of woody plants are hampered by periods of drought and flood, but plants here include the locally endangered northern bog violet.

ABOVE:

Herschel Island–Qikiqtaruk Territorial Park, Yukon, Canada
There are no permanent human inhabitants on the tundra of Herschel Island, but the ruins of whaling settlements remain. Roamed by porcupine caribou, musk oxen and Arctic foxes, the island is feeling the effects of climate change, which is melting permafrost and sea ice, resulting in coastal erosion of up to 3 m (9.8 ft) per year.

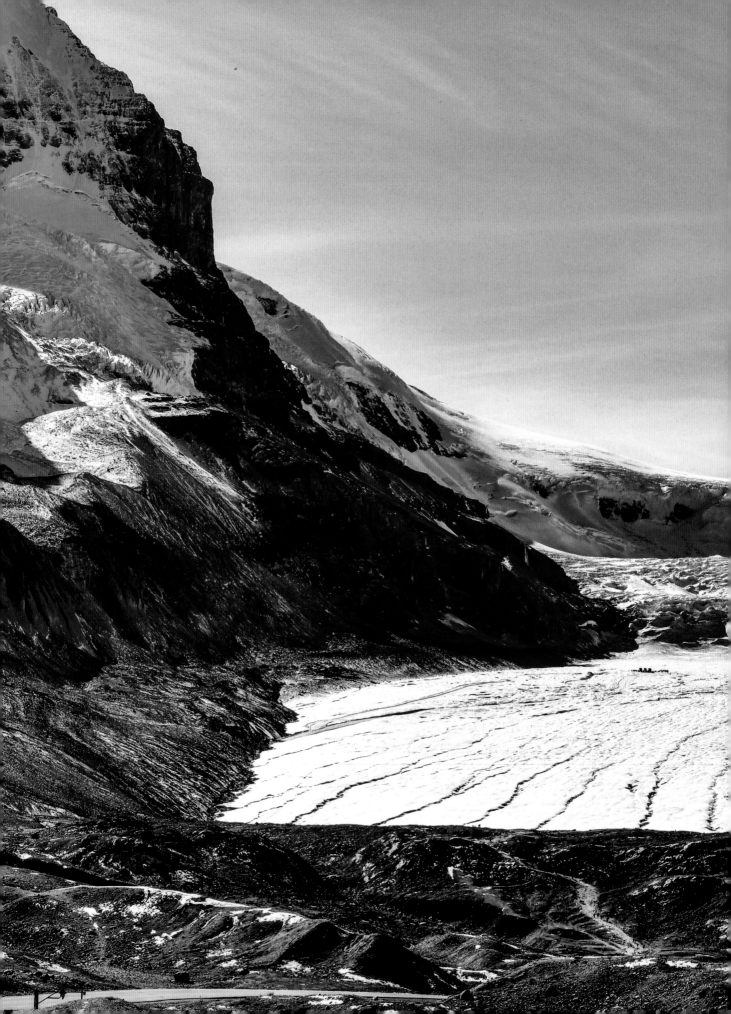

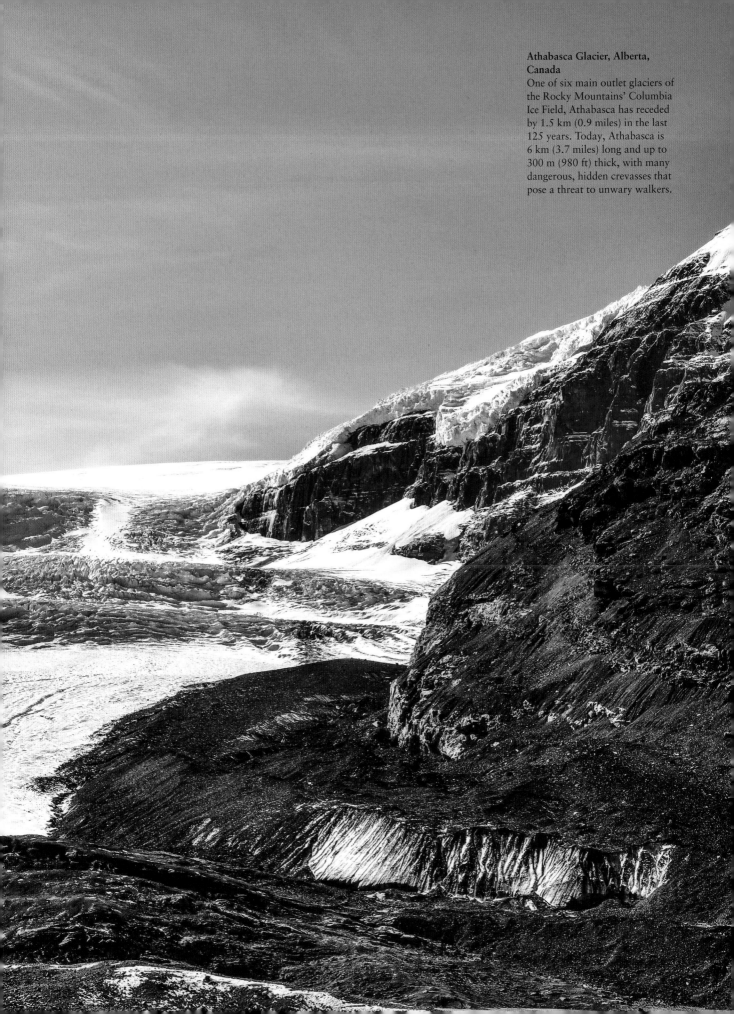

Athabasca Glacier, Alberta, Canada
One of six main outlet glaciers of the Rocky Mountains' Columbia Ice Field, Athabasca has receded by 1.5 km (0.9 miles) in the last 125 years. Today, Athabasca is 6 km (3.7 miles) long and up to 300 m (980 ft) thick, with many dangerous, hidden crevasses that pose a threat to unwary walkers.

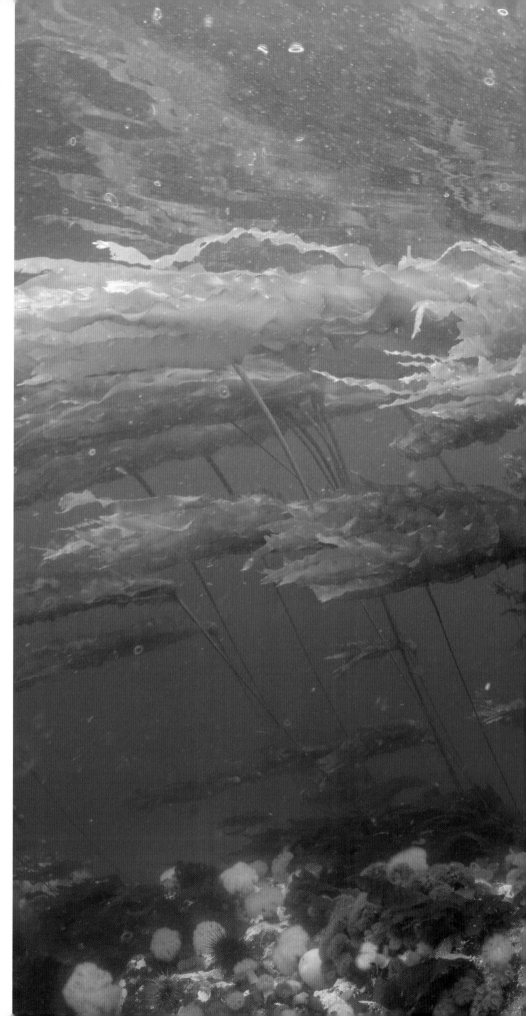

Bull kelp, Alexander Archipelago, Alaska, USA
Up to 36 m (118 ft) tall, bull kelp is a major component of kelp forests along the Pacific Coast of North America. Pollution and warming oceans have led to the near disappearance of kelp forests on vulnerable coastlines, such as northern California. Alaskan kelp forests are home to the endangered sea otter.

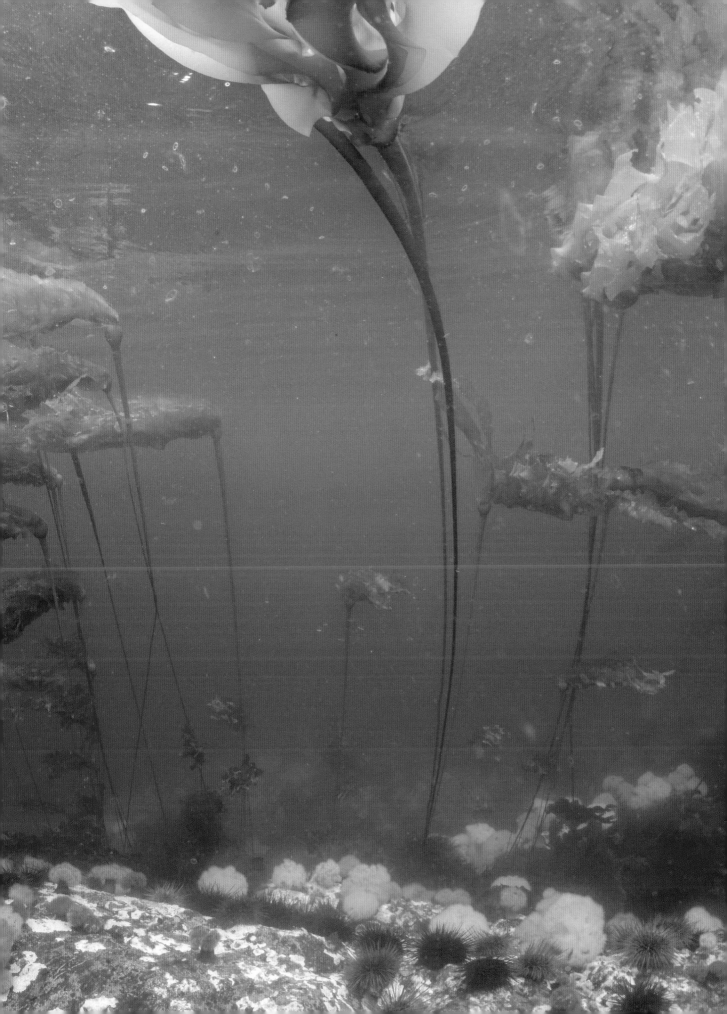

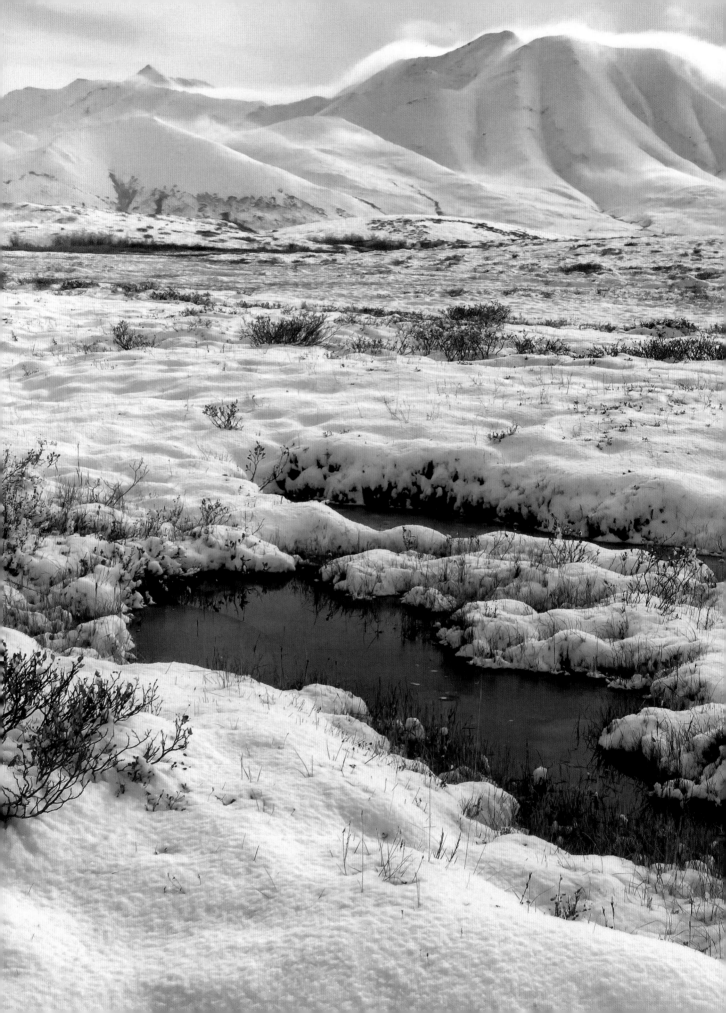

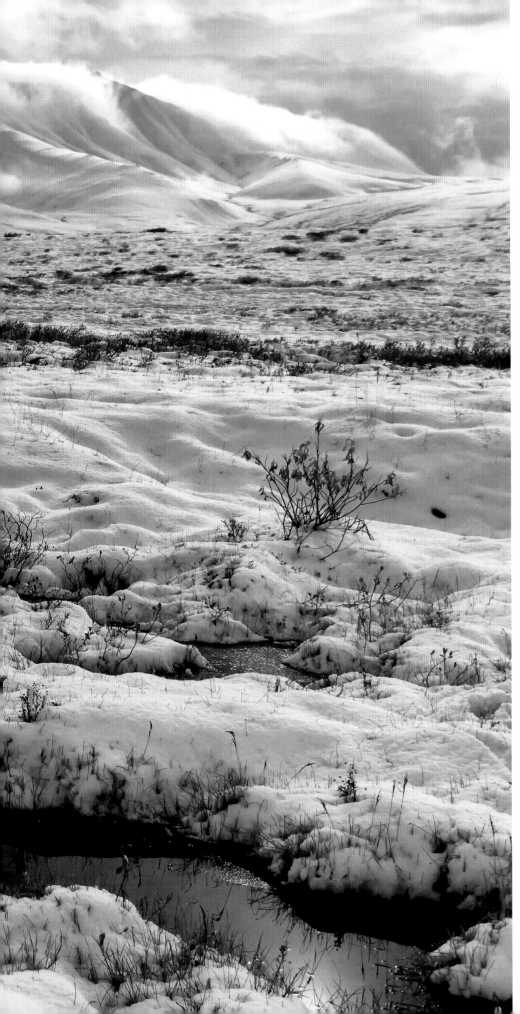

North Slope, Alaska, USA
In Alaska, the treeline follows the Brooks Range (pictured), with the tundra of the North Slope to the north and boreal forest to the south. As temperatures rise, the treeline is advancing. Species such as balsam poplar, black spruce and quaking aspen are now found in increasing numbers on the North Slope.

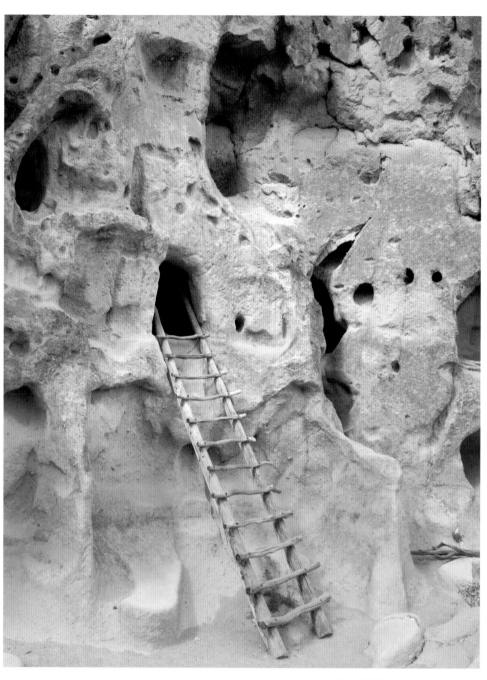

BOTH PHOTOGRAPHS:
Bandelier National Monument, New Mexico, USA
From around 1150 to 1600, the Ancestral Puebloans constructed pueblos such as Tyuonyi (right), defensive *cavates* (above) and *kivas* (ceremonial structures) on the Pajarito Plateau. Climate change has led to droughts and rising temperatures in the region, putting these monuments at increased risk from wildfires.

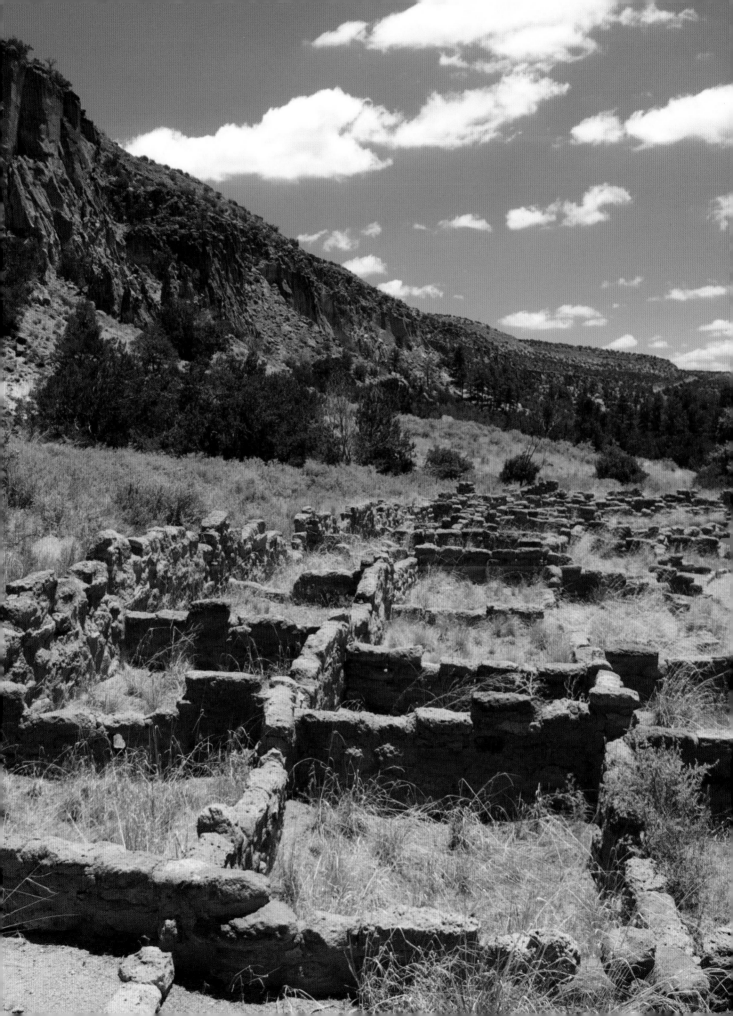

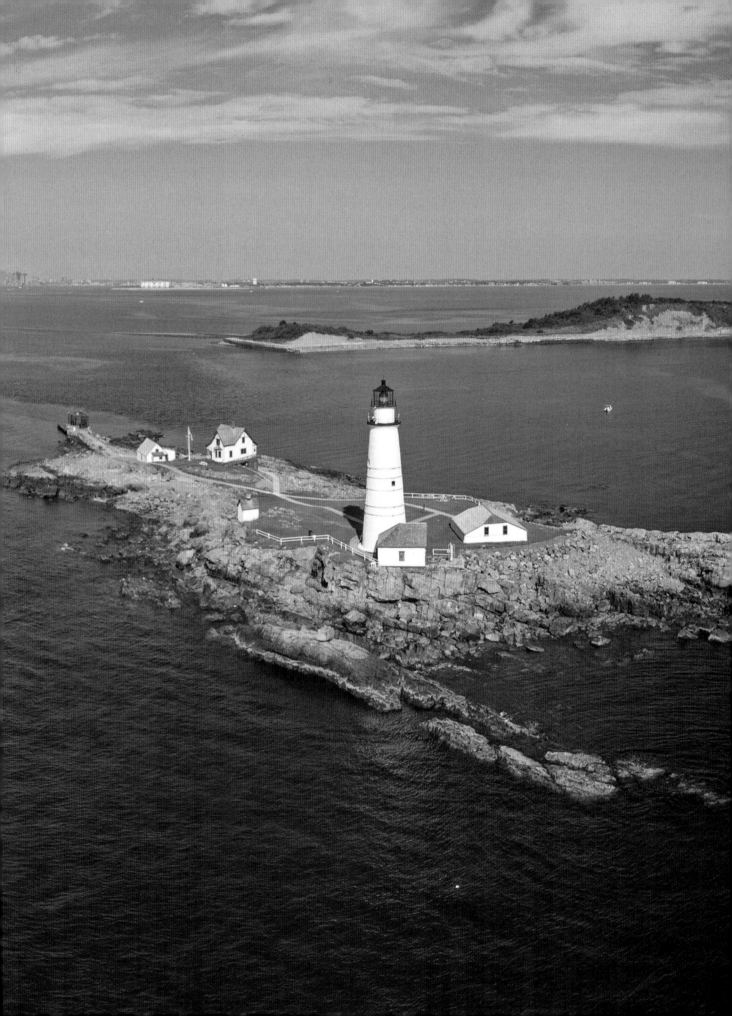

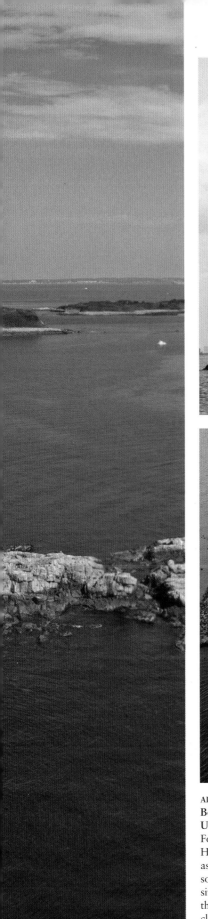

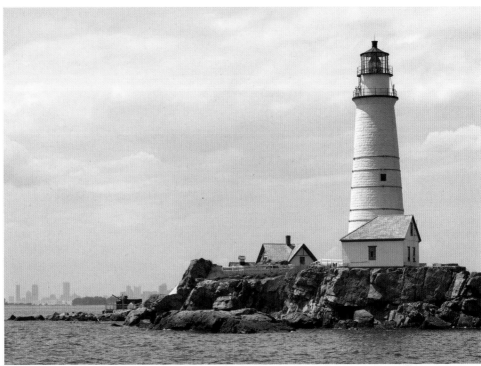

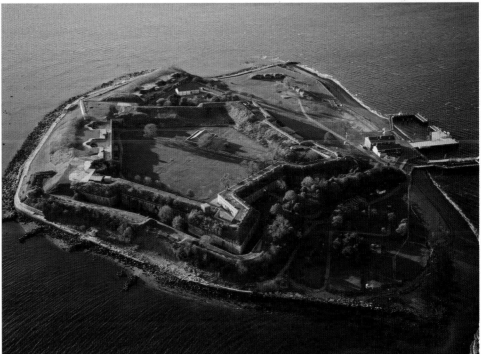

ALL PHOTOGRAPHS:
Boston Harbor, Massachusetts, USA
For many decades, Boston Harbor was polluted by sewage, as described in The Standells' song 'Dirty Water'. Today, the situation has improved, although there are still occasional beach closures after storms due to sewer overflows. The islands include Little Brewster (left and above top) and Georges (above bottom).

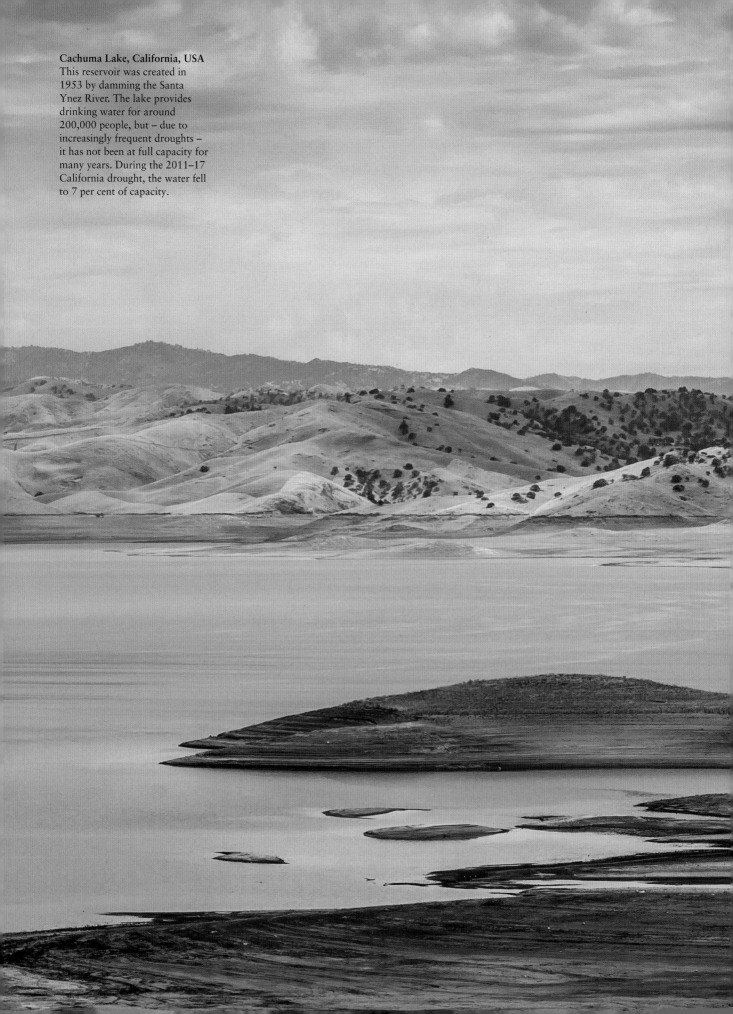

Cachuma Lake, California, USA
This reservoir was created in 1953 by damming the Santa Ynez River. The lake provides drinking water for around 200,000 people, but – due to increasingly frequent droughts – it has not been at full capacity for many years. During the 2011–17 California drought, the water fell to 7 per cent of capacity.

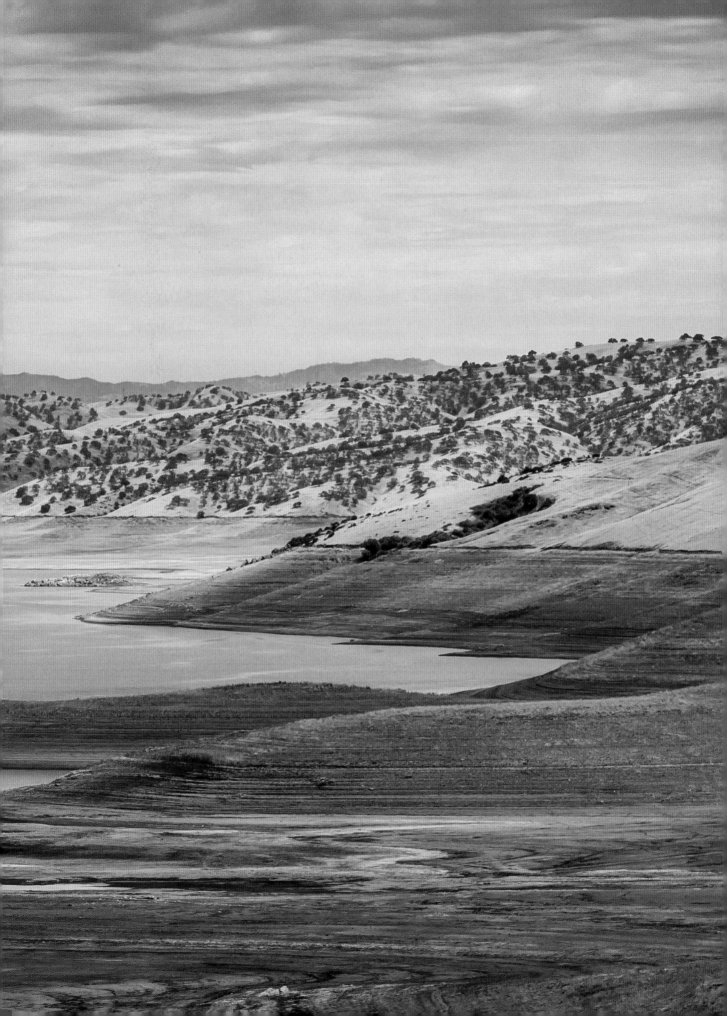

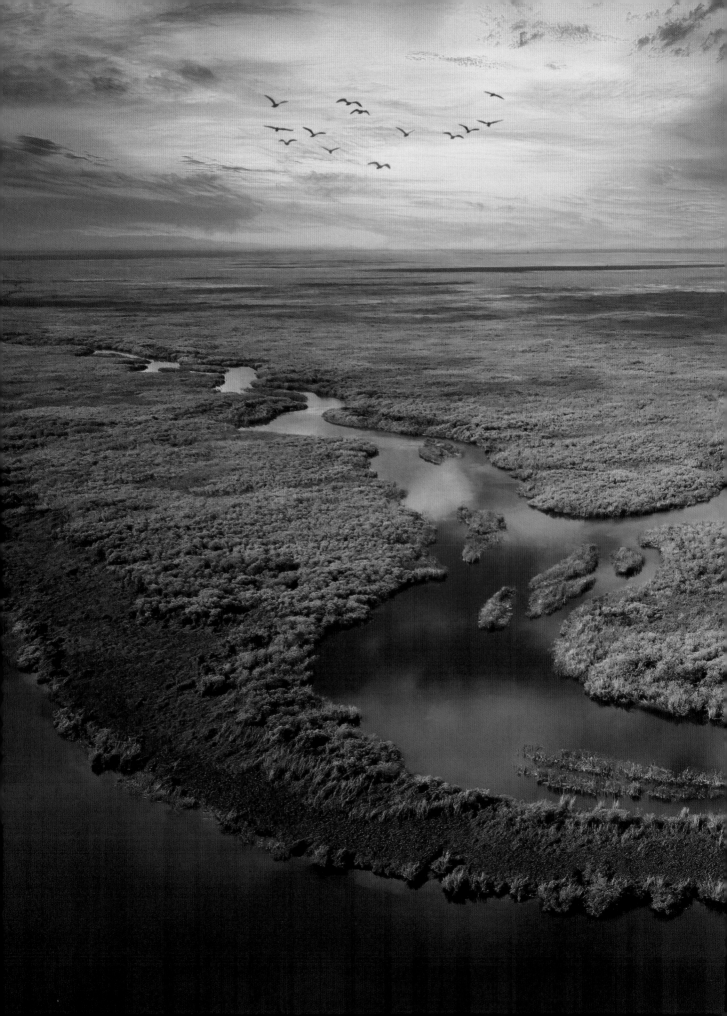

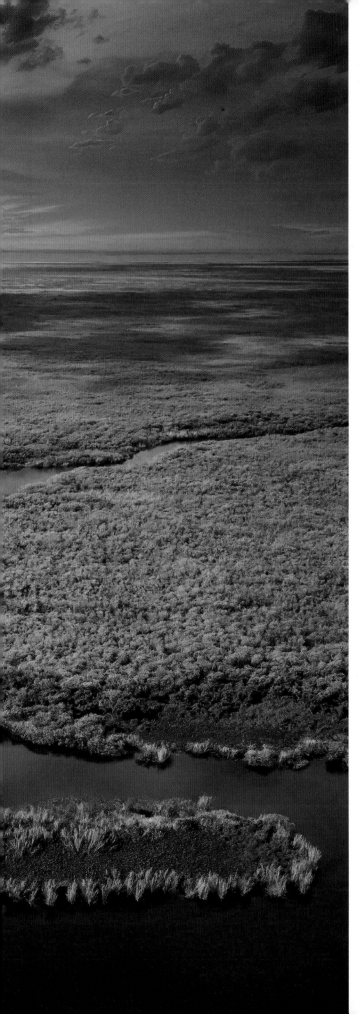

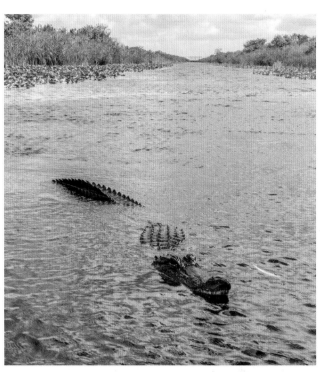

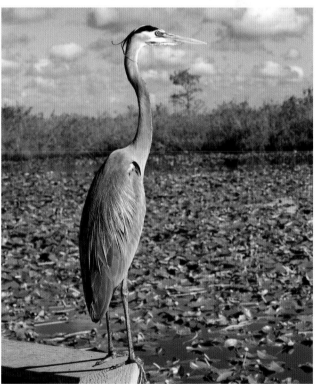

ALL PHOTOGRAPHS:
Everglades, Florida, USA
Covering about 20,000 sq km
(7,800 sq miles), the Everglades
wetland encompasses sawgrass
marsh, mangrove forest and
cypress swamp. Native predators
include the American alligator
(top) and the great blue heron
(above), which are facing
competition from invasive species
such as the Burmese python.

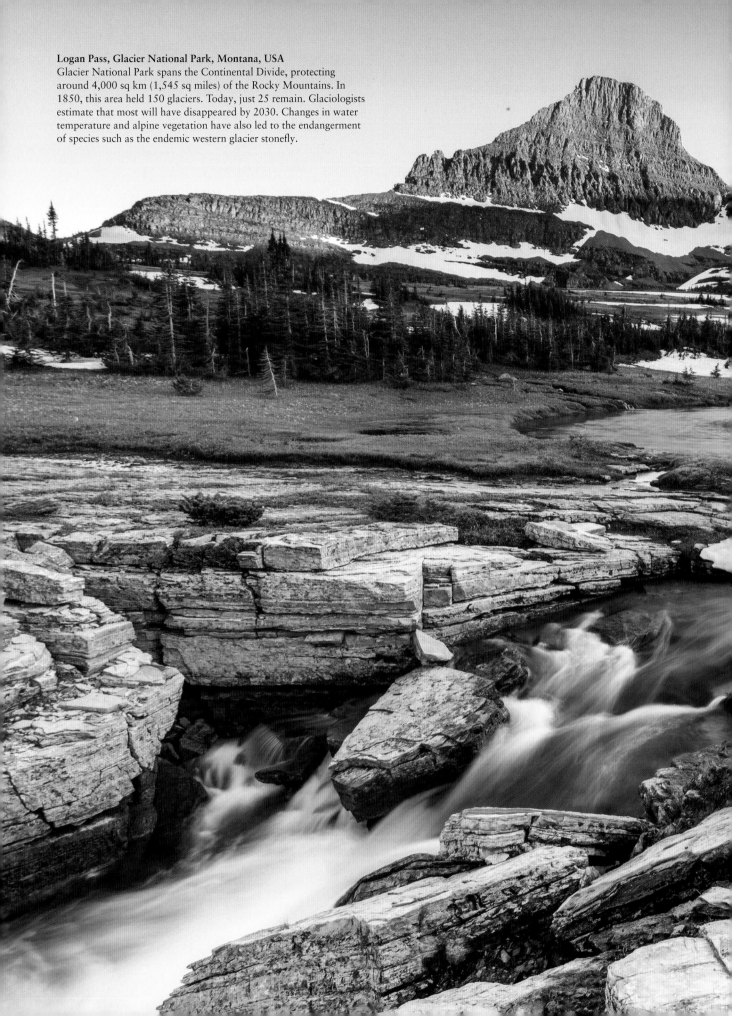

Logan Pass, Glacier National Park, Montana, USA
Glacier National Park spans the Continental Divide, protecting
around 4,000 sq km (1,545 sq miles) of the Rocky Mountains. In
1850, this area held 150 glaciers. Today, just 25 remain. Glaciologists
estimate that most will have disappeared by 2030. Changes in water
temperature and alpine vegetation have also led to the endangerment
of species such as the endemic western glacier stonefly.

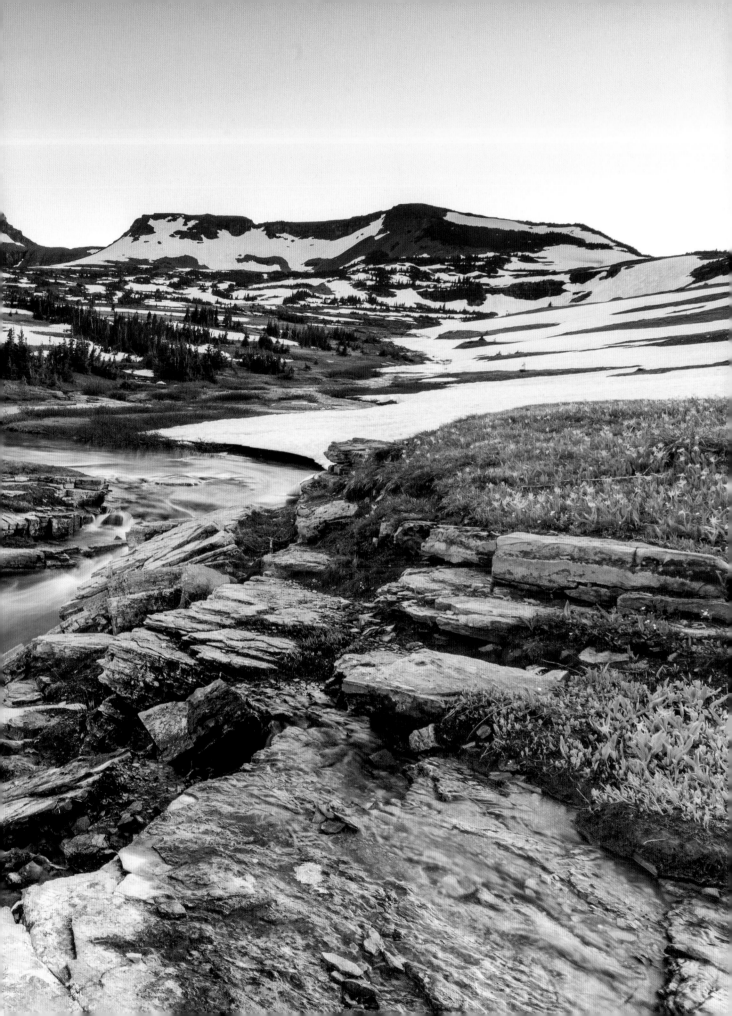

RIGHT AND BELOW:

Olivewood Cemetery, Houston, USA

In 1877, Olivewood opened as the first cemetery for African Americans within Houston city limits. In 2021, the historic cemetery received grants from the African American Cultural Heritage Action Fund to protect it from further vandalism, flooding and erosion, caused by proximity to White Oak Bayou.

OPPOSITE:

North Sixshooter Peaks, Bears Ears Monument, Utah, USA

This sandstone butte, 1,944 m (6,379 ft) tall, lies in Bears Ears National Monument. In 2017, President Trump reduced the extent of the monument by 85 per cent, a move seen as a victory for fossil fuel and uranium companies. In 2021, President Biden restored the monument to its previous size.

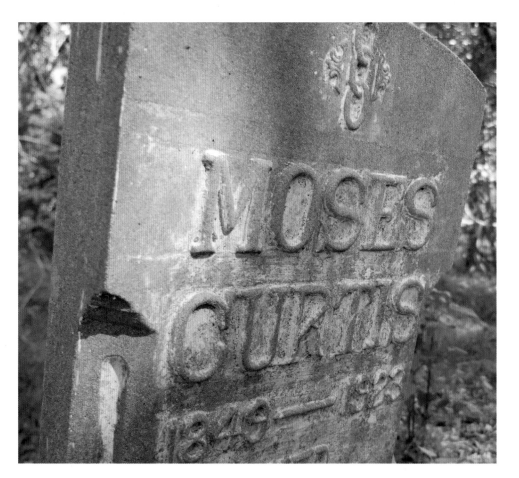

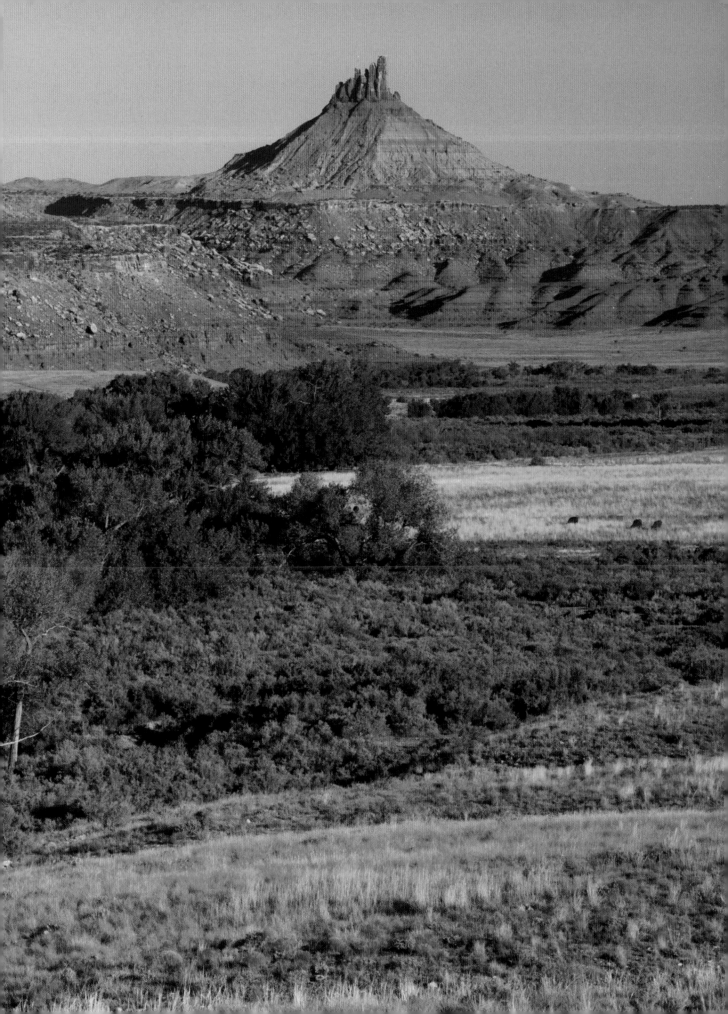

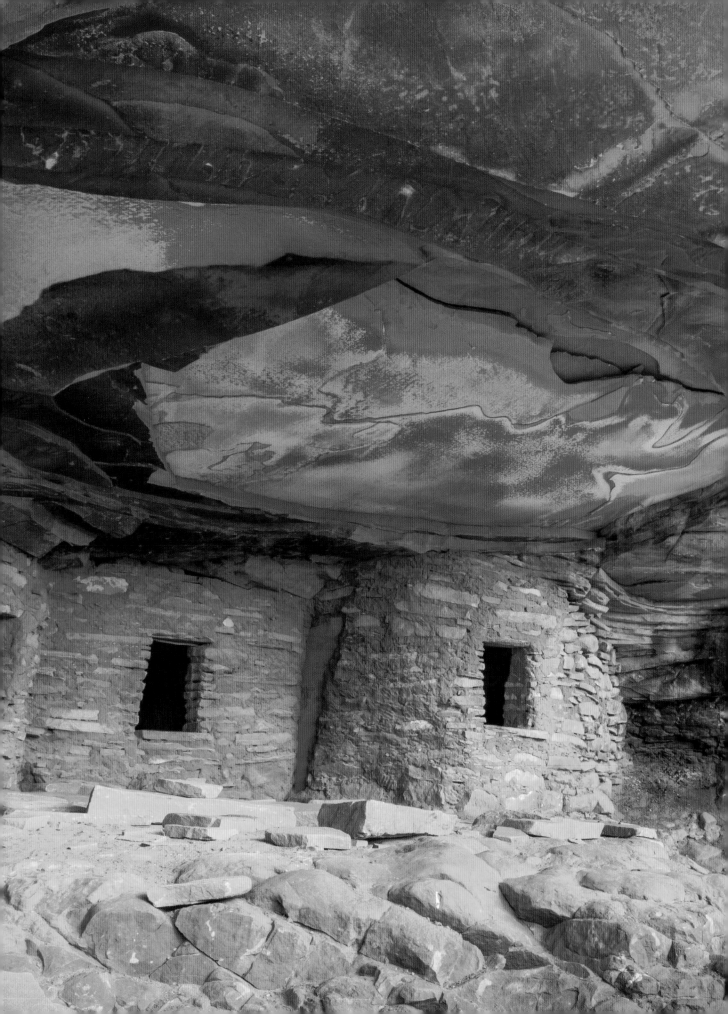

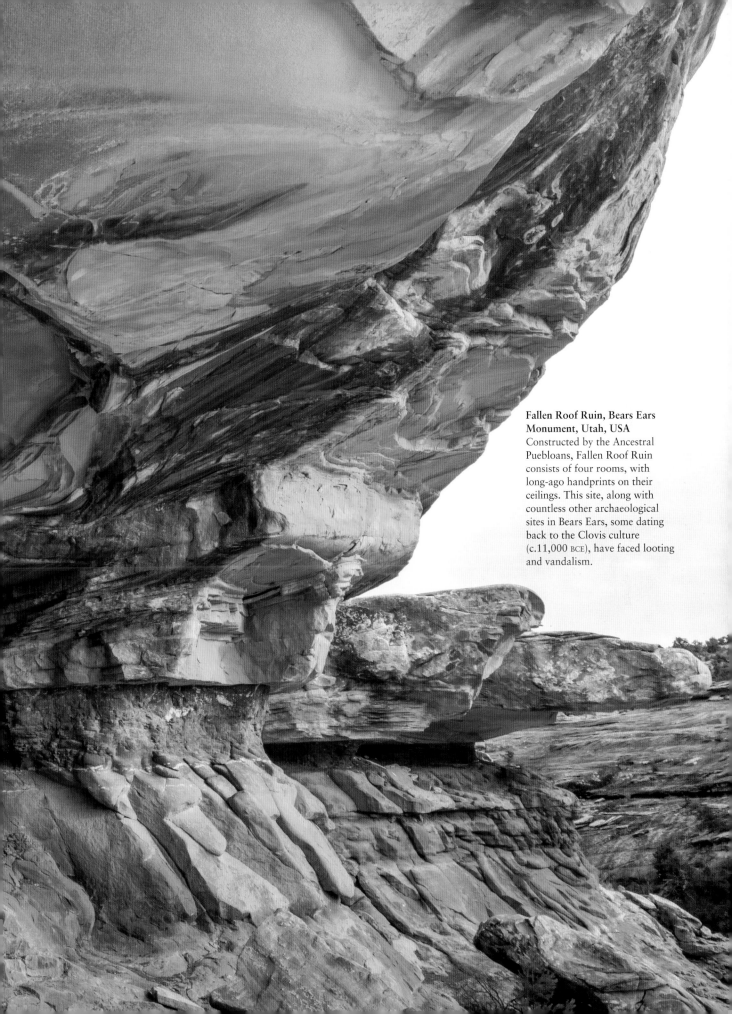

Fallen Roof Ruin, Bears Ears Monument, Utah, USA
Constructed by the Ancestral Puebloans, Fallen Roof Ruin consists of four rooms, with long-ago handprints on their ceilings. This site, along with countless other archaeological sites in Bears Ears, some dating back to the Clovis culture (c.11,000 BCE), have faced looting and vandalism.

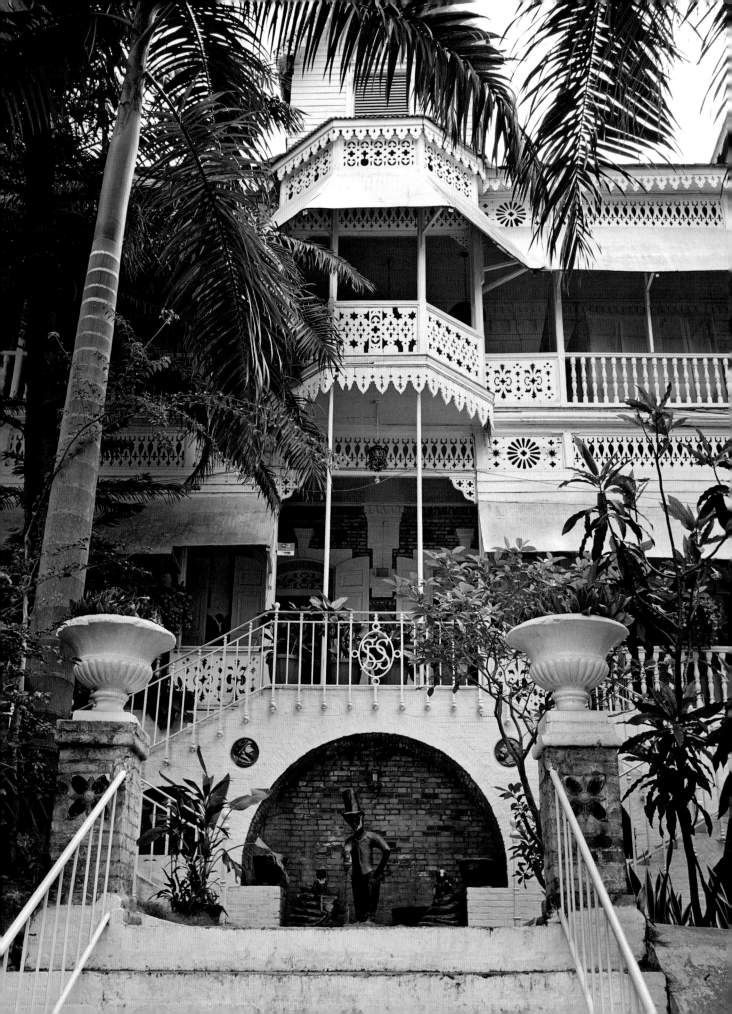

Central and South America

THE WORLD'S forests, from cloud forests to taiga, from dipterocarp forests to várzea, are shrinking. Every year, the world loses around 50,000 sq km (19,000 sq miles) of forest. South America hosts the world's largest forest, the Amazon Rainforest, covering 5.5 million sq km (2.1 million sq miles). The Amazon has become the poster child for deforestation and its threats to biodiversity and climate. Over the last 50 years, it has shrunk by 17 per cent. More than 10,000 species of its plants and animals are at high risk of extinction. Every year, land conversion and logging in the Amazon release up to 0.5 billion metric tonnes of carbon.

The more we hear statistics such as these, the more many of us are frightened or lulled into fatalism. Yet the Amazon – its stealthy jaguars and snuffling tapirs, its squawking macaws and scuttling tarantulas – is not lost. Deforestation can be slowed and even reversed. Costa Rica has also become a poster child, as the first tropical country to reverse deforestation. In the 1970s and '80s, Costa Rica had one of the highest deforestation rates in Central America, but a home-grown conservation movement, laws around logging, and governmental initiatives such as rewards for sustainable farming practices have worked. Today, 60 per cent of Costa Rica is once again covered by beautiful, noisy forest.

OPPOSITE:

Hotel Oloffson, Port-au-Prince, Haiti
Like many late 19th-century Haitian mansions, Hotel Oloffson was built in 'Gingerbread' style, characterized by elaborate fretwork. The hotel, which inspired Graham Greene's 1966 novel *The Comedians*, was one of the few hotels to withstand the 2010 earthquake.

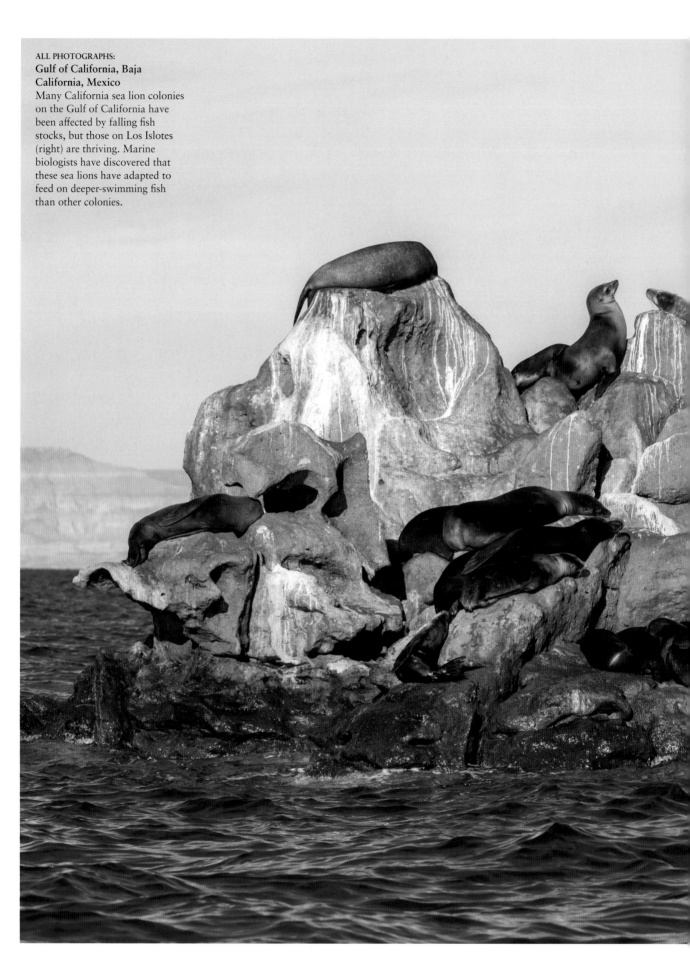

ALL PHOTOGRAPHS:
**Gulf of California, Baja
California, Mexico**
Many California sea lion colonies
on the Gulf of California have
been affected by falling fish
stocks, but those on Los Islotes
(right) are thriving. Marine
biologists have discovered that
these sea lions have adapted to
feed on deeper-swimming fish
than other colonies.

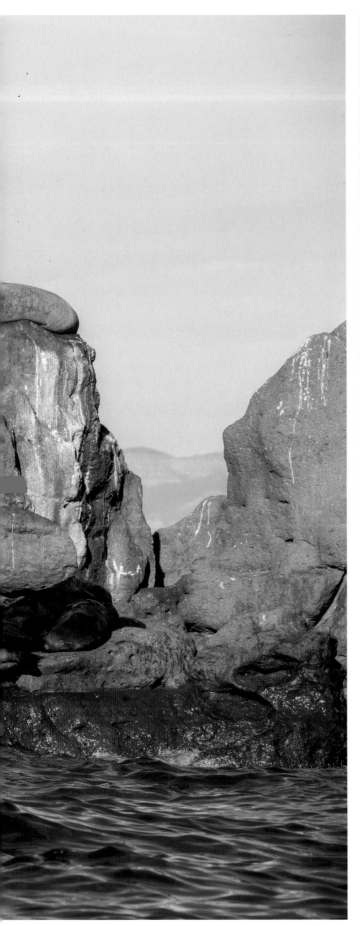

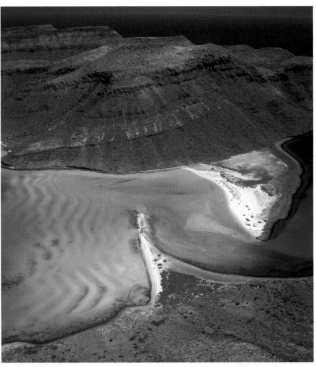

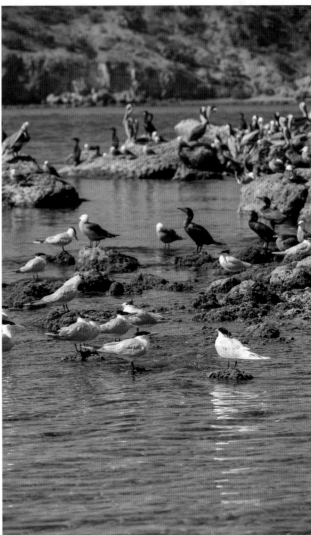

Old Town, Ponce, Puerto Rico
Ponce's late-19th- and early-20th-century old town is a blend of art deco and Ponce Creole styles. The latter combines neoclassical and vernacular elements, featuring Corinthian columns and wrought-iron balconies. Local and government organizations are working on a recovery plan for Ponce, which has been damaged by a string of hurricanes and earthquakes.

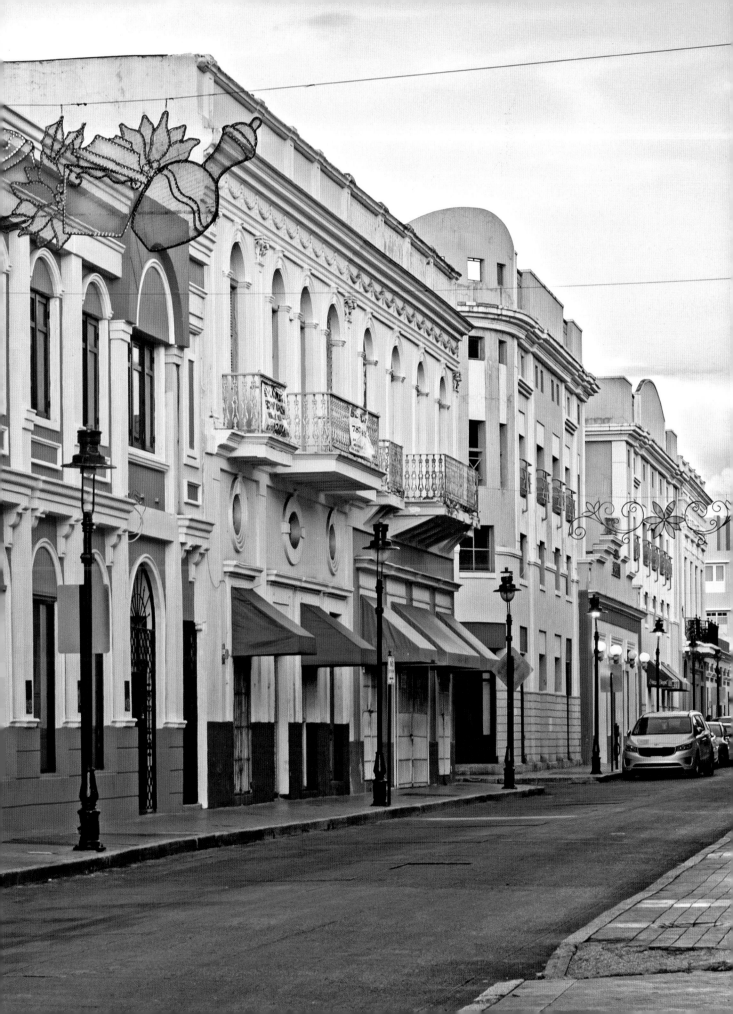

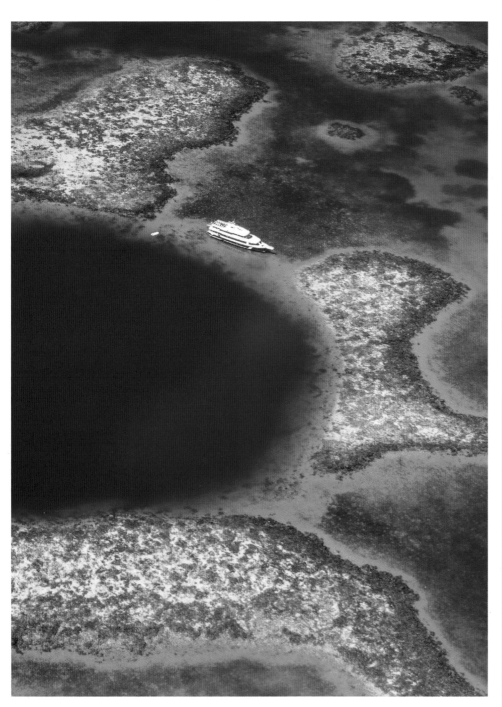

ABOVE:
Belize Barrier Reef, San Pedro, Belize

The Belize Barrier Reef has been impacted by mass-bleaching events caused by rising sea temperatures. Yet this reef still hosts 70 reef-building hard corals and 36 soft coral species. In 2010, Belize became the first country to ban bottom trawling. Then, in 2015, offshore oil drilling within 1 km (0.6 miles) of the reef was banned.

RIGHT:
Temple I, Tikal, Guatemala

Built in around 732 CE by the Maya, this stepped pyramid is topped by a temple with a high roof comb. The tomb of the ruler Jasaw Chan K'awiil I lies deep within the pyramid. The Tikal site and surrounding rainforest, home to howler monkeys and jaguars, are protected as a national park to prevent looting, hunting and logging.

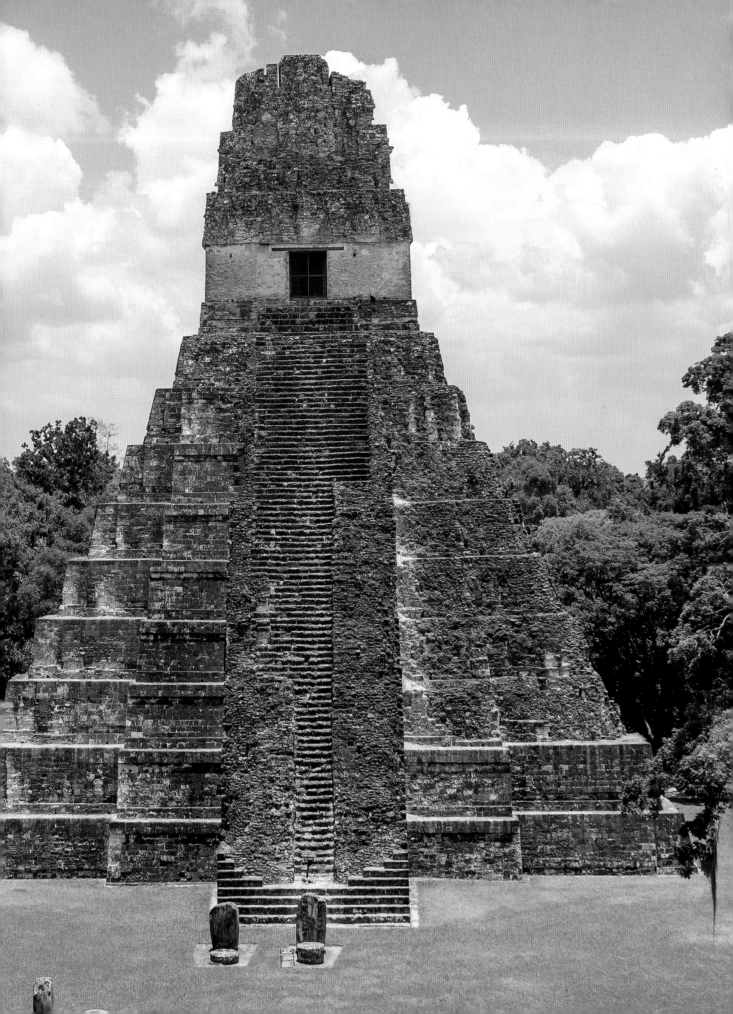

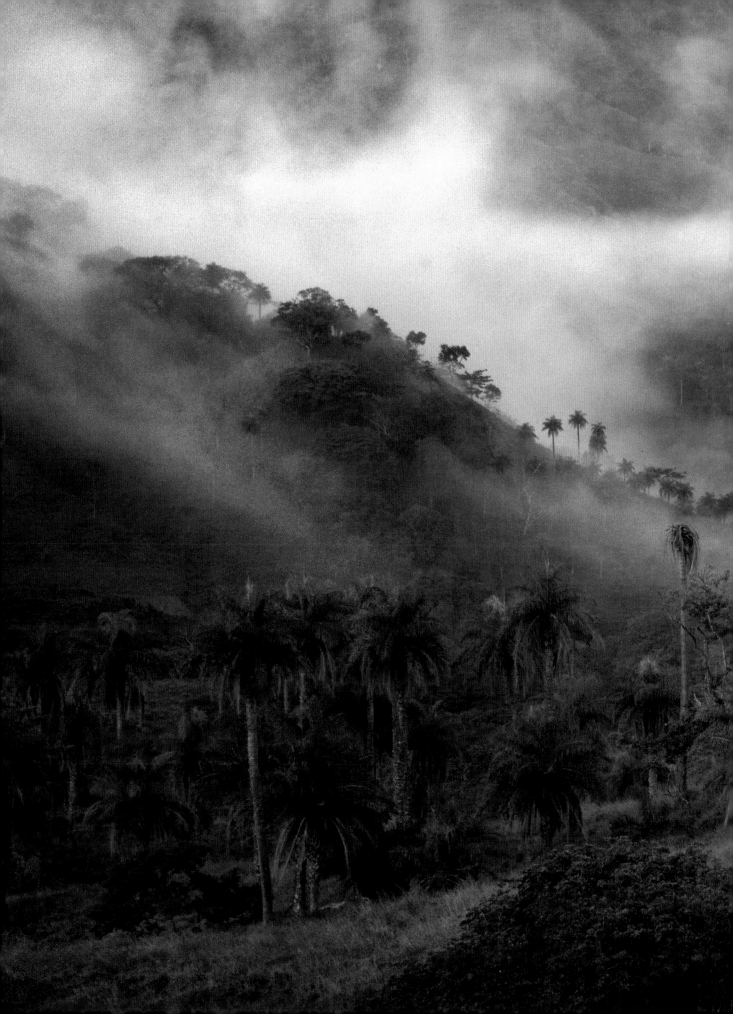

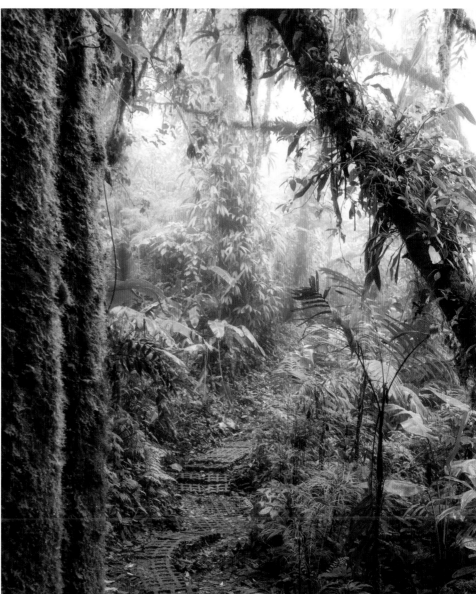

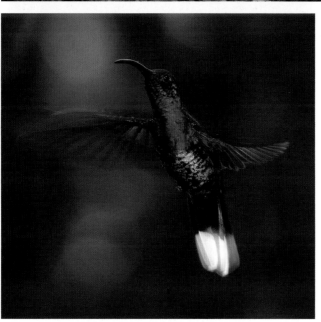

ALL PHOTOGRAPHS:
Monteverde Cloud Forest Biological Reserve, Costa Rica
Comprising 1 per cent of the world's remaining forests, cloud forests are moist montane forests usually cloaked in cloud. The first tropical country to reverse deforestation, Costa Rica has protected Monteverde well. The forest has around 880 species of epiphytes such as orchids, which grow on other plants. The majority of birds are frugivores, insectivores or nectivores, the latter category including the violet sabrewing, (left).

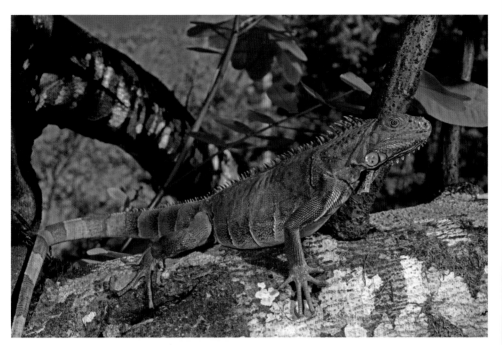

ABOVE TOP AND BOTTOM:
La Mosquitia, Honduras
This region of almost untouched
tropical rainforest and wetland
is largely accessible only by
boat or plane. Common species
include the green iguana (top),
while endangered ones include
giant anteaters and West Indian
manatees. Conservationists are
working to protect the region
from logging and clearance for
grazing cattle.

RIGHT:
Mesoamerican Barrier Reef,
Riviera Maya, Mexico
The 1,000 km (625 mile)-long
Mesoamerican Barrier Reef is
the world's second largest reef
system after Australia's Great
Barrier Reef. The reef is visited
by more than 500 species of fish,
including the widespread ocean
surgeonfish (pictured) and the
endangered splendid toadfish and
Nassau grouper.

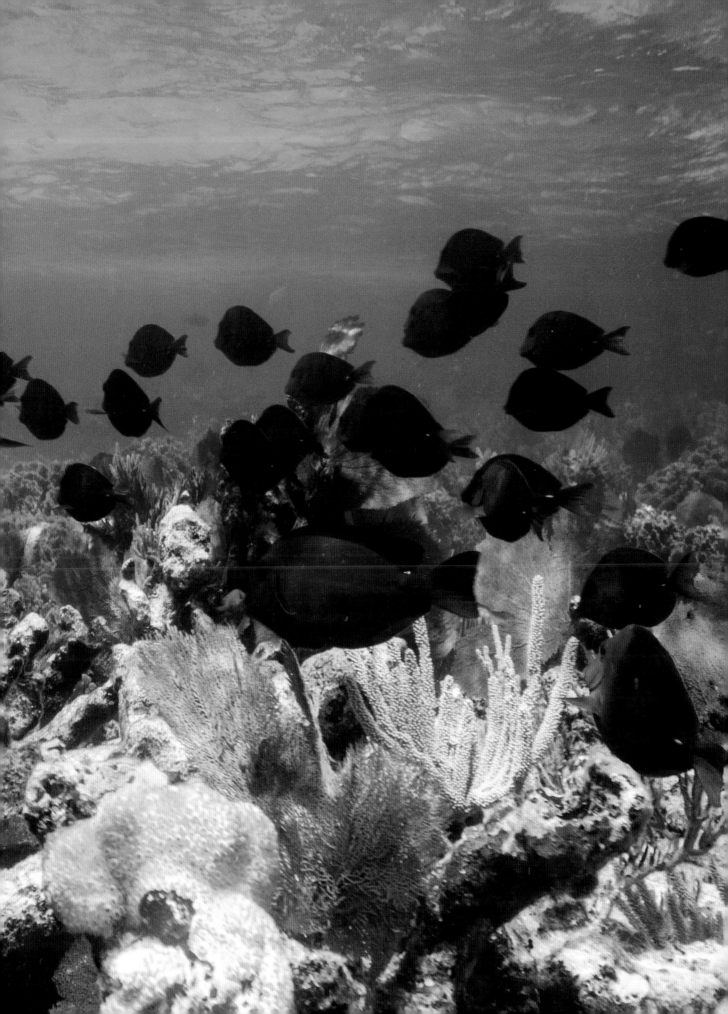

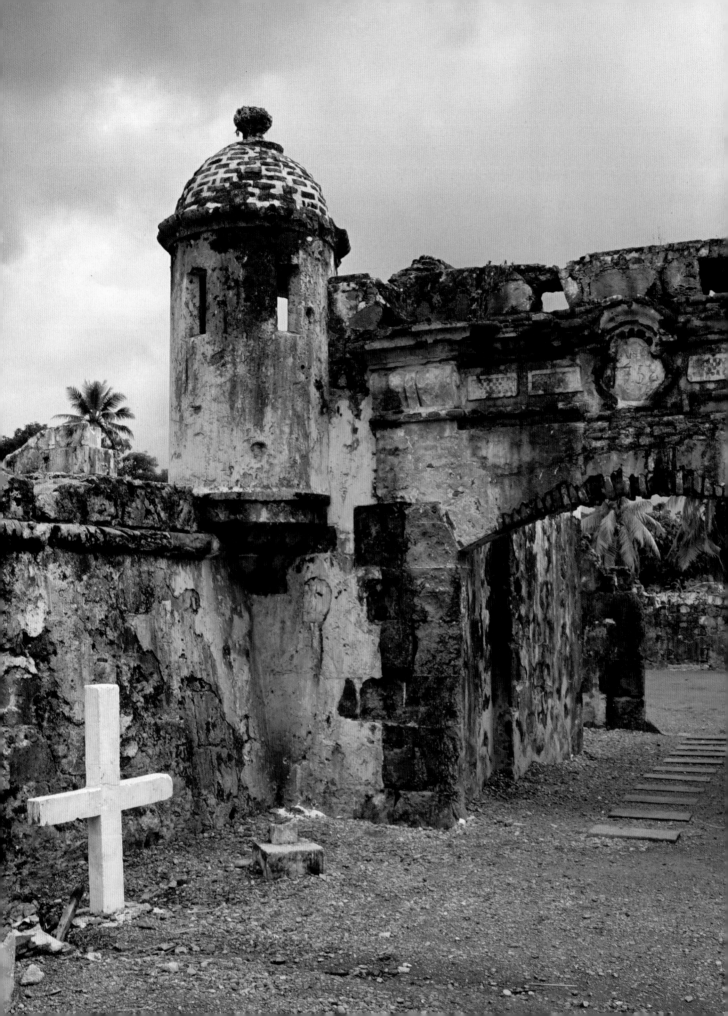

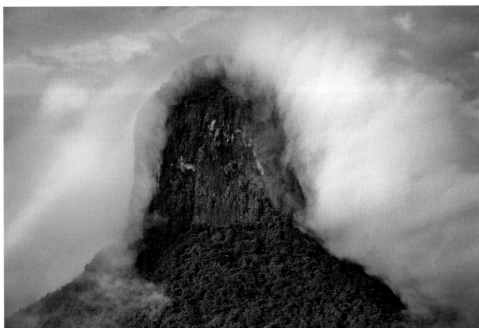

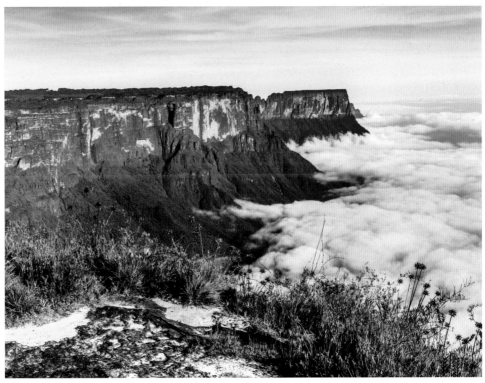

LEFT:

Fortifications of Portobelo and San Lorenzo, Colón, Panama
These forts on Panama's Caribbean coast form part of the Spanish Crown's 17th- and 18th-century defences to protect transatlantic trade from pirates. The forts document changing military building styles, from mock medieval to neoclassical. Battered by stormy weather, the forts are in need of maintenance.

ABOVE TOP AND BOTTOM:

Tepuis, Venezuela
Tepuis are tabletop mountains, the remains of a sandstone plateau that once covered this region's granite bedrock. The tepuis are home to an extraordinary number of endemic plants and animals, which evolved in the isolation of their tepui for millennia. Kukenán (bottom) is home to the tiny *Pristimantis aureoventris* frog.

BOTH PHOTOGRAPHS OVERLEAF:

Coro, Falcón, Venezuela
Founded in 1527, the city of Coro is a unique fusion of indigenous adobe construction methods with intricately ornamented Spanish Mudéjar architecture and more austere Dutch and German influences. It is the adobe buildings that are most at risk today from the region's changing climate, which is bringing heavy rains.

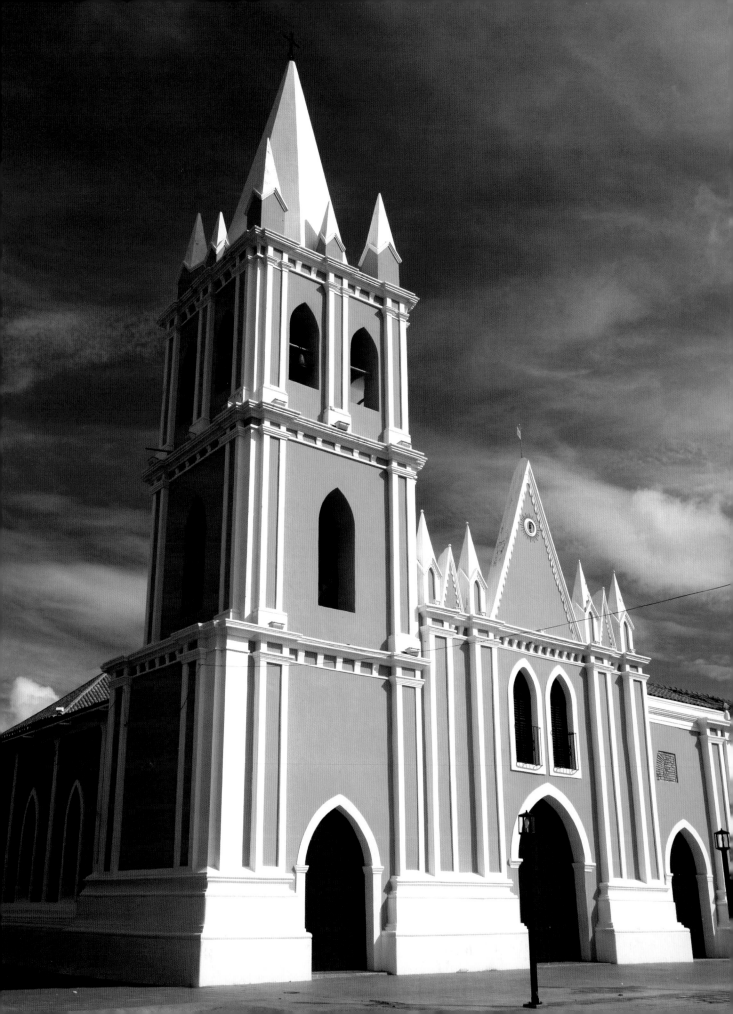

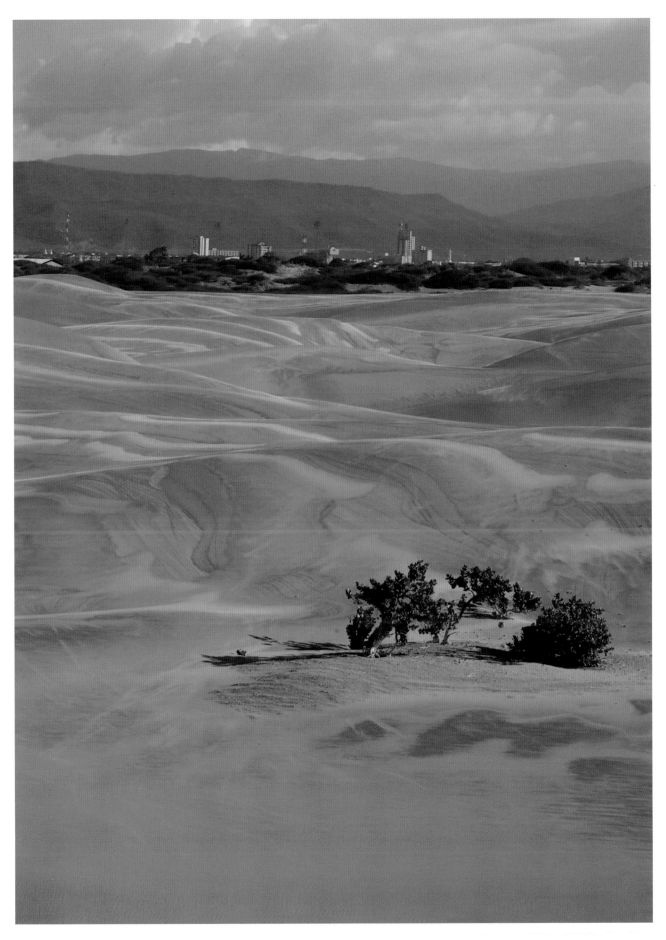

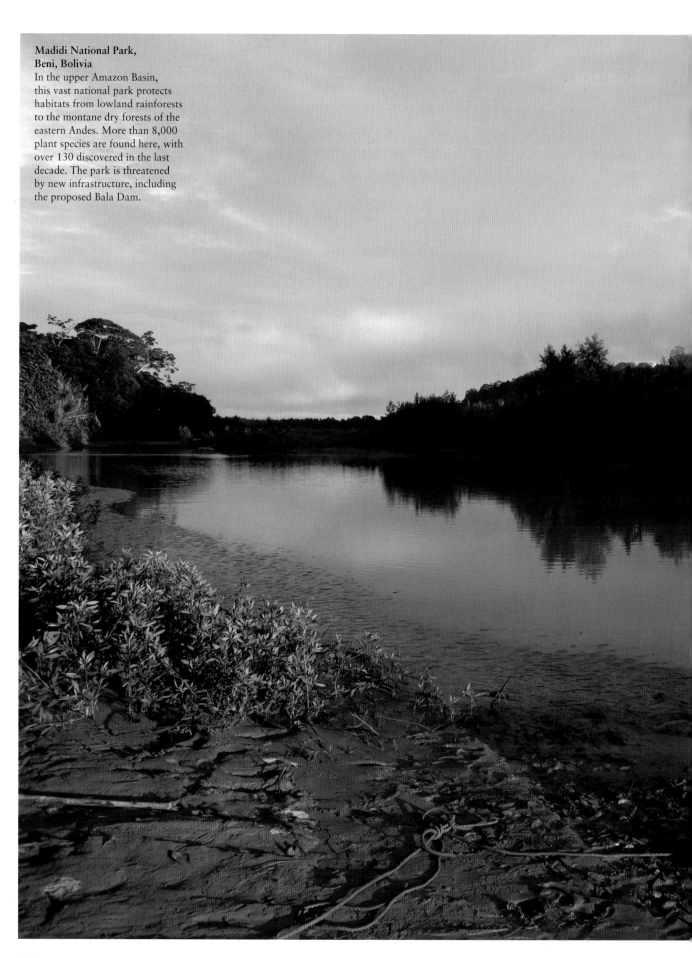

**Madidi National Park,
Beni, Bolivia**
In the upper Amazon Basin,
this vast national park protects
habitats from lowland rainforests
to the montane dry forests of the
eastern Andes. More than 8,000
plant species are found here, with
over 130 discovered in the last
decade. The park is threatened
by new infrastructure, including
the proposed Bala Dam.

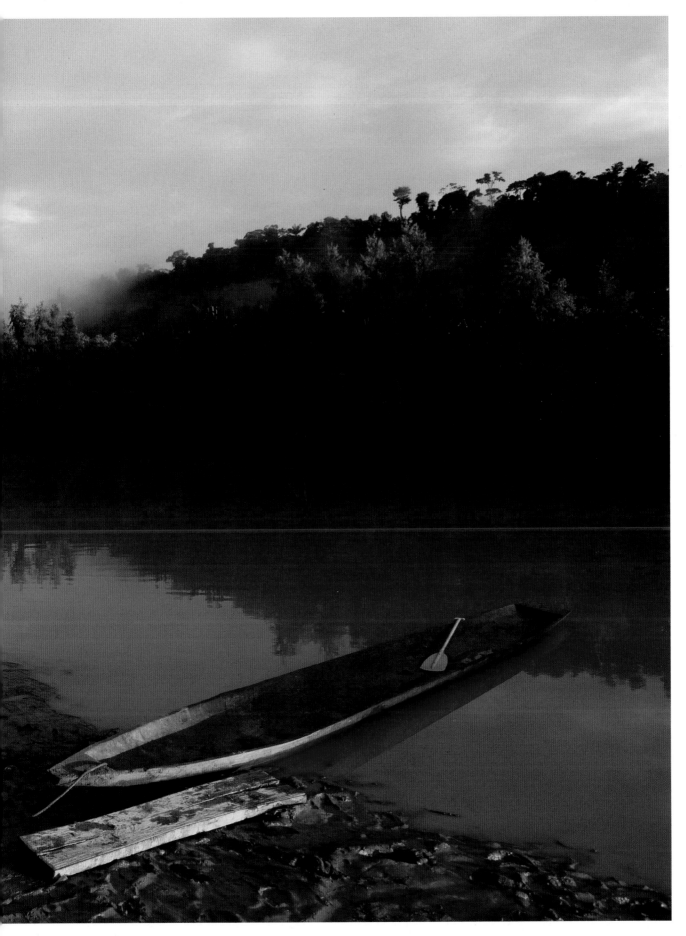

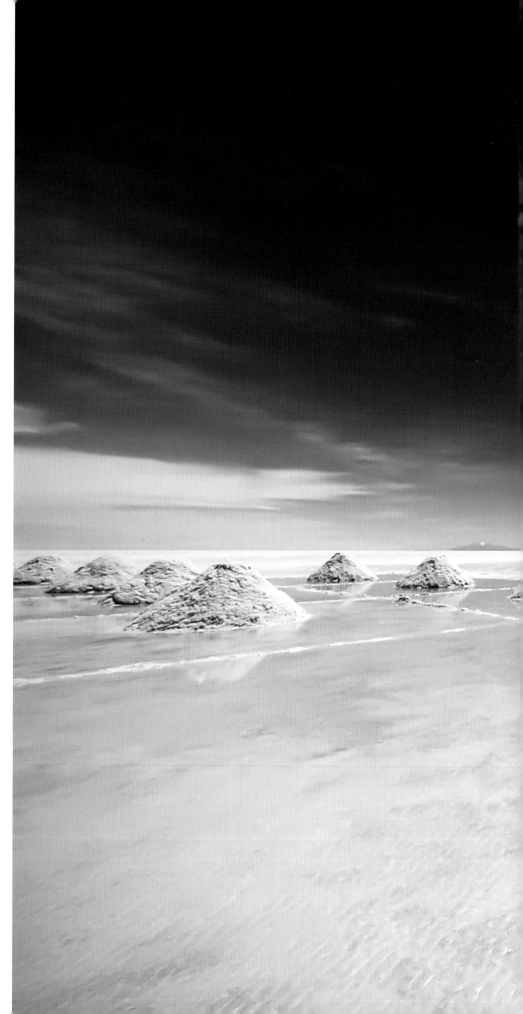

RIGHT:

Salar de Uyuni, Potosí, Bolivia
Covering some 10,000 sq km
(3,900 sq miles) of the Altiplano,
the world's largest salt flat
formed 40,000 years ago as
a vast lake evaporated. The
Bolivian government hopes
to extract the lithium that is
concentrated in the brine under
the salt crust. There are few
animals here, but the Andean
fox and three South American
flamingo species can be spotted.

ALL PHOTOGRAPHS OVERLEAF:

Potosí, Tomás Frías, Bolivia
Founded in 1545, Potosí is
situated at an altitude of 4,090 m
(13,420 ft) in the Andes. In the
latter half of the 16th century,
the prominent peak Cerro Rico
(overleaf left) produced 60 per
cent of silver mined in the world.
The Mint of Bolivia (overleaf
top right) opened in 1572.
Today, UNESCO is concerned
that uncontrolled mining risks
damage to the area.

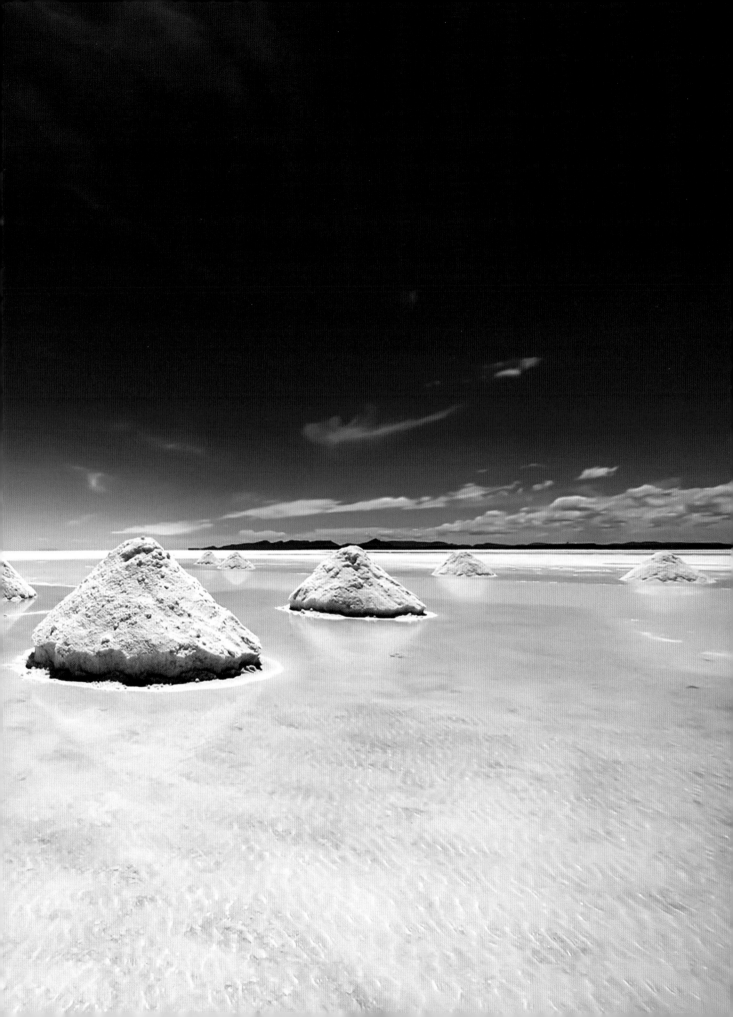

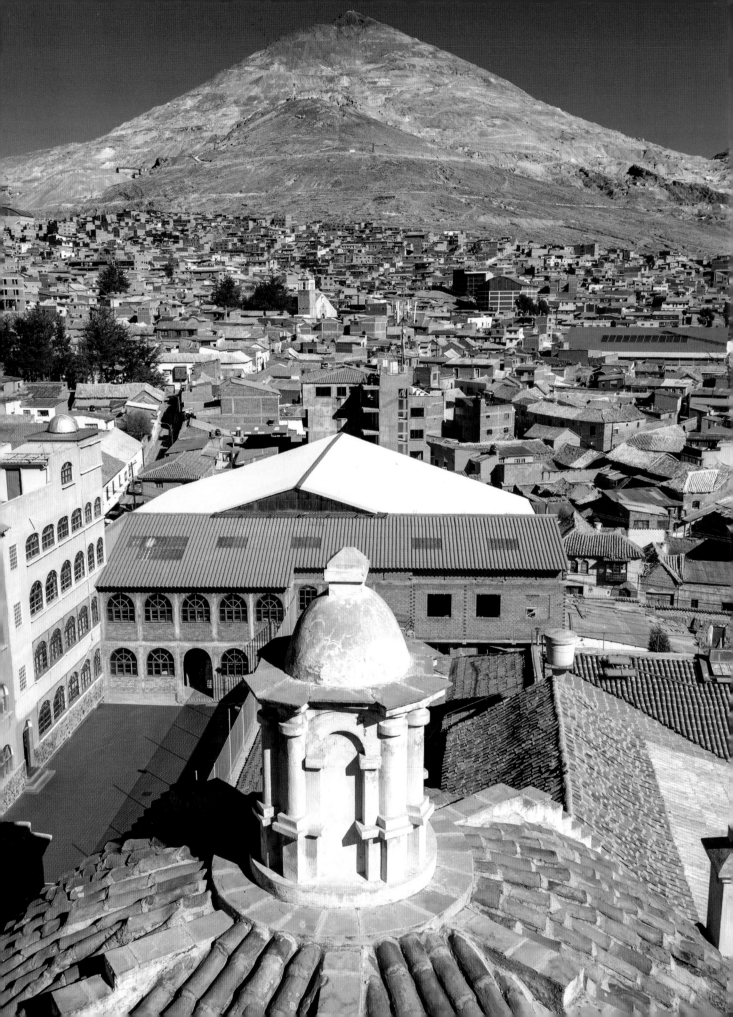

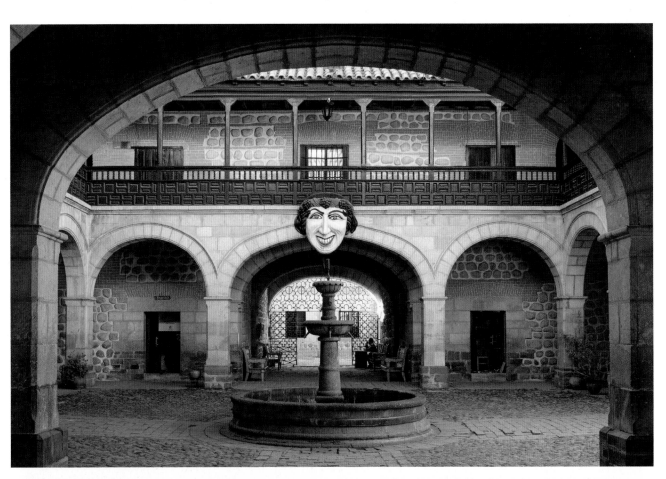

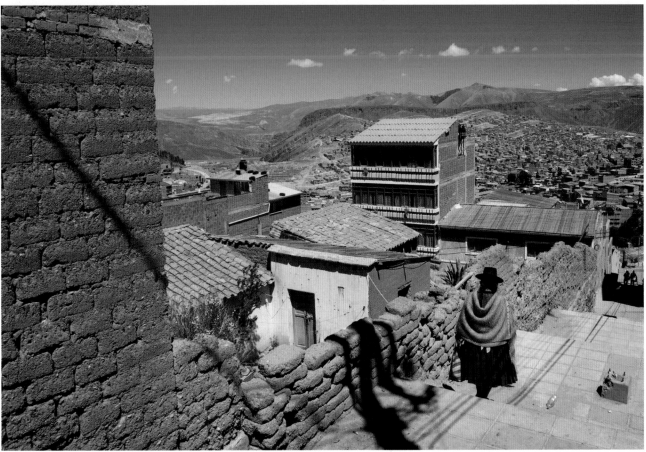

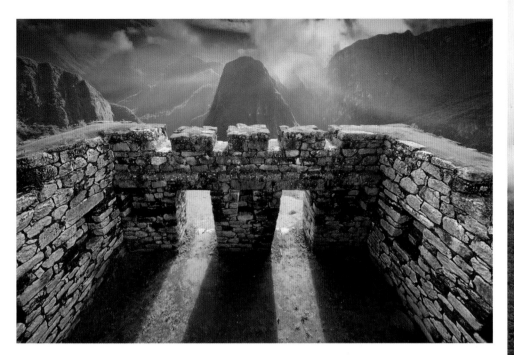

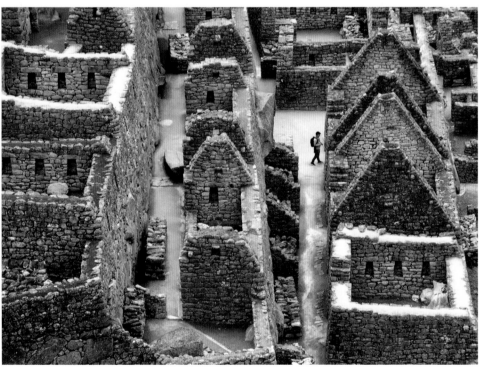

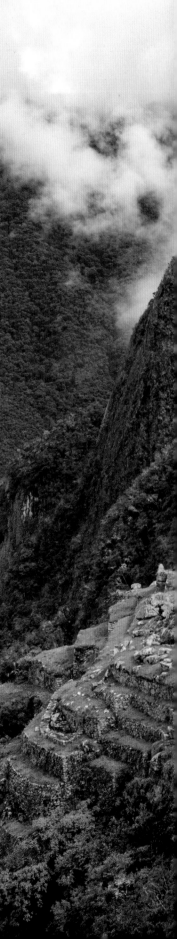

ALL PHOTOGRAPHS:
Machu Picchu, Cusco, Peru
This Inca citadel was probably
constructed as a retreat for
Emperor Pachacuti (1438–72).
The site lies above a bend in the
Urubamba River, with sheer cliffs
dropping 450 m (1,480 ft) on
three sides. Erosion and excessive
tourism take their toll on the
polished dry-stone temples,
palaces and workers' homes.

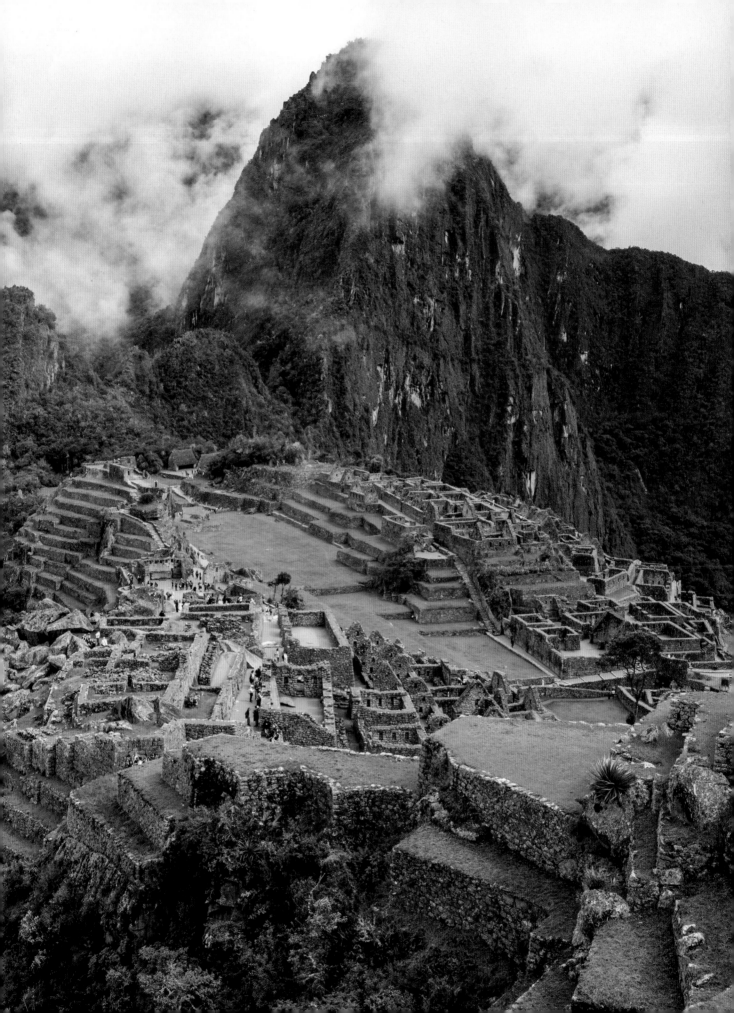

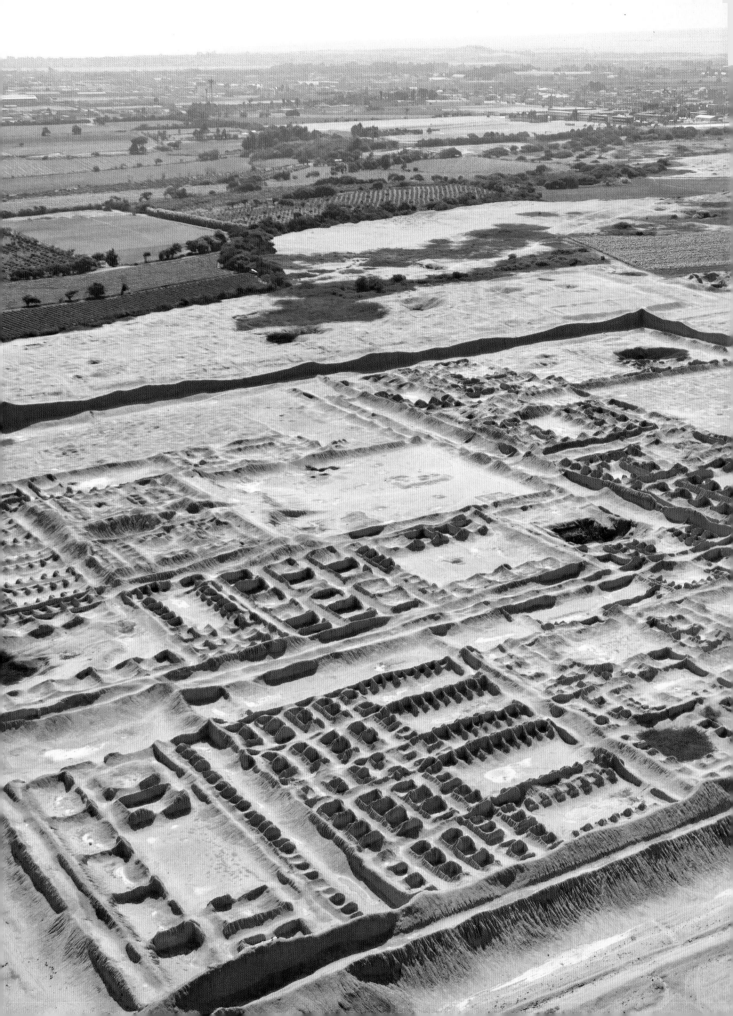

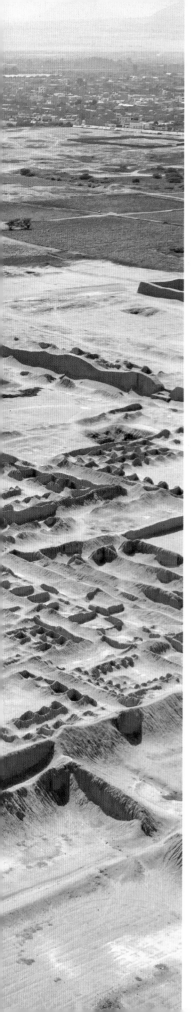

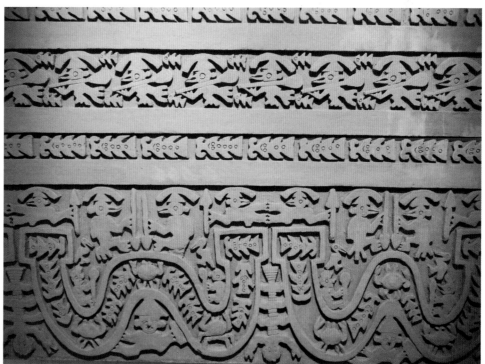

ALL PHOTOGRAPHS:
Chan Chan, La Libertad, Peru
Chan Chan was capital of the
Chimú Empire from 900 to
1470, when it fell to the Inca.
The city had 50,000 inhabitants.
Carvings here are in two styles:
naturalistic and highly stylized.
Climate change is increasing
extremes of dry and rainy
weather, resulting in erosion.

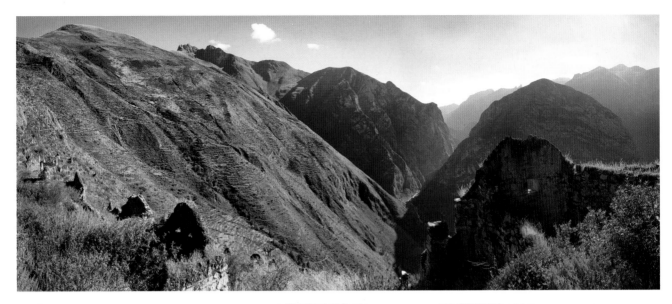

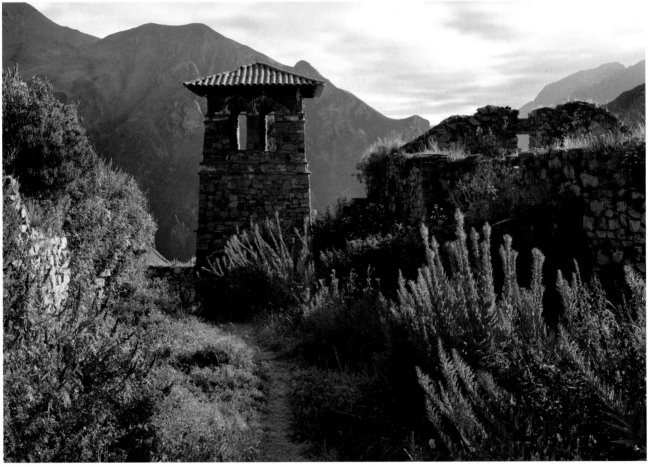

ABOVE TOP AND BOTTOM:
Huaquis, Nor Yauyos-Cochas Reserve, Lima, Peru
The pre-Inca town of Huaquis was abandoned in 1903. The inhabitants had built a system of dams to channel spring water and glacier melt for drinking and irrigation. Today, these vital methods of water conservation have been largely forgotten.

OPPOSITE:
Monte Alegre State Park, Pará, Brazil
Rock paintings decorate the cliffs and caves of the Serra da Lua. In Caverna da Pedra Pintada, the works are between 10,000 and 11,200 years old. The fragile paintings, in reds and yellows, include geometric designs and a woman giving birth.

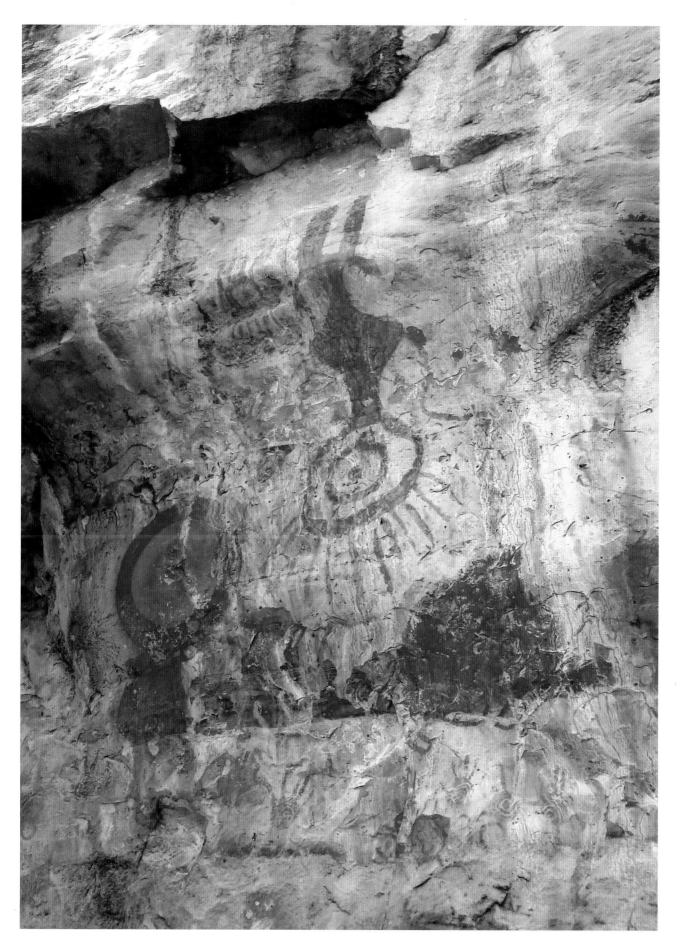

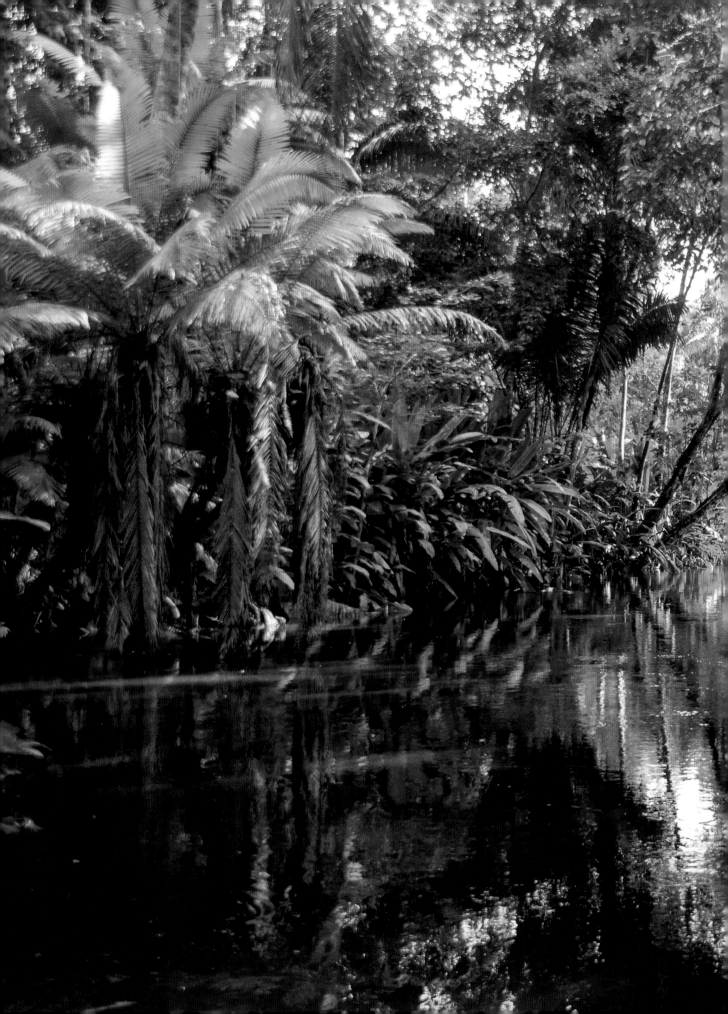

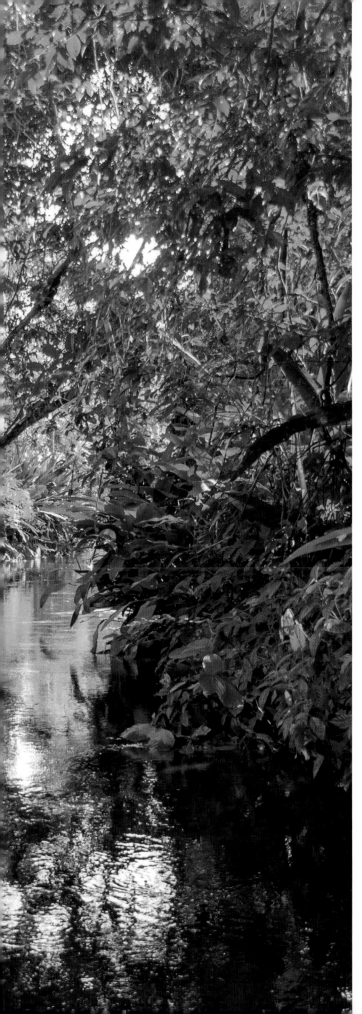

ALL PHOTOGRAPHS:
**Amazon Rainforest,
South America**
The Amazon's plant biodiversity
is the greatest on Earth: 1 sq km
(0.4 sq miles) of Ecuadorian
rainforest (left) is home to more
than 1,100 tree species. There
are around 60,000 plant species
in the entire Amazon Basin,
including *Heliconia rostrata*
(above top), which is pollinated
exclusively by hummingbirds.

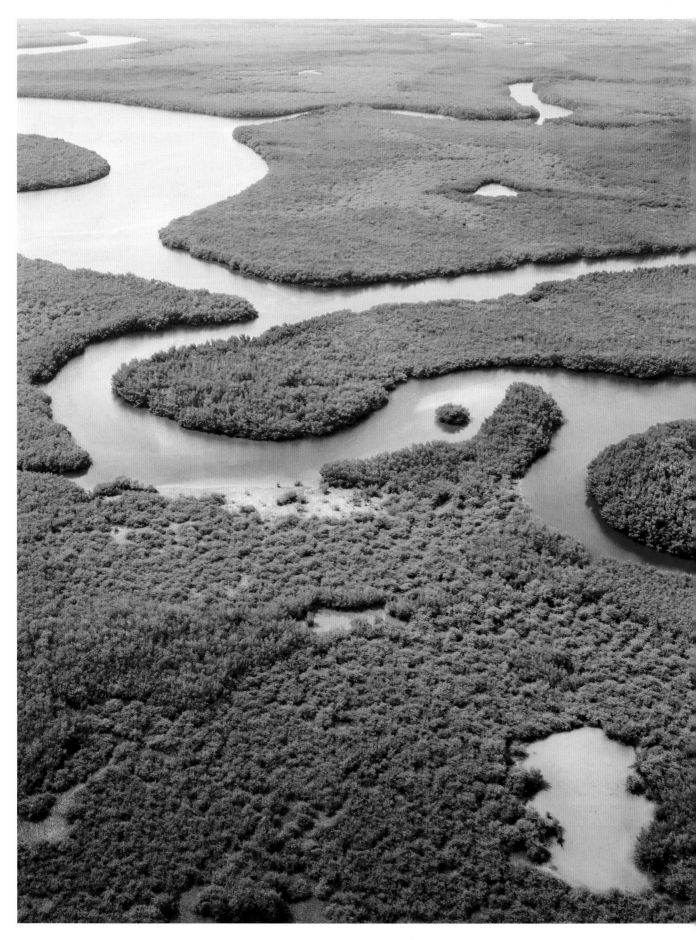

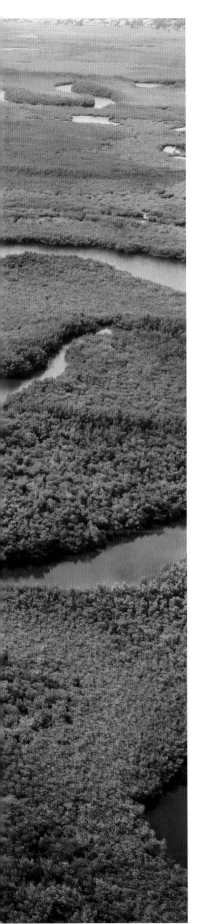

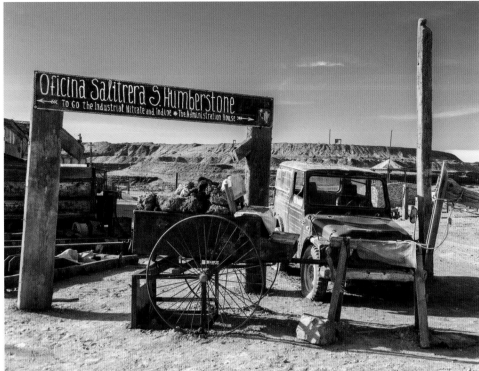

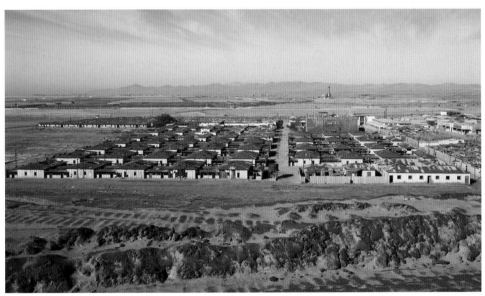

LEFT:

Amazon Rainforest, Brazil
Beset by a multitude of threats, including fires, logging, mining and clearance for farming, the Amazon is home to one in ten known species. One of its largest predators is the green anaconda, the world's heaviest snake, which reaches 9.3 m (30.5 ft) long. The largest land predator is the agile jaguar, which has a body length of up to 1.8 m (5.9 ft).

ABOVE TOP AND BOTTOM:

Humberstone and Santa Laura Saltpeter Works, Iquique, Chile
These saltpeter refineries were founded in 1872, becoming busy towns with homes for hundreds of workers. Their saltpeter was used in fertilizer, transforming farmland around the world. The works were abandoned in 1960 and, isolated in the Atacama Desert, they have since fallen into disrepair.

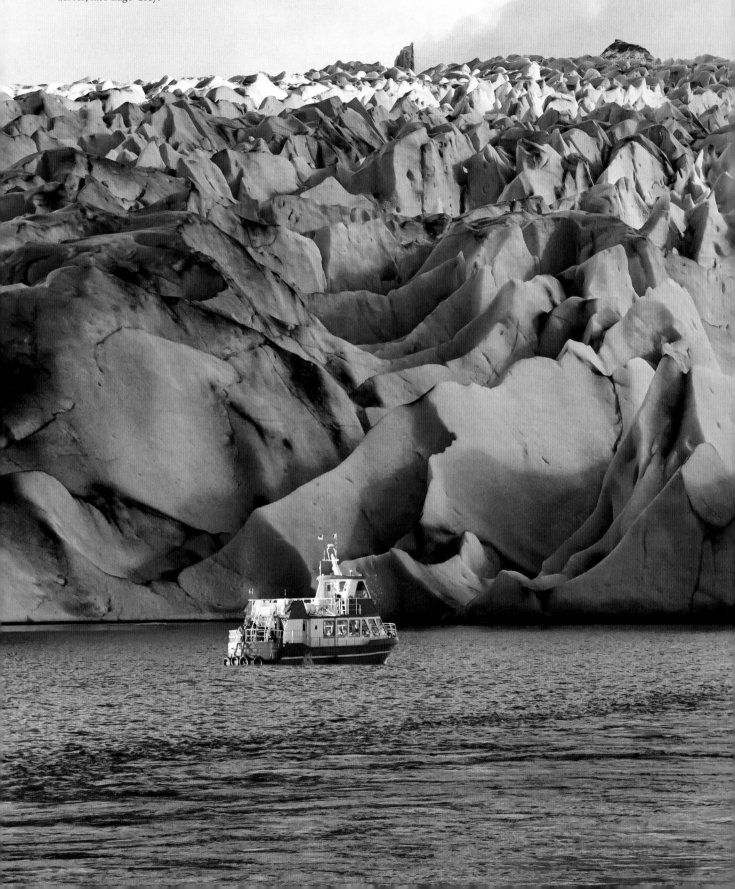

Grey Glacier, Southern Patagonian Ice Field, Chile
Although in retreat, Grey is over 30 m (98 ft) high and 28 km (17 miles)
long. It is the largest of the four main glaciers fed by the Southern
Patagonian Ice Field, which covers 16,480 sq km (6,360 sq miles) of
the southern Andes. The glacier calves icebergs, up to 380 m (1,247 ft)
across, into Lago Grey.

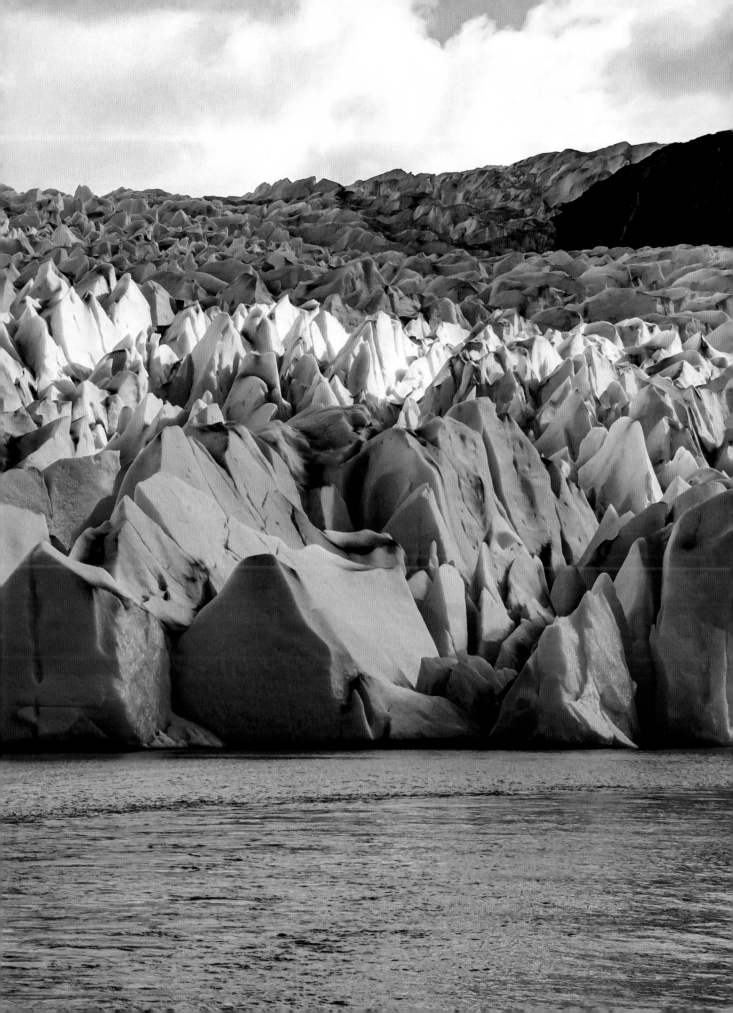

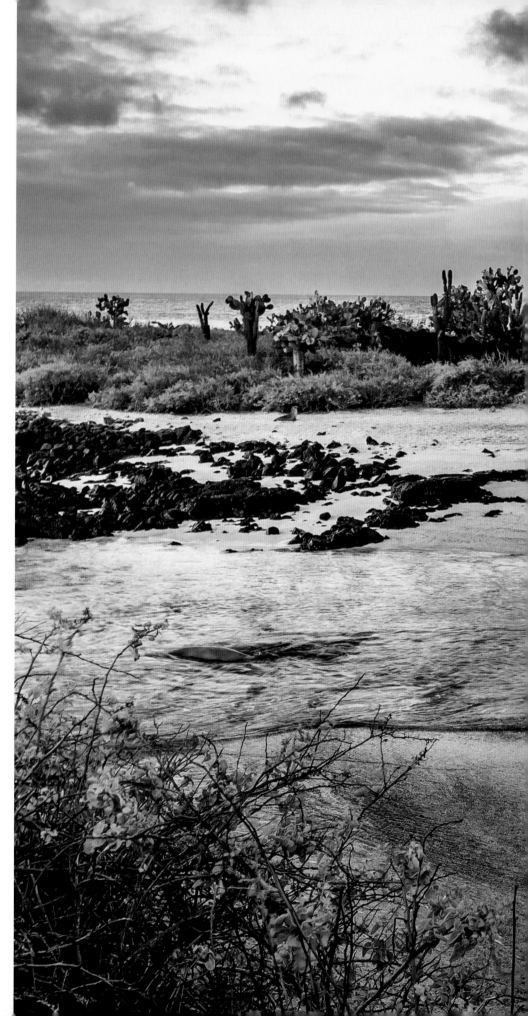

Floreana Island, Galápagos Islands, Ecuador
Around 906 km (563 miles) west of continental Ecuador, the Galápagos Islands are home to endemic species including Galápagos tortoises and the marine iguana, the only ocean-going lizard. Famously, the islands' fauna helped Charles Darwin develop his theories when he visited in 1835. Invasive species, including 500 plants, pose a threat to the islands' native flora and fauna.

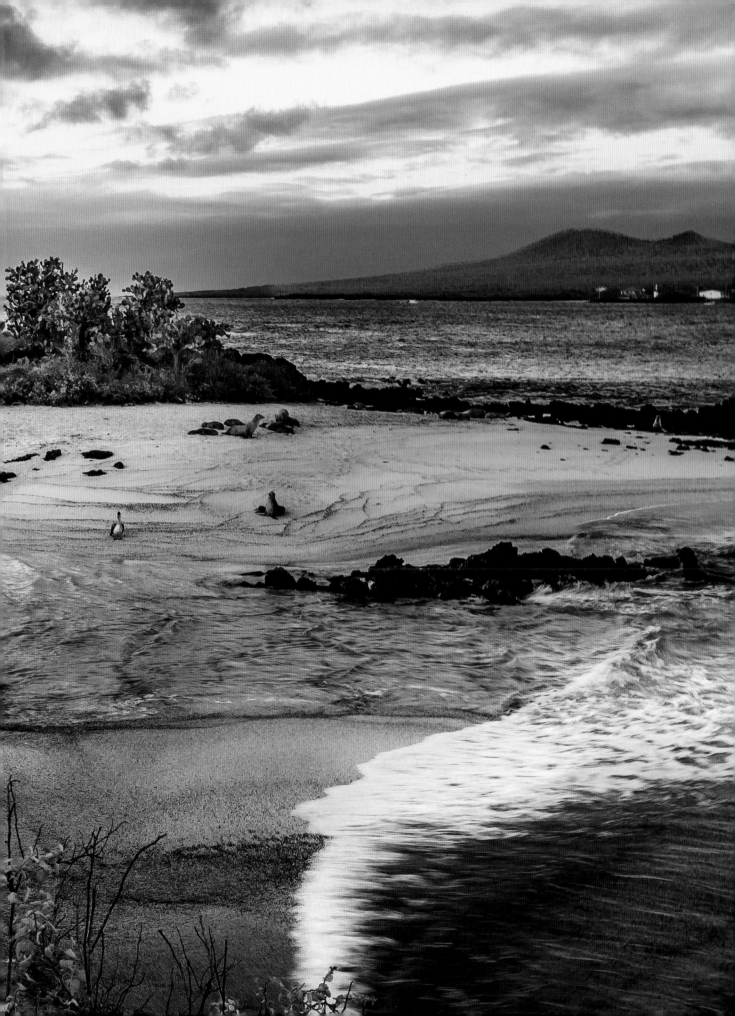

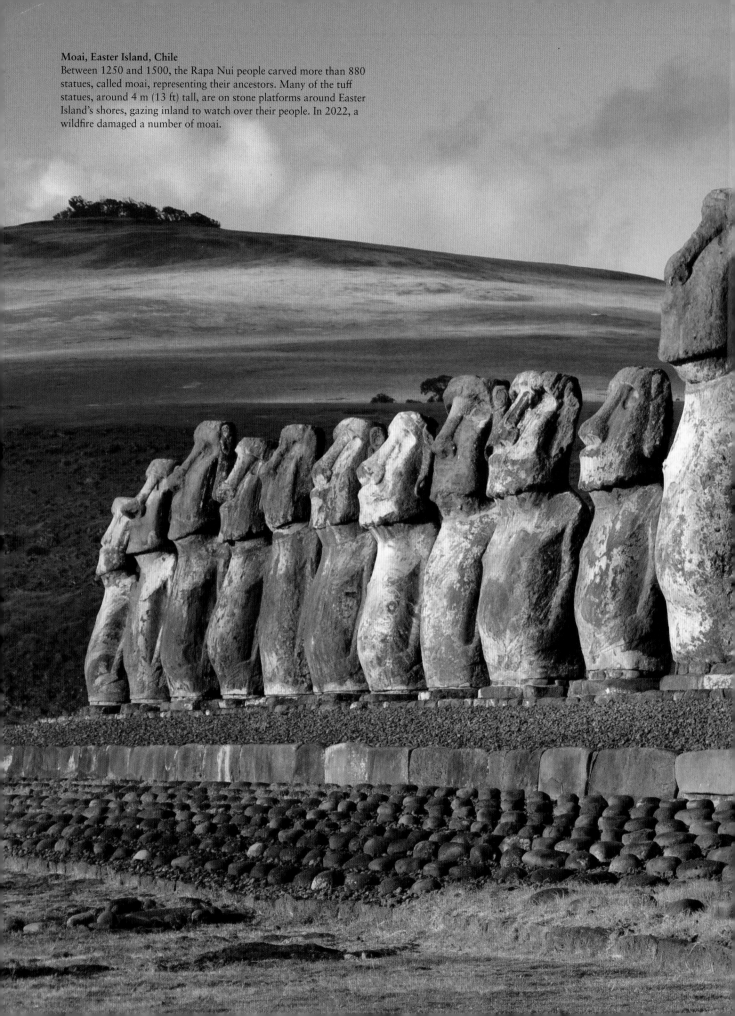

Moai, Easter Island, Chile
Between 1250 and 1500, the Rapa Nui people carved more than 880 statues, called moai, representing their ancestors. Many of the tuff statues, around 4 m (13 ft) tall, are on stone platforms around Easter Island's shores, gazing inland to watch over their people. In 2022, a wildfire damaged a number of moai.

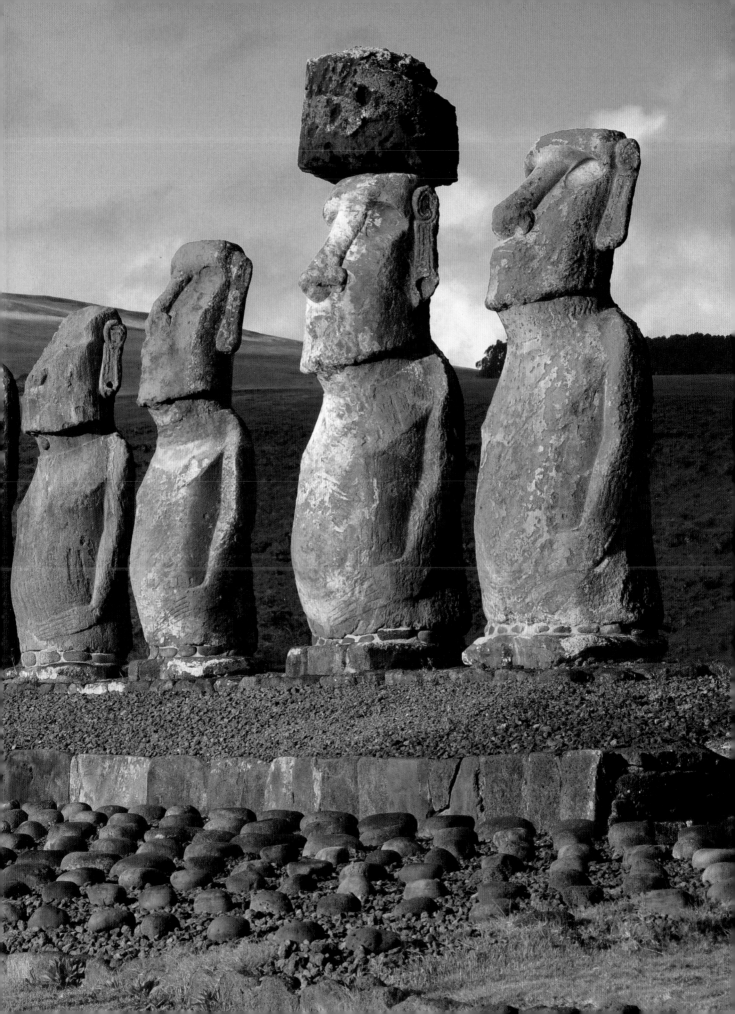

Picture Credits